Happy 60th Birthday
Carol !

D1466495

Buried the

Here lyes Bu
Mr MARY PER
to Mr ALEXAND
Daug of ye Rev
& Mrs MARGARET
departed this l

FOREVER DIXIE

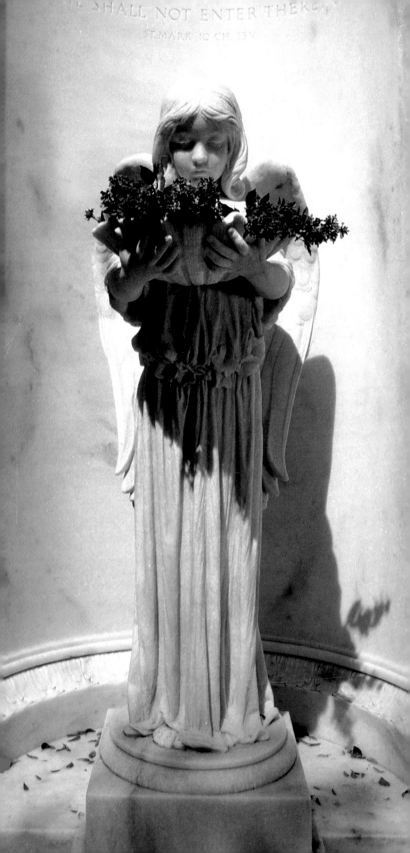

FOREVER DIXIE

A Field Guide to
Southern Cemeteries
& Their Residents

Written and Photographed by
DOUGLAS KEISTER

GIBBS SMITH
TO ENRICH AND INSPIRE HUMANKIND
Salt Lake City | Charleston | Santa Fe | Santa Barbara

TO SANDY, FOREVER

First Edition
12 11 10 09 08 5 4 3 2 1

Published by
Gibbs Smith
P.O. Box 667
Layton, Utah 84041

1.800.835.4993 orders
www.gibbs-smith.com

Designed by Lori Whitlock, Mi Studio, Inc.
Printed and bound in Hong Kong
Gibbs Smith books are printed on either recycled, 100% post consumer waste, or FSC certified papers.

Library of Congress Cataloging-in-Publication Data

Keister, Douglas.
 Forever Dixie : a field guide to Southern cemeteries and their residents /
written and photographed by Douglas Keister. – 1st ed.
 p. cm.
 Includes bibliographical references and index.
 ISBN-13: 978-1-4236-0314-6
 ISBN-10: 1-4236-0314-1
 1. Cemeteries–Southern States–Guidebooks. 2. Sepulchral monuments–Southern States–Guidebooks. 3. Southern States–Biography. 4. Southern States–Genealogy. I. Title.
 F210.K35 2008
 929'.50975–dc22
 2008012366

CONTENTS

ABOUT DIXIE..7

THE CEMETERIES.. 10

 1 Metairie Cemetery, New Orleans, Louisiana 13

 2 Bonaventure Cemetery, Savannah, Georgia 31

 3 Cave Hill Cemetery, Louisville, Kentucky 39

 4 Elmwood Cemetery, Memphis, Tennessee...................... 49

 5 Hollywood Cemetery, Richmond, Virginia 57

 6 Magnolia Cemetery, Charleston, South Carolina 67

 7 Mount Holly Cemetery, Little Rock, Arkansas 73

 8 Nashville City Cemetery, Nashville, Tennessee 79

 9 Oakland Cemetery, Atlanta, Georgia................................85

 10 Oakwood Cemetery, Montgomery, Alabama................... 97

 11 Oakwood Cemetery, Raleigh, North Carolina............... 103

 12 Charleston Churchyards, Charleston, South Carolina111

 13 Key Underwood Coon Dog Memorial Graveyard,

 Tuscumbia, Alabama..119

FUNERARY ARCHITECTURE127

SYMBOLISM...147

SECRET SOCIETIES AND CLUBS187

SOUTHERNERS FOREVER ...213

SUGGESTED READING...244

INDEX..246

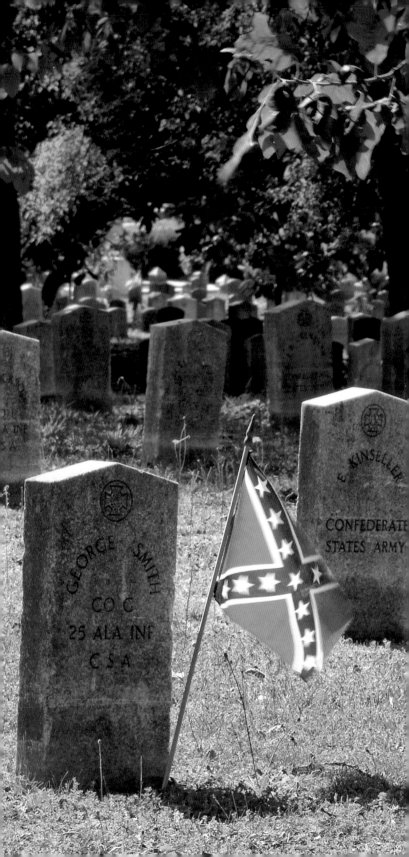

About Dixie

There are few words that are as emotionally charged as *Dixie*. Depending on the audience and venue, Dixie can evoke warm feelings of hearth, home, patriotism, and remembrance, or bristly feelings of segregation, prejudice, arrogance, and exclusion. The word *Dixie* first came into popular language when northerner Daniel Emmett published the song "I Wish I Was in Dixie's Land" on June 21, 1860. The song has since been published under the title "Dixie" and "Dixie's Land." The name *Dixie* may have come from privately issued ten dollar notes in Louisiana known as *dixes* (the French word for "ten"). Other theories refer to the Mason-Dixon Line and a purportedly kind New York slave owner, Mr. Dixy.

Nowadays, Dixie is attached to a variety of things. There are Dixie Chicks, Dixie Cups (invented by a Bostonian), Winn-Dixie supermarkets, Dixieland Jazz bands, Dixiecrats (a portmanteau of fiercely Southern politicians and Democrats), Dixie National Forest and Dixie State College (in southern Utah), and a multitude of brands and services.

The geographic borders of Dixie are hard to pin down. Most scholars agree that all of the states in the Deep South are part of Dixie, but even those scholars can't agree on what comprises the Deep South. For the purpose of this book, we've placed the center of Dixie in northwestern Alabama and drawn a very wavy line around it. We've only included states where almost all of the state has a Southern feel. Thus, we haven't included Florida, the state that has the southernmost point in the continental United States. In fact, the farther south one goes in Florida, the more northern it seems to become. Wander into a grocery store in Miami Beach and you're likely to find hush puppy mix in the exotic foods section. Another geographically southern state is Texas, but large parts of the Lone Star State are decidedly western in flavor;' you're more likely to find refried beans than black-eyed peas on the menu in El Paso. Missouri is another conundrum; although parts of it are definitely Southern (Dred Scott is buried in Bellefontaine Cemetery in St. Louis), most of Missouri stretches too far north. What you will find in this book are the solidly Southern states of Virginia (Richmond was the capital of the Confederacy), North Carolina, South Carolina, Georgia, Alabama, Mississippi, Louisiana, Arkansas, Tennessee, and Kentucky (that quintessential southern gentleman Col. Harland Sanders is buried in Louisville's Cave Hill Cemetery).

Ultimately, Dixie is not defined so much as a geographic area as by the heart and soul of its people. Although we can't possibly include every cemetery and every notable Southerner in this modest tome, we have tried to capture the spirit of Dixie—a spirit best summed up in words penned 150 years ago by a Yankee:

Facing: Confederate Section, Oakland Cemetery, Atlanta, Georgia

I wish I was in the land of cotton,
old times there are not forgotten,
Look away, look away, look away, Dixie Land.
In Dixie Land where I was born in,
early on a frosty mornin',
Look away, look away, look away, Dixie Land.

Chorus:
Then, I wish I was in Dixie,
hooray! hooray!
In Dixie Land I'll take my stand
to live and die in Dixie
Away, away, away down South in Dixie,
Away, away, away down South in Dixie.

FOREVER DIXIE

Note: Global Positioning System (GPS) coordinates are given to almost all of the graves and cemeteries. There are at least four ways GPS coordinates are displayed. We have chosen to use the one most often used in automotive devices. Converters for the other types of GPS coordinates are available on the Internet. The GPS directions to the entrances and not the graves of the smaller cemeteries are given since the cemeteries are best explored by walking rather than driving and individual graves are easy to locate. Most larger cemeteries have maps available in their office for free or a nominal charge. Many historic cemeteries are essentially full and rely on grants, donations, and the work of volunteers through "Friends of" organizations. Please support them in any way you can. They are preserving an important part of American history.

THE CEMETERIES

*I*n the United States, we tend to call all of our burying grounds cemeteries. In fact, there are a number of different types of burying grounds that often overlap each other.

Graveyards and City Cemeteries

The first formal burying grounds were graveyards located in newly formed municipalities. One of the facts of life is death, and after death the body needed to be disposed. These early graveyards were often little more than garbage dumps with a few haphazard wooden grave markers or gravestones for those souls lucky enough to have a family that could afford one. As time went on, some city graveyards became better organized because city fathers were concerned about how they looked and also about health concerns that arose out of less-than-hygenic burial practices.

Churchyards

In Colonial America, most folks belonged to some sort of church, and most churches provided burial space for their parishioners. Generally the churchyard, also known as God's Acre, surrounded the church and, unlike early graveyards, provided a bit more opportunity to erect elaborate and more-or-less permanent memorials to the dead. Although simple tablet gravestones dominate churchyards, there are often a number of specialized tombs, sarcophagi, and sculptures.

Garden and Rural Cemeteries

A profound change in America's burial grounds occurred in the early nineteenth century with the formation of the first cemeteries. The word "cemetery" comes from the Greek *koimeterion*, "dormitory" (a room for sleeping), via the Latin *coemeterium*. Although the word appears as early as the fourteenth century, it didn't come into common use in America until the advent of the garden cemetery. Garden cemeteries (sometimes called rural cemeteries) in America can trace their roots to Cimetière du Père-Lachaise in Paris, France. Père-Lachaise was founded in 1804 in response to the overcrowding in Paris's municipal cemeteries. Père-Lachaise was modeled on English estate landscape design and was intended to provide a more bucolic environment for tending the dead. American burying grounds soon followed suit with the establishment in 1831 of Mount Auburn Cemetery in Cambridge, Massachusetts, as America's first garden cemetery. Except for the tombstones, monuments, and mausoleums, garden cemeteries (with their lush plantings and groomed landscaping) look more like public parks than burying grounds.

Page 9:
Nashville
City Cemetery,
Nashville, Tennessee

Lawn-Park Cemeteries

Lawn-park cemeteries emerged at the end of the nineteenth century. These vast cemeteries combined elements of rural and garden cemeteries, such as room for large-scale monuments and mausoleums plus the addition of vast lawn areas for flat markers.

Memorial Parks

Nowadays, most new cemeteries are primarily memorial parks, which have flat markers. Promoters say they provide a more egalitarian and equalized form of burial, and the lack of upright markers softens the impact of death. Detractors say that memorial parks lack artistic integrity and simply make it easier for cemetery owners to mow the lawn. Memorial parks also tend to have large community mausoleums for those who prefer aboveground burial.

Specialty Cemeteries

America also has a number of specialty cemeteries. These can range from simple family cemeteries that dot the rural landscape, to cemeteries that are reserved for members of secret societies like the Freemasons, Odd Fellows, and Knights of Pythias, to the most popular specialty cemetery—the pet cemetery.

There are thousands of cemeteries in the Southern states, and we can only profile a few here. What you will find here are examples of different types of cemeteries, from Louisville's grand garden cemetery Cave Hill, to Charleston's churchyards, to the highly specialized Key Underwood Coon Dog Memorial Graveyard in Tuscumbia, Alabama.

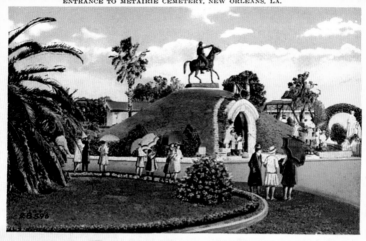

ENTRANCE TO METAIRIE CEMETERY, NEW ORLEANS, LA.

VIEW IN METAIRIE CEMETERY, NEW ORLEANS, LA.—116

METAIRIE CEMETERY
NEW ORLEANS, LOUISIANA

Maps available in cemetery office
www.lakelawnmetairie.com
29 59 10 N 90 06 58 W (cemetery entrance)

Ask the "man on the street" to tell you something about New Orleans and, even if he has never been there, he'll probably conjure up images of Bourbon Street, Mardi Gras, and the devastation caused by Hurricane Katrina in 2006. Ask someone who has visited New Orleans and the list will expand to beignets at the Cafe Du Monde, steamboats churning on the Mississippi, crawfish gumbo, voodoo and—cemeteries. Yes, cemeteries! Without a doubt, there is no city in the United States better known for its cemeteries than New Orleans.

The simple answer to why New Orleans is so well known for its cemeteries stems from the New Orleanian tradition of aboveground burial. The city's cemeteries don't blend into the landscape; they rise above it, making them an obvious part of the varied urban mosaic that is New Orleans. Why aboveground burial has been so popular has long been a subject of debate, even among longtime residents. The legend often conveyed to tourists is that aboveground burial is necessary because of the high water table. This stems from the fact that much of the land in New Orleans is slightly below sea level. Stories abound about early cemeteries in New Orleans full of coffins bobbing to the surface after a heavy rain or an unusually high tide. Well, it's simply not true. Many cities besides New Orleans have a high water table, but the deceased go right into the ground in those soggy burgs.

Scholars offer another explanation. In the first official cemetery in New Orleans, the St. Peter Street Cemetery, founded in the early 1720s, all burials were belowground. But overcrowding and fear of disease from the noxious vapors emitted from the cemetery forced its closing, and a new cemetery just outside the town limits was established. When the new cemetery, St. Louis Cemetery #1, was established, the budding metropolis of New Orleans was under the jurisdiction of Governor Esteban Miro, whose allegiance was to Spain. At the time, burial customs in Spain and, indeed, much of Europe leaned toward aboveground burial. Fashionable New Orleanians with their European-leaning culture simply adopted the tradition. Another factor: following devastating epidemics in the early 1830s, a series of laws were enacted that, once again, were instituted to get the dead out of town. But there was an important exemption in the law that allowed burials to continue at existing cemeteries as long as the burials were in existing aboveground structures. The law expressly forbade belowground burials. Thus, the tradition of aboveground burial was established.

New Orleans continued to prosper, and numerous compact cemeteries dotted the New Orleans landscape by

the Civil War. These cemeteries were quickly filled with tidy "house tombs" made of brick and plaster. The boundaries of the little cemeteries were often ringed with wall vaults, also known as side vaults or oven vaults, which served as a brick fence and limited the size of the cemetery.

After the Civil War, forward-thinking New Orleanians thought it was high time to develop a proper big city cemetery modeled after the park-like rural cemeteries in the East. This new cemetery allowed room for trees and lawns and lagoons and gardens and, most of all, lots and lots of acres for bigger and better and more glorious mausoleums. The promoters acquired a 150-acre tract of land formerly occupied by the Metairie Race Course. The development company, aptly named the Metairie Cemetery Company, consisted of a handful of New Orleans' movers and shakers, including Duncan Kenner, the president of the now-defunct racing association. Kenner had assumed the presidency of the racing association after his post of "Special Commissioner to Great Britain from the Confederate States of America" dissolved along with the Confederate States of America.

Metairie Cemetery was formally dedicated on May 25, 1872, and quickly became the most prestigious cemetery in New Orleans. Much of the beauty of Metairie Cemetery can be ascribed to designer Benjamin F. Harrod, who converted the $1\frac{1}{16}$-mile oval of the old racetrack into the principal avenue of the cemetery, then laid out broad avenues interspersed with small pathways. To complete the design, he added lakes, lagoons, bridges, and hundreds of plantings. The first thing visitors to Metairie Cemetery will note is that, when compared to the ramshackle conditions that exist in New Orleans' many small cemeteries, Metairie sparkles like a gem. Much of the reason for the well-kept appearance of Metairie is due to a law passed in 1908 by the Louisiana legislature (with some political nudging by the cemetery association) that allowed cemetery corporations to take cemetery tombs and plots in trust for their perpetual maintenance. Officials at Metairie say that over 9,000 of the tombs are provided with perpetual care. Some of the society tombs that were established before the enactment of the law were not constructed under the perpetual care program. The cemetery has taken on the care of these historically significant structures, which were originally constructed to provide an economical alternative to those desiring aboveground burial. These tombs provide historians, tourists, and artists a glimpse into a bygone age when "benevolent associations" offered burial services to their members in an elegant setting at an economical cost. Costs for burial in society tombs were kept down because the dear departed could only stay in a society tomb crypt for a finite amount of time. There were many more members of a benevolent society than crypts in the tomb. When room was needed for another body, the bones of the previous crypt occupant were gathered up and placed in an ossuary, thus creating space for the new arrival.

Visitors to Metairie will note a wealth of Civil War memorials, curious for a cemetery that was founded seven years after the

end of the Civil War. But, as anyone who has spent any time in the South knows, the Civil War is an enduring and celebrated part of the culture. Metairie Cemetery almost immediately became a showplace for cenotaphs of war heroes who died and were buried on the field of battle. Metairie Cemetery also contains the remains of many sons of the South who were felled by Yankee bullets and whose families had their bones transferred to Metairie after the war. The cemetery is also the final bivouac of many crusty veterans who had survived the war and chose Metairie as their last resting place. Chief among the Civil War elite was Jefferson Davis, president of the Confederate States of America. But Davis's stay at Metairie was a temporary affair. When he died in New Orleans in 1889, plans had not been made to secure his final resting place. So New Orleanians, not wanting to miss a chance for a good funeral, seized the opportunity and, according to the *Daily Picayune*, ""[the funeral] would be the grandest and most impressive that had ever been witnessed in the city." After the funeral, Davis's casket was placed in a crypt in the Army of Northern Virginia tumulus. There he remained until May 31, 1893, when he was moved to his final destination—Hollywood Cemetery in Richmond, Virginia (see page 57). Although Jefferson Davis moved out of the tumulus, the gilded marble tablet that bore Davis's signature remained, and the crypt was sealed forever.

Metairie Cemetery, of course, contains much more than Civil War heroes. Ever since its inception, it has been the place to spend eternity for stylish well-to-do New Orleanians as well as for those of lesser means. Because of its ample land, it has also been the showplace for New Orleans' finest mausoleum designers and builders. The list of spectacular monuments is too great to cover in a few pages, but cemetery buffs and architecture lovers will not be disappointed in a trip to Metairie Cemetery. Here you will encounter every significant style of architecture in the last century as well as some whimsical architectural blends of funerary art that can only be found in a cemetery. Much of the beauty and preservation of Metairie Cemetery needs to be credited to its succession of owners. Originally it was owned by members of the Metairie Cemetery Company, one of whom was John A. Morris, who died in 1895; eventually his estate acquired controlling interest in the cemetery. In 1951, John Weiblen, son of Metairie Cemetery's most prominent tomb builder, Albert Weiblen, and John Weiblen's wife, Norma Merritt Weiblen, purchased the cemetery from the

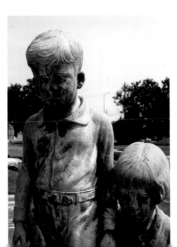

Vonderbank Mausoleum

Morris family. The Weiblens sold the property to the current owners, Stewart Enterprises, in 1969. After Metairie's acquisition by Stewart Enterprises, it was merged with neighboring Lake Lawn Park Cemetery, site of the largest community mausoleum in New Orleans. At the Lake Lawn section of Lake Lawn Metairie, Stewart Enterprises operates a more traditional cemetery, though with a distinctive New Orleans style. The renamed Lake Lawn Metairie Cemetery offers belowground burial, but the big business at Lake Lawn Metairie is still catering to New Orleanians' preferred aboveground burial.

ANGELE MARIE LANGLES
29 58 52 N 90 06 56 W (approximate)

There is a curious inscription carved into the thirty-foot Langles obelisk. Passersby might think the inscription "105 La. 39" is a maker's mark or perhaps a parts number from a funerary supply catalog. In fact, it refers to a statute in the state of Louisiana's laws of succession.

In a thick fog on the early morning of July 4, 1898, the French steamship *LaBourgoyne* was threading its way along the Nova Scotia coast. Suddenly, an ironclad British freighter, the *Cromartyshire*, was spotted through the fog, but it was too late to avoid a collision. The *Cromartyshire* rammed the French ship, which sank in less than thirty minutes. There were few survivors. Most were asleep in their quarters and, amid the chaos and confusion, were not able to make it above deck.

Among those lost at sea were Angele Marie Langles and her mother, Madame Pauline Costa Langles, wealthy widow of the owner of a New Orleans cracker factory. A month before, each of them had made out wills that were, for the most part, reciprocal, although each one did have a few specific requests. Since neither one had specifically willed the bulk of her estate to particular relatives, the question of who died first would have a tremendous effect on which set of heirs got the estate.

Lawyers were hired, family members took sides, and angry words were hurled back and forth. After much expense, the case finally came before the court of Judge N. H. Rightor. Upon hearing all the evidence, the jury came back to the judge and stated that it could not reach a decision. Judge Rightor took it upon himself to settle the case and ruled that, even though the evidence suggested that Madame Langles was in better physical health than Angele and was likely to survive a physical peril longer, Angele knew how to swim and Madame Langles did not. After all, ruled the judge, they were on a ship, and it was likely that though the bodies were never recovered they would have died from drowning. Angele simply would have been able to keep her head above water a bit longer.

Madame Langles' heirs appealed to the Louisiana Supreme Court but to no avail. Angele's heirs were victorious, but their legal battles were not over. Angele's will called for the allocation of $3,000 for the erection of a monument upon her death.

Her heirs greedily wanted to keep what was left of her estate after their lawyer's fees and argued that "we don't think there needs to be a monument since there isn't a body to put there." Luckily, good sense prevailed, and the judge ruled that it was Angele's intention to have a monument erected to her memory, not necessarily to her physical remains.

The attorney, who was now executor of the estate, ordered a monument from legendary New Orleans tomb designer Albert Weiblen and directed him to carve into the base of the monument "Angele Marie Langles, 105 La. 39," denoting the deceased's name and the Louisiana statute.

As a final punctuation to the case, there were three other New Orleanians—Mrs. Jules Aldigé, her daughter, and her granddaughter—who also perished in the shipwreck. The family waited until after the outcome of the Langles case to decide on the succession. The surviving Aldigé family members placed a tomb just a few feet away from the Langles monument, topped with two angels riding the bow of a sinking ship. Inscribed on the tomb are ALL the names of the members of the Aldigé family who perished that fateful July morning.

P.G. T. BEAUREGARD
May 28, 1818–February 20, 1893 ❦ 29 58 53 N 90 06 51 W

Pierre Gustave Toutant Beauregard (usually known as P. G. Beauregard or G. T. Beauregard) was the first prominent Southern general of the Civil War. Beauregard was born to a white Creole family on a plantation outside New Orleans. He spent his early life at New Orleans schools and a French school in New York before attending and then graduating in 1838 from the United States Military Academy at West Point, New York. While at West Point, he acquired the nickname "The Little Creole." After graduation, he served as an engineer in the Mexican-American War under General Winfield Scott. Returning to Louisiana in 1841, he married Marie Laure Villeré, the daughter of sugar planter Jules Villeré. Marie died in 1850 after the couple had three children.

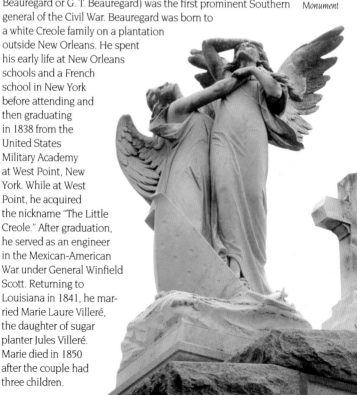

Aldigé Monument

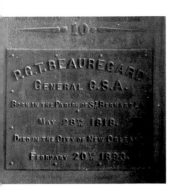

P. G. T.
Beauregard
Crypt

Beauregard returned to West Point to teach in January 1861 but resigned after only five days when Louisiana seceded from the Union. Beauregard entered the Confederate army, and by July 21, 1861, he had been promoted to full general. He advised Confederate president Jefferson Davis to station substantial forces to protect New Orleans, a request that Davis denied. New Orleans fell on May 1, 1862, without a single casualty. The Battle of New Orleans became a major turning point of the Civil War and created a lifelong friction between Beauregard and Davis.

Beauregard had already made a name for himself by ordering the shelling of Fort Sumter, which was the official beginning of the Civil War. He went on to defeat the Union troops at the First Battle of Bull Run (First Battle of Manassas) on July 21, 1861. During the Civil War, Beauregard participated in many battles and achieved a number of victories despite often being undermanned. He is also known as the man who standardized the Confederate Battle Flag and made it the most popular symbol of the Confederacy. The original Stars and Bars flag was often difficult to distinguish from the Union flag on the battlefield, making battlefield maneuvers problematic at times.

After the war, Beauregard spoke in favor of civil rights for the recently freed slaves, a very unpopular stance at that time. He went into government service and authored a number of books and articles, often blaming Davis for losing the Civil War (Davis often blamed Beauregard for losing the war). When Davis died in 1889, Beauregard was invited to ride in one of the lead carriages in the funeral procession. Beauregard declined, stating that Davis's death "did not overly disturb him."

Walker
Mausoleum

Pierre Gustave Toutant Beauregard died in New Orleans four years later and was buried in the Army of Tennessee tumulus in Metairie Cemetery. The tomb has multiple crypts that were often opened and reopened to receive the remains of Confederate soldiers. Beauregard's crypt is one of only three that are sealed for all time.

WALKER MAUSOLEUM
29 58 54 N 90 07 12 W

This mausoleum is attributed to monument manufacturer Charles Orleans and built for Joseph A. Walker (d. 1893). The Walker mausoleum has elements of both Romanesque and Gothic architecture but, on the whole, comes under the heading "uniquely

funerary." You're just not going to see this sort of architecture while walking down the street. Monument designer and contractor Charles A. Orleans (1839–1923) came to New Orleans in 1878 following a string of business failures in the building trade in Chicago, New York, and Paris. Almost immediately after his arrival in New Orleans, he turned to the business of building tombs and monuments. With the beautifully designed Metairie Cemetery as his palette, he began marketing and building with a vengeance. By 1894, he claimed in an advertisement that he had erected three-fourths of the principal granite vaults and monuments in New Orleans during the previous sixteen years.

VONDERBANK MAUSOLEUM
29 58 54 N 90 06 55 W

The Vonderbank mausoleum is fashioned out of a combination of rusticated and polished red Missouri granite. The especially interesting parts of this mausoleum are the ornaments and statues that adorn it. The mausoleum is dedicated to the memory of Mrs. Babette Vonderbank Ahrens, who died in 1928. Her husband, Arthur, who commissioned the mausoleum, died in 1932 and is also entombed inside. A bronze statue of Memory guards the door. The door is engraved with the names of various members of the Vonderbank family. On Memory's pedestal is a bronze relief of Babette with the words "Dear Tante [aunt] Babette," lovingly viewed by bronze statues of her niece and nephew (see also page 15).

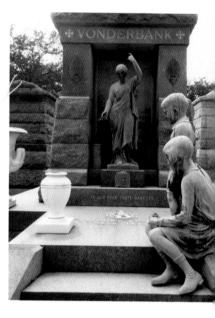

Vonderbank Mausoleum

The family crest and the name of Babette's husband have been carved on the walkway between the children's statues and the door plaque. The plaques and the statues were designed and fabricated by the sculptor Albert Rieker.

HARRINGTON MAUSOLEUM
29 58 59 N 90 06 59 W

This seated bronze female figure is laying a spray of roses at the door of the mausoleum of Joseph V. "Never Smile" Harrington. The mausoleum was designed by noted New Orleans mausoleum contractor Albert Weiblen. It seems "Never Smile," who earned his moniker for the poker face he displayed while playing games of chance in the gambling halls on Royal Street, met his end after a particularly successful night at the poker tables. Witnesses recount that on that warm July night in 1924, they

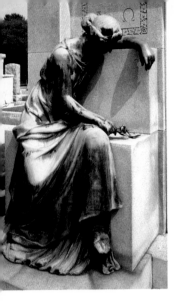

heard a hail of bullets followed by a crash as Harrington's car smashed into a utility pole. Wires from the downed utility pole danced and sparked on the street, illuminating the face of Harrington, who would certainly never smile again. When his wife, Bertha, ordered the mausoleum from Weiblen, a judge who was responsible for administering the estate would not approve the purchase, saying the expense of the mausoleum was out of proportion to the assets of the estate. But Bertha had her way and merely paid for the mausoleum in cash. The source of the funds was not immediately revealed to the judge.

Harrington Mausoleum

MAUSOLEUMS
Lake Lawn Section,
Lake Lawn Metairie Cemetery
29 59 06 N 90 07 08 W
This section was developed in 1969 after acquisition by Stewart Enterprises.

Lake Lawn Mausoleums

EGAN TOMB
29 58 56 N 90 07 17 W

It appears that the Egan family tomb has fallen into disrepair and is gently crumbling into the earth; actually, the tomb is in quite good repair and should stand for many years to come. It was built of Tennessee marble in the late 1800s and is one of the most unique and creative replica tombs in the world. Often referred to as "the ruined castle," its design is taken from a little chapel on *Egan Tomb* the family's estate in Ireland that had been burned and vandalized, and now lies in ruins.

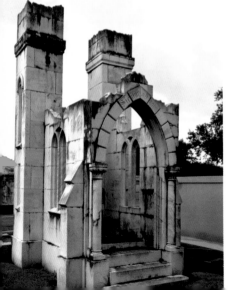

The design has been attributed to Pierre Casse, who skillfully carved the marble to make it appear chipped, cracked, and broken. To complete the illusion, the slab containing the names of the fallen Egans (on the floor of the tomb, covering the underground crypts) also appears to be cracked. Perhaps the tomb is a representation of life cut short: it contains the remains of two young Egan men who died in the Civil War: twenty-four-year-old Henry Egan was killed at Amelia Springs, Virginia, on April 6, 1865, and twenty-four-year-old

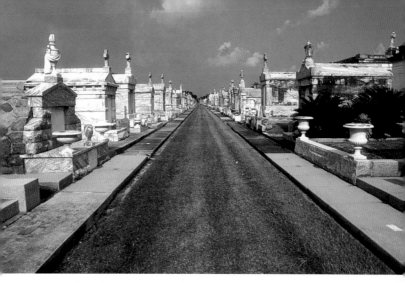

Yelverton Egan was killed at the Battle of Sharpsburg (Antietam) on September 17, 1863. The inscription above the Gothic arch—*Sic itur ad astra* ("Thus is accomplished the journey to the stars")—is from Virgil, book ix, line 641, written in 19 BC.

Mausoleums along one of the pathways designed by Benjamin Harrod in the 1870s reflect the lush well-kept grounds at Metairie.

LARENDON MAUSOLEUM

29 58 56 N 90 07 17 W

General P. G. T. Beauregard commissioned this unique mausoleum for his cherished daughter, Laure Beauregard Larendon (1850–1884). The mausoleum in which Laure is spending eternity with her husband and two children was built in 1885 of dark Belgian limestone. The design is Moorish with lobed horseshoe arches and a modified dome crowned with an Eastern Orthodox cross. The somber mood of the structure is enlivened with a circular stained glass window set into one of the arches.

PIZZATI MAUSOLEUM

29 58 51 N 90 06 56 W

The mausoleum of Captain Salvatore Pizzati was manufactured by Charles Orleans from a design by Orleans architect Charles Brune. During the Golden Age of the mausoleum (post Civil War to the Great Depression), there was lively competition among mausoleum builders to build the best and try to outdo one another. It would appear that the Pizzati mausoleum is a result of that competition and, consequently, is one of the most ornate and eclectic mausoleums in the cemetery.

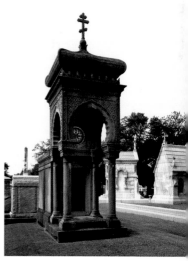

Larendon Mausoleum

Among its ornaments, the Pizzati monument is embellished with medieval turrets, Byzantine columns, curved dentils, a statue of Memory, elegantly carved garlands in the frieze area,

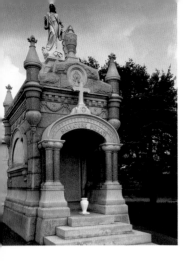

a blind window, a draped urn, and an alpha-and-omega symbol.

Captain Salvatore Pizzati was an Italian emigrant who made his fortune as an importer of tropical fruit. Perhaps Salvatore's mausoleum was just the reflection of a whimsical and somewhat eccentric man. The story goes that before he died, Pizzati requested that he be buried with his favorite rocking chair; apparently, the chair was placed in a chamber below his crypt.

Pizzati Mausoleum

CONTESSA ENTELLINA ASSOCIATION TOMB
MINERVA ASSOCIATION SOCIETY TOMB

29 58 53 N 90 07 06 W

Both of these society tombs are Classical Revival in style. The Minerva Society tomb, built in 1879, leans towards Renaissance Revival influences with its stucco masonry and red terra-cotta ornaments in the pediment and frieze. The Minerva Society disbanded, and the mausoleum was sold to the Vittorio Emmanuelle Society that, unfortunately, was also liquidated. A statue of the goddess Minerva, sculpted by the New Orleans stone carver Domingueaux, reigns majestically over the now-abandoned crypts.

The marble Contessa Entellina Association tomb built in 1886 is the largest society tomb in Metairie Cemetery. A faded inscription carved into the marble on the right side of the mausoleum reads as follows:

Contessa Entellina Association and Minerva Association Society Tombs

This monument stands as a tribute to the men and women of Contessa Entellina who came to this country as pioneers to start a new life. By their industry, integrity and honor, they earned the respect and admiration of the community.

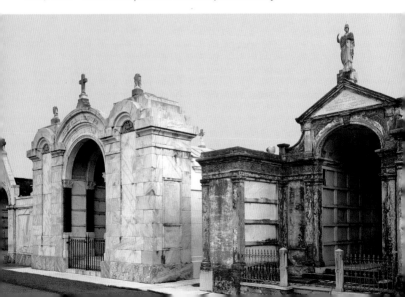

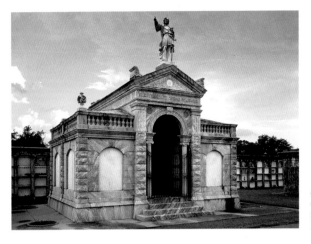

Cristoforo Colombo Society Mausoleum

CRISTOFORO COLOMBO SOCIETY MAUSOLEUM 🕮 29 58 53 N 90 07 06 W

Perched atop the Societa Cristoforo Colombo tomb, a life-size statue of the great Italian navigator Christopher Columbus points toward the New World. In the centuries to come, many Italians followed him to America but not all achieved his station in life. Many of these Italians and other nationalities as well formed fraternal or benevolent societies that were patterned after American organizations such as the Elks and the Masons. These societies, besides being a place to gather and talk, contracted with doctors and hospitals to provide access to basic medical care. The majority of the societies also provided a place of burial at a modest cost. By their nature, the society tombs had a finite amount of space, so one's stay in a crypt was a temporary affair. After an appropriate duration, the deceased's bones were scooped up and placed in a separate chamber. Sometimes these bone warehouses, known as ossuaries, were part of the tomb and other times they were off-site.

There are only a few active society tombs in New Orleans today. The Cristoforo Colombo Society is no longer active, and this tomb has been refurbished and converted to a community mausoleum where occupants are now guaranteed a permanent residence.

LACOSST MONUMENT
29 58 51 N 90 06 53 W

Eugene Lacosst spared no expense when it came to building his final resting place (his will provided $60,000 for his tomb). Built in 1918 in the midst of World War I, when building materials were in short supply, the monument is as much a testament to Lacosst's wealth as it is to the craft of the stone carvers. Architects Burton and Bendernagel of New Orleans based their design for the Lacosst monument

Lacosst Monument

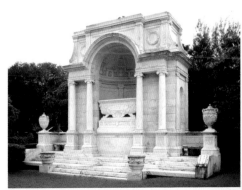

on a memorial honoring a cardinal in the Church of Santa Croce in Florence, Italy. The Renaissance Revival–style monument, in addition to providing a pedestal for and housing the sarcophagus, takes the form of an exedra, a rectangular or semicircular recess with raised seats. The cream-colored Alabama marble was brought from the Alabama quarries to the plant of monument manufacturer Albert Weiblen, where expert carvers had been brought from Italy to do the intricate and delicate work. The giant sarcophagus housing Lacosst's remains was carved from a solid block of marble and is finished front and back. The architects specified that only the finest pieces of the Alabama marble were to be used for the monument and their choices were so precise that the rejects were enough to build fifteen other mausoleums.

Officially, Eugene Lacosst was a hairdresser, but through crafty speculation, he amassed a huge fortune playing the stock market. Among his other talents was whistling, and he was often invited to participate in musical events held in people's homes, a popular pastime in the late nineteenth century. To further add to the curiosities of Eugene Lacosst's life is the provision in his will that his monument should only have enough space for the caskets of himself and—his mother.

McCAN MAUSOLEUM
29 58 54 N 90 07 14 W

The David McCan mausoleum, with its Gothic Revival form and strong verticality, is reminiscent of the Albert Memorial in London's South Kensington district. The death of Queen Victoria's consort, Albert, in 1861 was one of the major factors in the popularization of the funerary arts. One of Queen Victoria's first acts of memorialization of Prince Albert was the construction of the Albert Memorial. He died at age forty-two following a bout of typhoid fever. According to the Queen, their

McCan Mausoleum

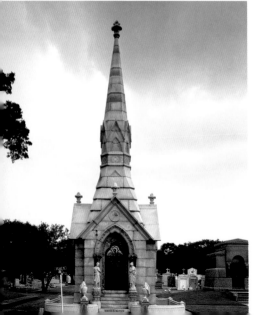

son Edward, Prince of Wales, brought on Albert's illness. It seems Edward's unseemly behavior caused Albert to explode in a fit of rage resulting in irreparable damage to his health. So great was Edward's sin in Victoria's mind that she never forgave her son for his behavior. Albert's death threw the Queen into a mourning frenzy. She wore only black clothing for the remaining forty years of her life; went to bed every night clutching Albert's nightshirt; kept

a portrait of him on the pillow next to her, and went on a memorialization rampage. She had numerous memorials, monuments, and buildings constructed in his memory. One of the results of Victoria's huge influence on culture (after all, an entire era was named after her) was erecting showy memorials, which became the fashionable thing to do.

VACCARO MAUSOLEUM

29 59 00 N 90 07 10 W

Three Vaccaros (Joseph, Felix, and Luca) have mausoleums on Metairie Avenue, but the Luca Vaccaro mausoleum, built in 1925,

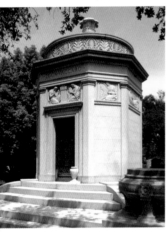

Vaccaro Mausoleum

is the most interesting. It is a personal interpretation of the Tower of the Winds (ca. 40 BC.) in Athens, an octagonal building designed by Andronicus Cyrrus that served as a weather guide and water clock. On each of the eight frieze panels were carvings of personified winds. The structure in Athens had three porticos (one round and two square) attached to its sides. For the Vaccaro mausoleum, sculptor Theodore Bottinelli carved some frieze panels as they appear in the Athenian temple, but for other panels he chose more funerary themes, such as a young man holding a torch and an hourglass and a young woman playing a harp.

BRUNSWIG MAUSOLEUM

29 58 56 N 90 07 14 W

Most large metropolitan cemeteries sport a pyramid or two. A number of cemeteries also have a variation of the type of pyramid found at the Brunswig mausoleum. The design of this mausoleum has been attributed to a tomb in the Cimitero Monumentale in Milan, Italy. These pyramids are usually found with smooth granite sides, a sphinx, and some sort of human figure. At the Brunswig mausoleum, the human figure is a female with a libation urn at her side. Since Egyptian architecture is pagan in origin, most mausoleum designers added Christian symbols to appease those who felt cemeteries should be a place to celebrate more traditional religious values and not pagan deities. Lucien Brunswig, who is spending all eternity in the style of the pharaohs, was the head of a large wholesale drug firm.

Brunswig Mausoleum

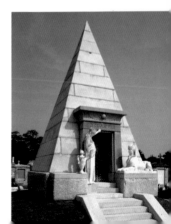

LEFEBVRE MAUSOLEUM
29 58 55 N 90 06 59 W

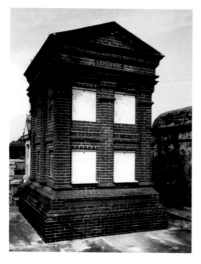

Lefebvre Mausoleum

Most brick mausoleums are rather plain affairs where utility and economy of construction are of prime importance. Often, they are covered with stucco or similar materials to provide some character. The Lefebvre mausoleum is an exception to the rule and is truly a tribute to the bricklayer's art. All of the architectural ornament in this Classical Revival mausoleum is expressed with bricks. Pediments, column capitals, dentils, engaged columns, and embossed panels are all brick. The only non-brick forms are the marble tablets calling the roll of departed family members. The Lefebvre family has actively used the mausoleum since its construction over a hundred years ago. Although cemetery records do not indicate the designer or builder of the mausoleum, its inspiration appears to have been the tomb of Cyrus the Great in ancient Persia.

ARMY OF TENNESSEE TUMULUS
29 58 53 N 90 06 51 W

Riding astride his noble steed, Fire Eater, General Albert Sidney Johnston directs his Confederate troops to charge the Federal lines on the first day of the Battle of Shiloh. Seconds later, he was felled by a Yankee bullet, ending his short but illustrious career. Now, he is frozen for all time directing automobiles, trucks, and motor homes speeding toward downtown New Orleans on Interstate 10. The General and his steed crown the Benevolent Association, Army of Tennessee, Louisiana Division Tumulus.

The tumulus is one of mankind's oldest burial monuments, dating back to 4000 to 5000 BC. Examples of tumuli can be seen peppering the landscape all over Western Europe. The foundations of most ancient tumulus-style monuments are assemblages of large rocks known as megaliths. These rock megaliths are not unlike Stonehenge but are smaller in scale. A megalith is transformed into a tumulus with the addition of rubble or earth to form a large imposing mound. Many megaliths seen today were, at one time, tumuli. Time and erosion have worn away their earth and rubble covering to reveal their megalithic foundation. Many large cemeteries have a tumulus or two. When found in modern American cemeteries, they are often used for members

of fraternal societies or military organizations such as the Army of Tennessee, because of their association with warriors.

The Army of Tennessee tumulus is one of four monuments in Metairie Cemetery dedicated to men who fought in the Civil War. Because of its vertical prominence and its location near the pedestrian entrance to the cemetery, this tumulus is one of the most recognized monuments in the cemetery. Its distinctive form has been preserved in books, magazines, and postcards. The monument was designed by famed New Orleans tomb contractor Pierre Casse; the project engineer was John Glenn. The bronze statue of General Johnston at the top of the tumulus and a marble statue at its base depicting a Confederate soldier reading the roll of the honored dead were crafted by a Northerner, sculptor Alexander Doyle of New York. When the statue at the base of the tumulus was constructed, the soldier had a carbine resting in the crook of his arm, but the rifle was stolen, no doubt by a souvenir hunter. At a later date, a second marble rifle was commissioned from a firm in Italy, and it was doweled in place. Once again it was pried from the statue, but the thief dropped the stone carbine while he was jumping over the fence to make his escape and it broke into many pieces. Rather than piece the gun back together or order another replica, it was decided to leave the soldier unarmed.

The tumulus is entered through a Gothic archway designed by New Orleans sculptor Achille Perelli. There are forty-eight crypts containing the remains of members of the Army of Tennessee, three of which are sealed for all time. The sealed crypts contain the remains of Colonel Charles Didier Dreux, the first Confederate field officer to be killed in battle; General Pierre Gustave Toutant Beauregard, who ordered the first shot fired at Fort Sumter; and John Dimitry, the man who wrote General Johnston's epitaph, which is on a large plaque at the back of the tumulus (see pages 28–29).

Curiously, despite the imposing statue of Johnston topping the tumulus and the flowery epitaph, he is not actually buried in the tumulus. Johnston's body was secretly moved to the Texas State Cemetery in Austin. The most famous person buried in the Army of Tennessee tumulus is General Beauregard. There were many more members of the Benevolent Association who wanted to be buried in the tomb than there were crypts to house their remains. When space was needed for another burial, one of the crypts was opened, and the remains of the previous occupant were placed on lead sheets that were soldered together. The package was tagged and placed in a large ossuary in the back of the tumulus. Consequently, most of the crypts have a number of names engraved on them. Burials continued in the tumulus until December 30, 1929, when the body of Captain George A. Williams, Assistant Adjutant General, Confederate States of America, was interred. There are no more members of the Army of Tennessee. No more of the soldier's bones will be wrapped in lead sheets and stacked up like cordwood. The soldiers of the Army of Tennessee can rest easy.

Albert Sidney Johnston
A General in the Army of the Confederate States,
Who fell at Shiloh, Tennessee, on the sixth day of April,
Eighteen Hundred and Sixty-two
A man tried in many high offices and critical enterprises
 and found faithful in all.
His life was one long sacrifice of interest to conscience
And even that life, on a woeful Sabbath,
Did he yield as a Holocaust at his country's need.
Not wholly understood was he while he lived;
But in his death, his greatness stands confessed
In a People's tears.
Resolute, moderate, clear of envy, yet not wanting
In that finer ambition that makes men great and pure,
In his honor—impregnable;
In his simplicity—sublime
No country e'er had a truer son,
No cause a nobler champion,
No people a bolder defender, No principal a purer victim
Than the dead soldier!

His fame consigned to the keeping of that time which,
Happily is not so much the tomb of Virtue as its Shrine,
Shall in the years to come fire Modest Worth to Noble Ends.
In honor now our great Captain rests;
A bereaved people mourn him;
Three commonwealths proudly claim him;
And history shall cherish him;
 Among those choice spirits, who holding their
 conscience unmixed with blame,
 Have been in all conjunctures true to themselves,
 their People and their God.

Army of
Tennessee
Tumulus

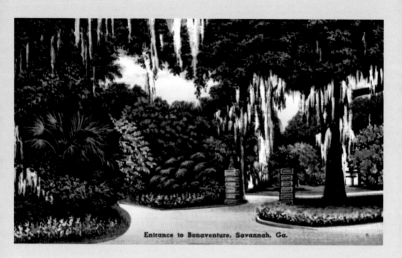

Entrance to Bonaventure, Savannah, Ga.

BONAVENTURE CEMETERY
SAVANNAH, GEORGIA

Maps available in cemetery office
www.bonaventurehistorical.org
32 02 43 N 81 03 02 W (cemetery entrance)

Most cemeteries maintain a pretty low profile on the public stage. They are places of peace, tranquility, and remembrance. But every now and then, a cemetery becomes a must-see tourist attraction, usually with no promotion on the cemetery management's part. Such is the case when a popular culture icon is buried there. Examples are Père-Lachaise in Paris, final resting place of singer Jim Morrison; a number of cemeteries in the Los Angeles area where movie stars are buried; and Recoleta Cemetery in the center of Buenos Aires, Argentina, where Eva (Evita) Peron is buried. Bonaventure Cemetery in Savannah is a must-see cemetery, not because of anyone famous but because of a photograph that graces the cover of a book. The photograph, taken by Jack Leigh, is a moody evocative image of a statue in the cemetery known as the Bird Girl. Leigh took the photograph for Random House publishers to grace the cover of John Berendt's book *Midnight in the Garden of Good and Evil*. The book went on to become an enormous success and later became a movie directed by Clint Eastwood. The book was so successful that in Savannah it is simply called The Book.

Bonaventure was originally part of a plantation established in the mid-eighteenth century by Colonel John Mullryne and his son-in-law, Josiah Tattnall. The land became known as Bonaventure ("good fortune")—not exactly good fortune for Mullryne and Tattnall, as they were accused of treason because of their allegiance to King George during the Revolutionary War, and the 750 acres were sold at auction in 1782 to John Habersham. However, Josiah Tattnall Jr., who didn't share his father's political views, bought the land back from Habersham in 1785. The Tattnall family established a small family cemetery on the Bonaventure property but eventually sold most of the land (excluding the family cemetery) to Savannah businessman Peter Wiltberger in 1846. Wiltberger is said to have made plans to set aside seventy acres of the land for a public cemetery. Thus, some people say that Bonaventure Cemetery was established in 1846. However, records show that in 1857, it was established as a private cemetery known as the Evergreen Cemetery of Bonaventure. Peter Wiltberger's son, William, ultimately turned the land into a public cemetery and formed the Evergreen Cemetery Company in 1868. Over the years, the cemetery's name evolved into Bonaventure Cemetery and officially became Bonaventure Cemetery when the land was sold to the City of Savannah in 1907.

Bonaventure is typical of many Victorian-era cemeteries with its beautiful monuments and lush grounds. What sets it off a bit from many other Victorian garden cemeteries is

the abundance of Spanish moss dangling from the trees. Depending on one's perspective, the moss creates an eerie or romantic atmosphere. Over the years, writers, artists, and photographers have ventured to Bonaventure to experience and capture its quiet beauty. In 1859, traveler and lecturer Dr. Charles Mackay wrote about Bonaventure's "mournful avenues of live oak" and "never was a place more beautifully adapted by nature for such an object." In 1867, Sierra Club founder John Muir camped in Bonaventure for five days while on a thousand-mile walk from Louisville to the Florida Keys. And renowned Civil War photographer Matthew Brady was said to have executed a number of views at Bonaventure.

In 1937, the City of Savannah acquired neighboring Greenwich Plantation and turned it into the Greenwich addition. Wedged between Bonaventure and Greenwich is Forest Lawn Memory Gardens, a modern memorial park–type cemetery with no upright markers.

JOHN HERNDON "JOHNNY" MERCER
November 18, 1909–June 25, 1976 &&& 32 02 36 N 81 02 38 W

It's reasonably safe to say that everyone knows one or more of Johnny Mercer's songs. Over the course of his life, he wrote the lyrics to over 1,100 songs, many of which were for movies and Broadway shows. He received nineteen Academy Award nominations.

Mercer was born into a wealthy Savannah, Georgia, family and enjoyed a rich and diverse social and artistic life. Unfortunately, the collapse of the Florida real estate market in 1927 bankrupted his father, George Anderson Mercer Jr., and ended young Johnny's formal education. Armed with his taste for music and theater, he took off for New York to earn his fortune and help his father out of his money woes (a task he was finally able to fulfill in the early 1950s when he sent a Savannah bank a check for $300,000 to clear his father's debts).

While in New York, Mercer took a stab at acting and landed a few small parts. He also met and married Ginger Meehan. The couple remained married until Mercer's death in 1976. Mercer found that his real talent was for songwriting and, in particular, for lyrics. He wrote songs for Hoagy Carmichael ("Lazybones"), Billie Holiday ("Trav'lin' Light"), Lionel Hampton ("Midnight Sun"), and Duke Ellington ("Satin Doll"). Although Mercer loved New York, Hollywood beckoned, and he left for Tinseltown in the early 1930s. He hit the ground running and wrote and co-wrote a long list of hits, including "I'm an Old Cowhand from the Rio Grande," "You Must Have Been a Beautiful Baby," "Day In—Day Out," and "And the Angels Sing." During World War II, Mercer continued to write such hits as "I Remember You," "That Old

John Herndon "Johnny" Mercer

Photo courtesy of Lisa Pompeo.

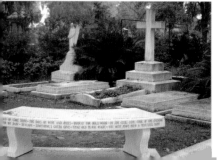

Black Magic," and "Hit the Road to Dreamland." Then, in 1942, he co-founded Capitol Records with Buddy DeSylva and Glen Wallichs. When the trio sold out to EMI Records, Mercer was able to use part of the proceeds to pay off his father's debts.

Mercer continued to turn out hits throughout the 1950s and '60s, including his Oscar-winning songs "Moon River" (1961) and "The Days of Wine and Roses" (1962). He had previously won Oscars for "On the Atchison, Topeka and the Santa Fe" (1946), and "In the Cool, Cool, Cool of the Evening" (1951). In later life, Mercer spent more and more time at his house on Burnside Island near Savannah. At the back of his house was a river with the undistinguished name, Back River. In honor of Mercer, the Georgia legislature renamed it Moon River. John Herndon "Johnny" Mercer was diagnosed with brain cancer in the spring of 1976. He underwent surgery from which he never fully recovered and died on June 25.

Dr. Phineas Miller Kollock

DR. PHINEAS MILLER KOLLOCK
1804-1872 ❧ 32 02 38 N 81 02 55 W

The Dr. Phineas Miller Kollock tomb looks like the roof of a house that has been blown off in a windstorm. The tomb holds the remains of a number of members of the Kollock family. Dr. Kollock served as president of the Georgia Medical Society and was a professor at Savannah Medical College. After his death in 1872, he was interred in Laurel Grove Cemetery until this tomb could be built. It was finished in 1877, and Dr. Kollock was finally moved to Bonaventure Cemetery on March 5, 1878.

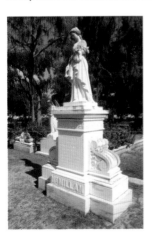

GERTRUDE A BLISS
1864-1903 ❧ 32 02 33 N 81 02 51 W

This majestic marble statue is no doubt a likeness of Gertrude A Bliss, the wife of Thomas H. McMillan. The epitaph reads, "Ever thoughtful of home and loved ones, as wife and mother she was all that one could be." Behind the statue are some of the twenty-seven miles of azaleas that line the cemetery plots and roads.

Gertrude A Bliss

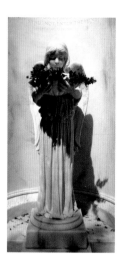

Baldwin Family Plot

BALDWIN FAMILY PLOT
Multiple Burials ❧ 32 02 38 N 81 02 57 W

The Baldwin family plot is adorned with a childlike angel cradling a planter fashioned out of a shell. The inscription above the angel is from Mark 10:15: "Verily I say unto you whosoever shall not receive the Kingdom of God as a little child he shall not enter therein."

BIRD GIRL
207 West York Street
32 04 43 N 81 05 42 W

The now-famous Bird Girl statue was created in 1936 by sculptor Sylvia Shaw Judson. Four copies of the fifty-inch-tall bronze statue were made, one of which was purchased by Lucy Boyd Trosdal to grace her family plot in Bonaventure. In 1993, Random House hired Savannah photographer Jack Leigh to create an image for the cover of John Berendt's book, *Midnight in the Garden of Good and Evil.* At Berendt's request, Leigh scouted Bonaventure for a suitably moody photograph and took a picture of the Bird Girl late one afternoon. Leigh reportedly spent a number of hours in the darkroom, creating what has become one of the world's most recognizable book covers.

Midnight in the Garden of Good and Evil was an instant best seller, and legions of tourists and the just plain curious were soon making their way to Bonaventure to view the now-famous statue. The traffic became more than the cemetery management could handle and they feared that the Bird Girl could be vandalized or damaged because of all the attention it was getting. They

Bird Girl

elected to move the statue to the nearby Telfair Museum, where it now resides. A host of Bird Girl paraphernalia, including bracelets, tie tacks, charms, dishtowels, key rings, candles, and doormats can be found in Savannah souvenir shops.

SEILER MONUMENT
Charles Seiler &c August 15, 1839-January 9, 1912
Ernestine Seiler &c November 9, 1839-January 28, 1894
32 02 32 N 81 02 51 W

This statue of the virtue Charity, with her hand at her breast and offering a rose, marks the graves of Charles and Ernestine Seiler.

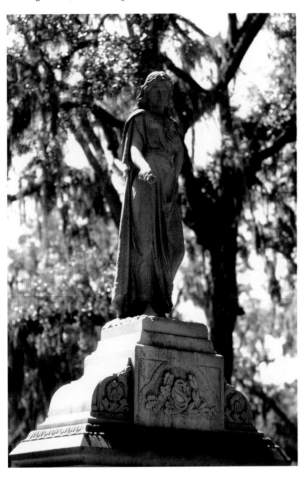

Seiler Monument

LAWTON FAMILY PLOT
Corinne Lawton &c 1846-1877
Alexander Robert Lawton &c 1818-1896
Sarah Hillhouse Alexander Lawton &c 1826-1897
32 02 36 N 81 02 31 W

Two substantial monuments mark the Lawton family plot. The monument in the foreground is for Corinne Lawton, eldest daughter of Brigadier General Alexander Robert Lawton and his wife, Sarah Hillhouse Alexander Lawton. Corinne was originally buried in Laurel Grove Cemetery. Her remains were moved to Bonaventure in 1896. The arched monument in the background honors General Lawton. The

*Lawton
Family
Plot*

monument, which has a statue of Jesus on the left, was
sculpted by Professor R. Romanellit in Florence, Italy, in 1898.

MONGIN-STODDARD TOMB

Multiple Burials ❧ 32 02 39 N 81 02 52 W
The Mongin-Stoddard tomb is done in
Egyptian Revival style. The abbreviated
pyramid has a cavetto cornice (flared with
curve) with a sun and vulture wings. The
symbol, known as a winged disk, is often
seen with twin cobras around the sun disk,
usually gracing the entry of Egyptian Revival
buildings and tombs. It has been widely
used by the Freemasons and Rosicrucians.

*Mongin-
Stoddard
Tomb*

GRACIE WATSON
1883-1889 ❦ 32 02 36 N 81 02 50 W

Gracie Watson, who died of pneumonia in 1889 at the age of six, was the only daughter of Savannah hotel owner W. J. Watson and his wife, Frances. The year after Gracie's death, Mr. Watson took a photograph of Gracie to local monument sculptor John Walz and requested a suitable memorial to his daughter. Rather than give Gracie an angelic or heroic look, Walz sculpted this stunning statue with lifelike accuracy to look like a pensive child lost in thought. Although Gracie's grave is one of the most visited sites in Bonaventure Cemetery, she is spending eternity quite alone. She is the only burial in the large family plot; her mother and father moved away from the area and are buried in another cemetery.

Gracie Watson

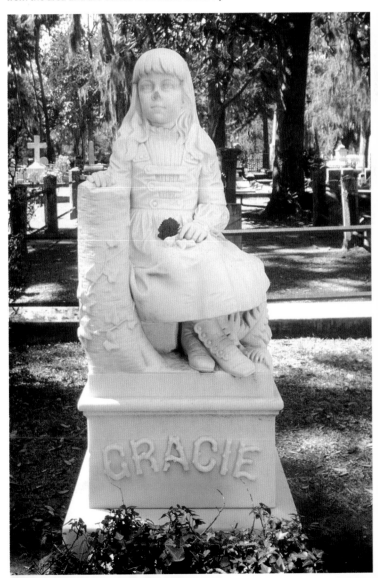

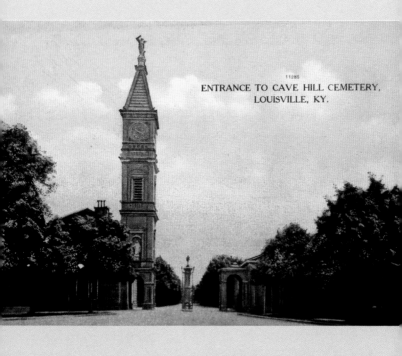

ENTRANCE TO CAVE HILL CEMETERY,
LOUISVILLE, KY.

CAVE HILL CEMETERY
LOUISVILLE, KENTUCKY

Maps available in cemetery office
www.cavehillcemetery.com
38 14 41 N 85 43 39 W

Where the most beautifully landscaped cemetery in America is located will always be debatable, but Louisville's Cave Hill certainly occupies a spot at the top of the list. And if that isn't enough to get you there, lovers of finger-lickin'-good Kentucky Fried Chicken can pay their respects at the portico-like monument marking the final resting place of KFC's founder, Col. Harland Sanders.

In 1832, Louisville's city fathers purchased a tract of land known as Cave Hill Farm on the south side of town. It had a plentiful spring and a quarry, and it just happened to be on the route proposed for a railroad line that would link Louisville and Frankfort. After the city purchased the land, they leased parts of it to farmers and surveyed a small section to be used potentially as a burial ground. Alas, plans for the rail line never materialized, and by 1846, the city fathers turned their attention to developing a large-scale burial ground that would be based on a new concept sweeping the country: the garden cemetery. The first garden cemetery in the United States was Mount Auburn in Cambridge, Massachusetts, founded in 1831. Modeled after Père-Lachaise Cemetery in Paris, Mount Auburn was a beautifully landscaped burial ground, a far cry from the overcrowded, grim, and unsanitary graveyards and churchyards in America's cities. Louisville's civic leaders agreed that this idea was worth pursuing and hired civil engineer Edmund Francis Lee, who was familiar with the garden cemetery esthetic, to draw up plans for what would become Cave Hill Cemetery.

The cemetery was officially dedicated on July 25, 1848. At the time, there was little public open space in Louisville, and Cave Hill quickly became a prime leisure time destination for the city's citizens. It would remain as Louisville's premier "park" until the opening of Cherokee Park in 1892. One of the early suppliers of permanent residents for Cave Hill was the unfortunately named Pest House, a hospital and sanitarium on the cemetery's grounds. However, Edmund Lee's garden cemetery landscaping plan was an immediate success, and many of Louisville's prominent citizens purchased grave sites and family plots. The graceful natural contours of the land, basins that were developed into ponds, and permanent and seasonal planting that include more than 500 varieties of trees and shrubs have made Cave Hill more than just a cemetery. Over the years, the cemetery has acquired surrounding land and now consists of close to 300 acres, enough land to accommodate Louisville for generations to come. Cave Hill was placed on the National Register of Historic Places in 1979.

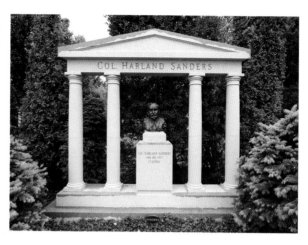

COL. HARLAND SANDERS

September 9, 1890–December 16, 1980 &c; 38 14 49 N 85 42 38 W

Oh, where would we be if it wasn't for Kentucky Fried Chicken? Subsisting on tasteless and unremarkable pot roasts and liver and onions, no doubt. In 1952, at age sixty-two, Col. Harland Sanders was living on $105-a-month Social Security checks but was in possession of a secret fried chicken recipe and, more importantly, the marketing skills and luck of a P. T. Barnum. By 2008, there were over 11,000 KFC restaurants bearing the goateed Southern gentleman's visage. What happened?

Sanders was born in Indiana and lost his father when he was only six years old. Many of the family chores fell on his shoulders, including a large share of the cooking. He got his first paying job when he was ten years old and held a variety of jobs for the next thirty years. In 1930, at age forty, he was operating a service station in Corbin, Kentucky. Employing his culinary skills, he also prepared and served food to the station's customers. His venture was so successful that he acquired a motel and restaurant across the street and opened a formal restaurant. During the next nine years, his business grew, thanks to his ever-evolving and very secret chicken recipe. Sanders and his chicken were so admired that in 1935, Governor Ruby Laffoon of Kentucky bestowed Sanders with the honorary title of Colonel. During Laffoon's ten- ure, he also anointed a number of others with the title of Colonel, including Mae West, Clark Gable, W. C. Fields, and Will Rogers.

Life was good for Col. Harland Sanders until the 1950s when a new interstate highway bypassed his establishment and business ground to a halt. He sold his assets, and after paying his debts, the sixty-two-year-old Sanders was reduced to living off his $105-a-month Social Security check. Retirement didn't suit him so he hawked his famous chicken recipe, driving all over the countryside cooking chicken for restaurant owners and their employees. If the owners liked the chicken, Sanders sold them his secret mixture and entered into a handshake agreement that the owners would give him five

cents for every chicken they cooked using his recipe. By 1964, he had over 600 franchises selling his chicken. Later that year, he sold the business to a group of investors for $2 million.

Knowing that Sanders' image would be a big part of the marketing of the company, the investors hired Sanders as the company's public spokesman. By the time Sanders died at age ninety, he was traveling over 250 thousand miles for the company every year. Before he died, he commissioned his monument in Cave Hill cemetery and visited it for publicity photos.

WATCHMAN'S SHELTER HOUSE

Cemeteries are full of authoritative stone edifices, so it is rare to find anything as simple and rustic as this Watchman's Shelter House, designed by the firm of Max Drach and John Hardin Thomas in 1892. Building contractors Bittner and Just erected the 18 x 18-foot structure for the modest sum of $607. To add to the rusticity of the building, the contractor sheathed it in oak bark in what is known as the St. Andrew's Cross pattern.

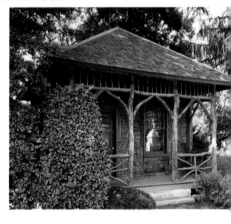

Watchman's Shelter House

TWIST MONUMENT

38 14 39 N 85 42 33 W

Louisville sculptor Barney Bright fashioned this sculpture of Saundra Curry Twist (1941–1981). She died tragically in an automobile accident and was described as a fashion model and a cheerleader. The monument—comprised of the statue, a colonnade, and a plaque with a eulogy—was ordered by her family. Spending eternity with her are and will be other family members, including her daughter Tonjua Lynn Twist (1964–2000), who was singer Mariah Carey's stylist. Tonjua committed suicide on May 20, 2000, using a mixture of sleeping pills and narcotics. A 2000 article about Tonjua's life in US *Weekly* describes the Twist family: "This was not your typical little Kentucky family," says younger sister Tyra Twist-Amrein. "This was something out of Jerry Springer."

Twist Monument

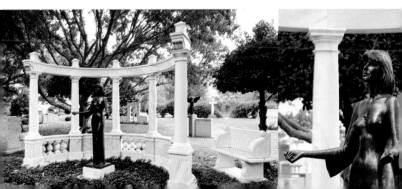

IRVIN MAUSOLEUM
38 14 37 N 85 43 09 W

Noted Louisville architect Henry Whitestone designed this modified Gothic Revival mausoleum for James F. Irvin in 1867. Whitestone drew his inspiration from the Greffulhe family mausoleum designed by A. T. Brongniart, ca.1816, in Père-Lachaise Cemetery in Paris. A description of the Irvin mausoleum appeared in the April 16, 1871, edition of the *Louisville Daily Commercial.* The newspaper described the "Scotch granite" columns, dome, and exterior walls, and noted the different varieties of marble used on the interior surfaces. The

Irvin Mausoleum

newspaper went on to describe the crypts as "four depositories for coffins, with marble doors, awaiting their inmates."

Captain James F. Irvin (1812–1883) made his fortune as a steamboat captain on the Ohio River. He was also on the cemetery board of Cave Hill Cemetery. This connection no doubt assured him of one of the choice hilltop lots as his burial site. Sharing the mausoleum with Captain Irvin is his wife, Florence McHarry, and Florence's father, Frank McHarry.

Frank McHarry was originally buried in a tomb overlooking the Ohio River so, legend has it, he could hurl curses at the passing steamboats. Apparently, McHarry, who operated a ferry service on the river, had a long-standing feud with the steamboats, and even in his death he wanted the opportunity to voice a ghostly epithet. Another part of the legend has it that McHarry was buried standing up, but such is the stuff of legends. What is true is that his body is now quite horizontal in the Irvin mausoleum, out of earshot of those pesky steamboats.

SATTERWHITE MONUMENT
38 14 46 N 85 43 18 W

Dr. Preston Pope Satterwhite hired famed Philadelphia architect Horace Trumbauer to design a monument for his wife, Florence Brokaw Martin Satterwhite, who died in 1927 at the age of sixty-one. Trumbauer based his design on the Classical Revival Temple of Love constructed by French architect Richard Mique (1728–1794) for Marie Antoinette in the gardens of the Petit Trianon at Versailles. Mique had based his design on the Roman Temple of Vesta at Tivoli, built in the first century BC. While Trumbauer worked with B. A. & G. N. Williams, stone contractors in New York City, on the fabrication of the Tennessee marble monument, Dr. Satterwhite busied himself with the selection

and preparation of the site, a 26,343-square-foot area at Cave Hill, which he purchased for $50,000. Then he hired Wadley and Smythe, New York City landscape contractors, to prepare the site. Wadley and Smythe promptly ordered four freight cars of plantings, which arrived in Louisville in the spring of 1928. On June 18, 1928, the monument was officially declared finished.

Florence Brokaw Martin Satterwhite was born into a high society family. The Brokaw family had done well as clothiers and provided young Florence with a taste for the finer things in life. Her first marriage to Standard Oil Company executive James E. Martin ended when he died tragically in 1905 at age fifty-nine. He and his son were racing through New York City's streets when his car overturned. Florence inherited a considerable estate.

Satterwhite Monument

In 1908, she married Dr. Satterwhite. They also led a lavish lifestyle, dividing their time between New York and Palm Beach. Although the Satterwhites did not live in Louisville, Dr. Satterwhite, like his father and grandfather, studied medicine in Kentucky. After his studies, he set up his surgery practice in New York. Dr. Satterwhite donated considerable money to the J. B. Speed Art Museum in Louisville and to Cave Hill Cemetery.

GHEENS MAUSOLEUM

Charles W. Gheens (1837–1927) wasn't about to take any chances when it came to selecting and building his final resting spot. Mr. Gheens apparently reasoned that death could come at any moment, so he planned ahead and built his mausoleum when he was only thirty-seven years old. The May 7, 1874, minutes of the Cave Hill Cemetery Board of Managers stated: "Charles W. Gheens submitted drawings for a family vault to be erected on a lot selected for that purpose by Mr. Robert Ross, Superintendent, soliciting a permit therefore which was unanimously granted." After completing construction of his mausoleum, Charles proceeded to live for another fifty-three years, dying at the ripe old age of ninety in New Orleans.

Gheens was engaged in a number of businesses, including interests in wholesale groceries, cement manufacturing, and real estate. He contributed to many charities and actively supported the Southern Baptist Theological Seminary.

Gheens Mausoleum

SPOTTS MAUSOLEUM
38 14 47 N 85 43 20 W

John Baird of Philadelphia designed and erected this marble mausoleum in 1866, using an Islamic style with some Classical embellishments, often called Venetian Gothic. Understandably, many fine examples can be seen in Venice, Italy. Baird was an innovator in the use of steam power for cutting marble. On the Schuylkill River, he eventually built the largest establishment for the sawing and manufacturing of marble in the United States.

The mausoleum was commissioned by Mrs. Spotts, the widow of Captain Harry I. Spotts, a popular Louisville steamboat captain. The lines and the overall shape of the mausoleum (only the front is seen in the photograph) are reminiscent of a funeral barge, perhaps a nod to Captain Spotts' career on the Ohio River.

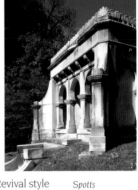

SHANNON MAUSOLEUM

38 14 47 N 85 43 20 W

One of the earliest mausolea erected at Cave Hill Cemetery is the eternal home of New Orleans merchant, John Carrick Shannon. The mausoleum, built in 1858, is designed in Classical Revival style with swagged Ionic columns, gargoyles, an hourglass, and what appears to be a family crest.

Spotts Mausoleum

Shannon Mausoleum

SHERLEY MAUSOLEUM

38 14 47 N 85 43 20 W

A Classical Revival façade is all that remains of the Sherley mausoleum. The original structure tunneled into the hillside and was more of a vault than a freestanding mausoleum. In 1900, due to erosion and, perhaps, faulty construction, the inside of the mausoleum collapsed. The crumbled pieces were removed, but the façade was salvaged. A large boulder was placed next to the mausoleum to represent the stone in front of Christ's tomb, which had been rolled away after Christ's entombment, indicating "He is not here, He has risen."

Nineteenth-century entrepreneur Zachary Madison Sherley (1811–1879) owned ferry lines, transported mail, and was one of the founders of the Citizen's National Bank in Louisville. He was a philanthropist as well, active in the Kentucky Institution for the Blind and the medical school of the University of Louisville, and was a member of the Cave Hill Cemetery Company. Sherley was looked upon as a wise and learned counselor. A nineteenth-century biographical sketch of his life in the *History of Kentucky*, described him thus:

No tempest-tossed mariner in a dark and murky night ever watched rifts in the clouds that might reveal a glimmering of light, than we often watched in like circumstances for Captain Sherley; we felt that he was our pole star who would infallibly lead us out of perplexity and bewilderment into paths of security and safety.

Sherley Mausoleum

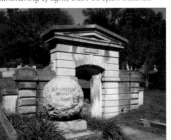

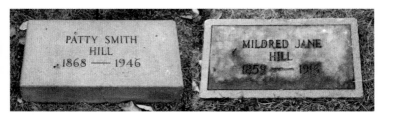

HILL SISTERS

Patty Smith Hill &oe; March 27, 1868-May 25, 1946
Mildred Jane Hill &oe; June 27, 1859-June 5, 1916
38 14 44 N 85 43 13 W

Patty Smith Hill and her sister Mildred Jane Hill are two of
the most famous people you have never heard of. Mildred
was a concert pianist, author, and teacher, and Patty was a
kindergarten teacher. They co-wrote a song that was published
in 1893 titled "Good Morning to All." The catchy sing-songy
tune was an immediate success. In the early twentieth century,
the lyrics were modified, and the words "good morning to all"
were replaced with "happy birthday to you." Although exact
figures are impossible to tally, the *Guinness Book of World Records*
lists "Happy Birthday" as the most popular song in the English
language. ("For He's a Jolly Good Fellow" is second.) The Summy
Company copyrighted the "Happy Birthday" version of the
song in 1935, with an arrangement by Preston Ware Orem. That
copyright was sold and is currently owned by Time Warner.

JAMES D. PORTER

December 15, 1811-April 26, 1859 &oe; 38 14 45 N 85 43 09 W
On the east side of a hill on Section N is a rather odd stone that
looks like the end of a casket sticking out from the hill. It almost
looks like the casket was a bit too long for the space and didn't
quite make it all the way into its crypt. Appropriately, the stone
marks the grave of 7 foot 8 inch Big Jim Porter, "The Kentucky
Giant." Porter was described as a small and sickly child—so small
that at age fourteen, he was a jockey at a racetrack in the small
town of Shippingport near Louisville. Then, at age seventeen,
he began to grow—and kept on growing until at age twenty,
he attained the height of 7 feet 8 inches. At age twenty-five, he
toured for a year performing *Gulliver's Travels* with midgets, but
Porter was happiest living in Louisville and being a businessman.
He ran the Big Gun Tavern in Shippingport. The tavern attracted a
sizeable number of patrons just so they could meet him. In April

1842, noted author Charles Dickens met him in Louisville and

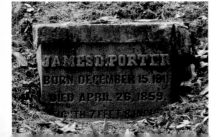

later described Porter in his book
American Notes as a "lighthouse
walking along lamp-posts." After
reading Dickens' comments
about Porter, circus magnate
P. T. Barnum contacted Porter and
asked him to join his circus, but

he declined. Porter died quietly in his sleep at age forty-eight. A special nine-foot casket needed to be made for his enormous frame. That casket, alongside a regular-sized casket, could be seen through a viewing window in a vault in Cave Hill for a number of years. Around the end of the nineteenth century, the vault fell into disrepair and was torn down; Big Jim Porter was placed in the grave that now sticks out of the hill in section N.

HARRY LEON COLLINS
April 27, 1920–May 3, 1985 〜 38 14 51 N 85 42 34 W

The golden age of cemetery monuments and mausoleums (after the Civil War until the Great Depression) is long past, but after years of ho-hum funerary monument building, in recent years there has been a movement toward unique and interesting funerary art. This is quite evident at Cave Hill, where there are a host of new monuments. The most striking of these have been executed in bronze. One of the best is that of magician Harry Collins, a World War II hero who was wounded in Saipan. Later during the war, he started performing his magic act for the troops in shows put on by Bob Crosby (brother of Bing Crosby). In the early 1950s, he started doing magic tricks during promotional campaigns for Frito-Lay, a job that lasted until his death. When he did the "prestige" part of the trick, instead of saying "voila" or "alakazam," he'd say "Frito-Lay."

Harry Leon Collins

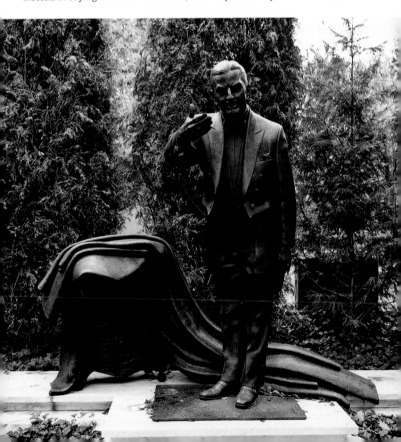

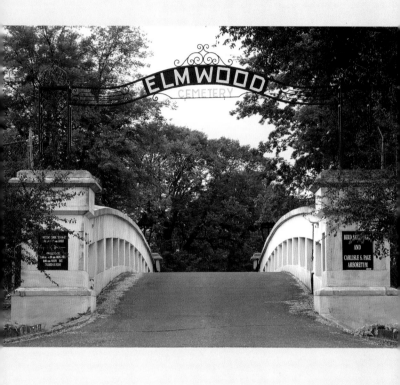

ELMWOOD CEMETERY
MEMPHIS, TENNESSEE

www.elmwoodcemetery.org
35 07 28 N 90 01 46 W

Most cemeteries have some sort of gateway that serves as an entrance. Elmwood has taken the entry one step farther in the form of a narrow arching bridge that tells visitors they are entering some place different and special. The entry bridge, known as the Morgan Bridge, connects East Dudley Street to the cemetery. It was designed by J. A. Omberg, City of Memphis Engineer and now permanent Elmwood resident. The arching design was employed to give sufficient room for the trains on the railway below and to give visitors a stunning panoramic view when they enter the grounds.

Elmwood Cemetery, established in 1852, was one of the first cemeteries in the South to adopt the rural/garden cemetery template first seen in the United States at Mount Auburn Cemetery in Cambridge, Massachusetts. True to the rural cemetery aesthetic, Elmwood was situated 2.5 miles away from the city proper. Its founders, fifty Memphis men, pooled $500 each to purchase the forty acres of land and develop the grounds. The original forty acres was expanded to the present eighty acres after the Civil War. In the 1870s, the for-profit corporation was dissolved and Elmwood was restructured into what has become one of the oldest nonprofits in the State of Tennessee. Elmwood is still a very active cemetery. Although there have already been over 75,000 burials, there is still sufficient undeveloped land and enough room in existing plots in the developed area to accommodate at least 15,000 future burials.

The cemetery also contains the Carlisle S. Page Arboretum, which includes approximately 800 trees (400 are labeled), representing sixty-three species. According to cemetery officials, eight of these are National Champion Trees and two are State Champion Trees. Ornamental trees include Chinese fringe tree, crepe myrtle, dogwood, magnolia, deciduous holly, and fruit trees.

THE COTTAGE

35 07 27 N 90 01 45 W

The Cottage, which serves as the visitor center and office, was built in the Carpenter Gothic style in 1866. A parlor, brick vault, and front porch were added in 1902. The Cottage is the only known example of Carpenter Gothic architecture in Memphis. In 1998, an addition to accommodate business offices was added, using funds

The Cottage

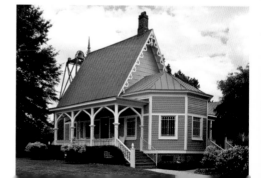

provided by the Crawford Howard Family Foundation.
The bell located on top of the brick vault at the back of
the cottage has tolled at every processional since it was
donated by Memphis's State Female College in the 1870s.

WADE HAMPTON BOLTON
1812-1869 &oc; 35 07 17 N 90 01 35 W

Wade Hampton Bolton

What exactly is Wade Bolton trying
to say? At first glance, the statue
marking his grave seems like a perfectly
ordinary rendering of a stoically
postured Victorian gentleman. But
inspect further and you'll see his vest
is buttoned crooked. Then look at his
shoes; one is untied. What we do know
about Wade Bolton is he was a rather
contrary sort, and the statue is, in fact,
a remarkably true rendering of him.
Apparently, he liked to walk around
with a crookedly buttoned vest and
an untied shoe. His family was one
of the first settlers in the Memphis
area, a fact he took more than a little
pride in. By the late 1840s, Bolton
had set up a thriving and prosperous
slave trading business. All went well
(except for the slaves, of course) until
1857, when he and his brother Isaac (a partner in the business)
became embroiled in a dispute with Wade's brother-in-law,
Thomas Dickens, over the sale of a slave who turned out to be a
"free apprentice." Unable to quickly resolve the dispute, tempers
flared, resentments festered, and violence followed. At one point,
shots were fired at Dickens; then armed men broke into his
house, killing two men and wounding Dickens. Not long after, on
July 23, 1869, Dickens confronted Bolton in downtown Memphis
and shot him dead. Despite considerable evidence (Bolton's
dying words were, "Dickens did it"), Dickens was tried and
acquitted by a jury. The Bolton family wasn't exactly thrilled with
the verdict, and on July 30, 1871, Thomas Dickens was gunned
down, followed a week later by his son Samuel, who was killed
at the same spot. The feud finally ended after eight people died.

When Wade Bolton's will was read, there were some
interesting bequests. Among the proceeds doled out were a
number that had the condition that the recipients would do all
they could to "defeat this gigantic swindle of the old land pirate
Tom Dickens." In a fit of avariciousness, Bolton willed his niece
Josephine, who had married Samuel Dickens, "five dollars, one
sixth of what Judas Iscarrot [*sic*] got for betraying his Lord." There
was also a $10,000 bequest to the widow of General Stonewall
Jackson so she could buy some furniture. His most generous
bequest was for an endowment to establish a school for the

county's poor and orphaned children. That endowment is still active today and is a major funding source for Bolton College.

CONFEDERATE REST MONUMENT

35 07 23 N 90 01 35 W

Like most Southern cemeteries, Elmwood has a Confederate area. The first burial at Confederate Soldiers Rest was William Gallagher on June 17, 1861; the last was John Frank Gunter on April 1, 1940. The central monument was erected in 1878 with funds supplied by the Ladies Confederate Memorial Association (LCMA) and the Confederate Relief and Historical Association (CRHA). More than 1,000 Confederate soldiers are buried in this section.

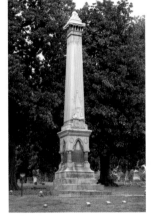

Confederate Rest Monument

ODD FELLOWS REST

35 07 25 N 90 01 38 W

Many cemeteries have areas reserved for clubs and organizations. Many of the so-called secret

societies such as the Freemasons and Odd Fellows provided a cemetery plot as a benefit of membership. The Woodmen of the World went one step farther: they provided a gravestone, usually in the shape of a tree trunk or log. (For more on the Odd Fellows, see page 207.)

Odd Fellows Rest

BOSWELL MONUMENT

Geogina Rose Boswell 1911–1985
Melvin Boswell 1910–2000
35 07 25 N 90 01 42 W

This monument to Geogina and Melvin Boswell lists their parents and grandparents, and celebrates the heritage of Romany travelers, better known as gypsies. The word "gypsy" is actually a misnomer. People thought they came from Egypt when, in fact, their roots are in India.

Boswell Monument

SLAVE MONUMENT

35 07 13 N 90 01 45 W

This memorial commemorates the more than 300 slaves who were buried here between 1853 and 1865.

HAROLD SMITH JR.

1919–1993 35 07 15 N 90 01 48 W

Harold Smith Jr. was one of the elite all-black fighter pilots in World War II known

Slave Monument

Harold Smith Jr.

as the Tuskegee Airmen. Prior to the Tuskegee Airmen, no U.S. military pilots had been African American. There were 992 pilots trained in Tuskegee from 1940 to 1946; about 445 deployed overseas and 150 Tuskegee Airmen lost their lives in training or combat. Harold Smith Jr. became an educator after the war.

HENRY A. MONTGOMERY
1827-1887 35 07 18 N 90 01 47 W

Henry A. Montgomery is portrayed during his last day on earth as welcoming visitors to the Memphis Jockey Club. As soon as he started his speech and uttered the word "welcome," he dropped dead. A bale of cotton symbolizes his occupation as a cotton grower.

Henry A. Montgomery

GRACE TOOF
1860-1928 35 07 19 N 90 01 47 W

In 1957, Elvis Presley purchased a home and property known as Graceland from Memphis socialite Ruth Brown Moore. The home was named after Grace Toof, daughter of S. C. Toof, a Memphis businessman and founder of a printing firm. Grace acquired the property and a number of surrounding acres in 1894. After Grace's death, it went to her sister Ruth Toof Brown and hence to Ruth Brown Moore.

Grace Toof

LILLIE MAE GLOVER
1907-1985 35 07 26 N 90 01 49 W

Glover was a blues singer who was a regular on Memphis's famous Beale Street. She modeled herself on famous blues singer Ma Rainey and performed under the name Ma Rainey II. Her epitaph reads, "I'm Ma Rainey #2 mother of Beale Street. I'm 78 years old ain't never had enough of nothing and it's too damn late now!"

Lillie Mae Glover

PROFESSOR HERMAN FRANK ARNOLD

1838-1927 ❦ **35 07 24 N 90 01 51 W**

Arnold, a native of Eilenburg, Prussia, Germany, was the first person to write a band arrangement for the song "Dixie." On February 18, 1861, in Montgomery, Alabama, he led the band that played "Dixie" at the inauguration of Jefferson Davis as president of the Confederacy. The faded "Dixie" score is inscribed on the slab over his grave.

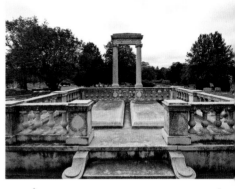

Professor Herman Frank Arnold

NO MAN'S LAND

35 07 24 N 90 01 40 W

Near the Odd Fellows section is an area that looks undeveloped. In fact, there are more than 1,400 burials in the four lots that No Man's Land encompasses. The burials represent victims of three epidemics of yellow fever that swept through Memphis in 1873, 1878, and 1879. At the epidemic's peak, over fifty burials a day were conducted at Elmwood.

No Man's Land

DR. DAVID TINSLEY PORTER

1827-1898 ❦ **35 07 23 N 90 01 50 W**

Dr. David Tinsley Porter's monument is a testament to the durability of monuments crafted in granite. Despite being more than a century old, it looks brand new. Porter was a successful Memphis merchant who made his fortune in the grocery, drug, and other businesses. More importantly, he was known as a person of great generosity and integrity. When Memphis was bankrupted in the late 1870s—primarily as the result of the loss of revenue when people left the city to escape the yellow fever epidemics and the cost of the epidemics themselves—Porter was appointed as the president of the taxing district (the equivalent of mayor, but Memphis had lost its city status because of the bankruptcy). Porter did much restructuring of city operations, and Memphis was soon thriving again. Porter continued to serve the city and also served on the boards of a number of corporations.

Dr. David Tinsley Porter

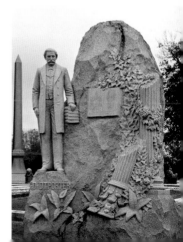

ETTA GRIGSBY PARTEE
1884-1911 &c 35 07 23 N 90 01 50 W

When Etta Partee died tragically young, her family commissioned this evocative marble statue that was carved in Italy. Until the 1940s, Etta's sculpture was covered by a glass dome. Unfortunately, marble ages much faster than granite, and the elements have taken their toll. Somehow, though, the gentle aging adds an even more mournful tone.

*Facing:
Etta Grigsby
Partee*

LAUKHUFF MONUMENT
35 07 19 N 90 01 44 W

Elmwood is still a very active cemetery and has its share of new creative monuments. The chapel-like Laukhuff monument commemorates the lives of Ralph Lewis Laukhuff and his wife Mickey, who had a stained glass business in Memphis. Mickey designed the monument for Ralph (1919–1993) after he died. Although Mickey's name is inscribed on the monument, her birth/death date is not because she is still alive at this writing.

EMILY SUTTON
1818-1873 &c 35 07 19 N 90 01 44 W

The statue atop the monument to Emily Sutton, also known by her business nom de plume Fanny Walker, is posed in a way that almost looks as if she is looking for forgiveness. She just may be: Emily Sutton was a madam in Memphis. She evidently ran her business well, as evidenced by the quality of her monument. In an effort to redeem herself, she became a generous supporter of charities that helped victims of yellow fever epidemics. She left specific orders for the verse on her monument. It reads,

> *Let sweet-voiced Mercy plead for her
> Who liest beneath the sod
> May erring man not in pride usurp
> The providence of her Judge, her God.*

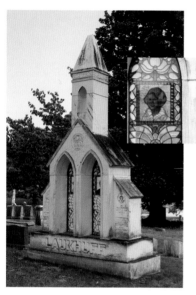

*Laukhuff
Monument*

Emily Sutton

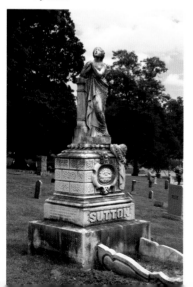

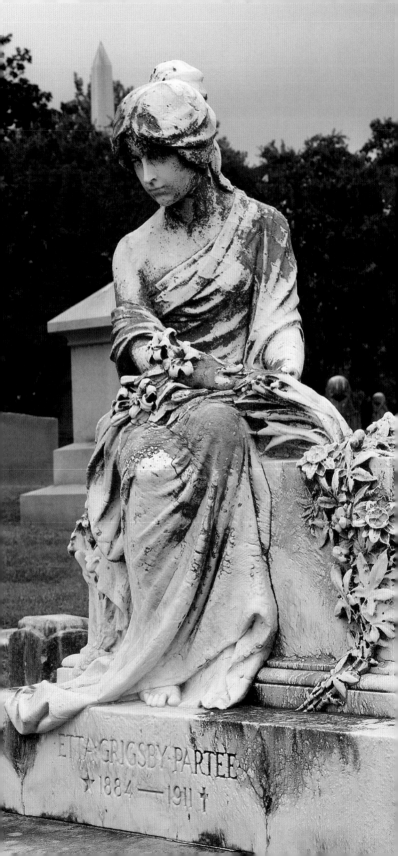

ETTA GRIGSBY PARTEE
★ 1884 — 1911 ✝

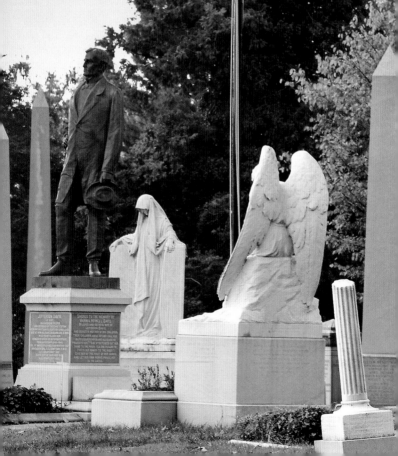

HOLLYWOOD CEMETERY
RICHMOND, VIRGINIA

Maps available in office
www.hollywoodcemetery.org
37 32 25 N 77 27 11 W

Fittingly, the premier cemetery in Richmond, Virginia, former capital of the Confederacy and the capital of Virginia, Hollywood Cemetery has its share of luminaries. Three presidents rest in Hollywood Cemetery: the fifth and tenth presidents of the United States—James Monroe and John Tyler—and the only president of the Confederate States of America: Jefferson Davis. Hollywood Cemetery (named after the large number of holly trees on the grounds) was designed in 1847 by John Notman and officially opened in 1850. It was one of many cemeteries in the United States that was part of the garden cemetery movement.

The cemetery was developed because Richmond's other cemeteries were simply filling up. Rather than enlarge existing cemeteries or develop new cemeteries based on the old graveyard designs, Richmond's city fathers wanted to develop something that fit the current sensibilities toward death and dying and cemetery design. Hollywood Cemetery was carved out of land that was known as Harvie's Woods, originally owned by Colonel John Harvie. Its western border was the James River. Getting the necessary permits and signing subscribers wasn't an easy job for the newly formed Hollywood Cemetery Company. City officials didn't like the idea that the cemetery grounds essentially prevented westward expansion of the city and gobbled up some prime building lots. But after a while, good sense prevailed (after all, people kept dying and needed to be buried somewhere), and the Hollywood Cemetery Company was allowed to continue with its plans. The first grave site was sold in 1849. By the spring of 1856, 1,240 souls called Hollywood their permanent home. By the end of the twentieth century, over 62,000 people, including 18,000 Confederate soldiers, had been buried in Hollywood's 135 acres. Estimates are that Hollywood will fill up sometime around 2030. But, thanks to endowments and a perpetual care program, Hollywood's beauty should be able to be enjoyed for generations to come.

JEFFERSON FINIS DAVIS
June 3, 1808–December 6, 1889 37 31 55 N 77 27 36 W

As the leader of the Lost Cause, Jefferson Finis Davis has attained saint-like status among certain groups in the South. Davis was the youngest of ten children born to Samuel Emory Davis and Jane Cook. He spent most of his youth in Louisiana and two years at a Catholic school in Kentucky. His military education began in 1824 when he entered the United States Military Academy at West Point. Davis served in a number of campaigns, one of which was headed by Colonel Zachary Taylor, who would

Facing:
Davis Circle

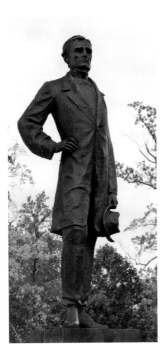

Jefferson Finis Davis

later become the twelfth president of the United States. Davis fell in love with Taylor's daughter, Sarah Knox Taylor, and married her on June 17, 1835. Unfortunately, Sarah contracted malaria and died three months later. After her death, Davis became somewhat of a recluse. For the next eight years, he busied himself studying government and history at the Brierfield Plantation in Warren County, Mississippi.

He emerged from his seclusion in 1844, and ran for and won a seat in the United States House of Representatives. He resigned from his seat in 1846 to serve in the Mexican-American War. Upon returning from the war, Davis was appointed by the governor of Mississippi to serve the remainder of the Senate term of Jesse Speight, who had died in office. In the following years, Davis was appointed to a series of offices with a more military bent and was eventually appointed Secretary of War in 1853 by President Franklin Pierce. After Pierce's term ran out, Davis ran once again for the Senate and became a Senator for the second time in 1857. As secessionist fever over states' rights and the right to keep slaves increased in the South, Davis was named the provisional president of the Confederate States of America at the constitutional convention in Montgomery, Alabama. His position was formalized when he was elected as the president of the Confederacy on November 6, 1861.

Although Davis was an effective political leader, he has been criticized for his military leadership, especially when it was obvious that the war was lost and he continued with the effort at a great price. When Union general Ulysses S. Grant was poised to capture the Confederate capital in Richmond, Virginia, in the spring of 1865, Davis fled to Danville, Virginia, and then to Greensboro, North Carolina. He was eventually captured in Irwinville, Georgia, and spent two years as a prisoner in Fort Monroe, Virginia. After his release, he traveled widely and entered into a number of businesses. He was elected to the United States Senate again in 1875 but was not allowed to take office because of the 14th Amendment provision that prohibits anyone serving as a member of Congress who "has engaged in insurrection or rebellion."

Davis spent the rest of his life writing and promoting trade between the United States and South America. After he died on November 6, 1889, in New Orleans, his body was placed in a tomb near the Louisiana Division of the Army of Northern Virginia tomb in Metairie Cemetery. Eighteen months later, at the request of his widow, his second wife Varina Howell Davis, his remains were readied for transfer to

Hollywood Cemetery in Richmond, Virginia. Upon removal from Metairie Cemetery, Davis's coffin was placed on a flag-draped caisson and was transferred to Memorial Hall in New Orleans, where thousands gathered to say goodbye. The next day, his coffin was placed on a funeral train, which slowly made its way to Richmond, Virginia. Thousands of people lined the tracks for hundreds of miles. Davis's body then lay in state in the rotunda at the Richmond state capitol building before finally being transferred to Hollywood Cemetery.

Davis was buried in an area that came to be called Davis Circle. In 1899, the first three monuments were unveiled—one to Jefferson Davis, another to his daughter Varina Anne Davis, and another to his son Jefferson Davis Jr. The bronze statue of Jefferson Davis was designed by a native of Hungary, sculptor George Julian Zolnay, who described his rendition of Davis as "typical of a Southern gentleman. The elasticity of the step, the proud and haughty air, all point to the characteristics of the former president of the Confederacy." Zolnay also designed the Varina Anne Davis monument, which is a seven-foot statue of Grief. A third monument was executed by Andrew J. Wray for Jefferson Davis Jr. That monument is a broken column, a typical Victorian-era symbol for a life cut short. A second monument to Varina Anne Davis was commissioned by the citizens of Richmond and was executed by Zolnay. It depicts a seated angel. Also buried at the Davis Circle are his wife Varina Howell Davis (her epitaph is inscribed on the pedestal of the Davis statue) and his other daughter, Margaret Howell Davis Hayes, who died in Colorado.

James Monroe

JAMES MONROE
April 28, 1758-July 4, 1831
37 32 01 N 77 27 23 W

James Monroe was the fifth president of the United States. He was born in Westmoreland County, Virginia, to well-to-do but not wealthy parents. He was privately tutored until eleven and then attended Campbelton Academy in Virginia. One of his classmates was future Chief Justice John Marshall. He then enrolled at the College of William and Mary but got caught up in the revolutionary spirit. He enlisted and fought in the American Revolution in the Third

Virginia Regiment. In 1780, he went back to school and studied law under Thomas Jefferson.

In 1780, he married seventeen-year-old Elizabeth Kortright, who was a great beauty by all accounts. In 1790, Monroe was elected to the United States Senate. For the next twenty-seven years, he held a variety of high-level political offices, serving twice as governor of Virginia, as Secretary of State, and as Secretary of War. He was elected president of the United States and served two terms (1817–1825). Highlights of his presidency were the enactment of the Monroe Doctrine (which declared that the United States would regard any interference in the internal affairs of any states in the Western Hemisphere as an unfriendly act) and the Missouri Compromise (which delineated the parts of the United States where slavery would be allowed). Monroe also advocated the establishment of a refuge for freed slaves in the African nation of Liberia by supporting the efforts of a group called the American Colonization Society. That plan never came to fruition, but in the midst of the planning, the capital city was named Monrovia, the only foreign capital named after an American president.

James and Elizabeth Monroe were the first couple to live at the newly rebuilt White House after the British burned it in 1814. Unfortunately, their tastes ran well beyond their means (at the time the presidential salary was $9,000 a year). Congress had appropriated $20,000 the first year of Monroe's term so the couple could buy furniture for the White House, and an additional $18,000 the next year. The couple spent much of the money on French antiques and diverted at least one-third of the money for entertainment. A scandal ensued and Congress asked to be reimbursed for the money spent entertaining. Still, the couple entertained and even used the White House for the marriage of their daughter Maria. When Monroe's term ended in 1825, he left Washington essentially broke because Congress had withheld his salary until he paid the couple's entertainment debts. Congress eventually gave him $30,000 of the $53,000 it had withheld. Elizabeth's health had been in decline for a number of years and she finally succumbed on September 23, 1830, at age sixty-two. She was interred in a vault on their Oak Hill, Virginia, estate. James Monroe was then convinced to leave Oak Hill. He moved in with his daughter and her husband in New York City, where he lived out his remaining months of life. After his death, he was buried in the Gouverneur family vault (their daughter Maria's husband's family) in the New York City Marble Cemetery. Rest in peace, James Monroe. Well, not yet.

James Monroe rested peacefully for over twenty years; then in the 1850s in a resurgence of state's pride, politicians in Virginia started lobbying to bring home all of the deceased presidents who were born in Virginia. The plan to bring all the fallen Virginia-born presidents home never materialized, but the Virginia General Assembly did convince Monroe's descendents to request that Monroe's body be brought back to Virginia and buried in the Dignitaries Circle in Hollywood

Cemetery. The owners of the Hollywood Cemetery Company were enthusiastic supporters of the plan and knew that having Monroe buried in the cemetery would boost lot sales and revenue. Monroe's body was disinterred from the Gouverneur family vault on the morning of July 2, 1858, and placed in a mahogany coffin studded with thirteen stars in a circle to represent the thirteen original states. Other silver stars were added around the coffin. After the disinterment, a formal ceremony followed at the Church of the Annunciation, where ten thousand mourners filed past the draped coffin. The coffin was loaded onto the steamer *Jamestown* on the East River in New York on July 3, 1858, bound for Richmond via the Atlantic Ocean and the James River. On July 5, 1858, hundreds of mourners slowly walked through the cemetery's gates following the horse-drawn hearse carrying James Monroe's remains. His coffin was lowered into the ground at Dignitaries Circle. In late 1859, a 12-foot tall cast-iron monument—manufactured by the Philadelphia company Wood and Perot and labeled as a birdcage by detractors—was placed over his grave. His wife, daughter, and son-in-law were moved from their burial places and reinterred alongside James Monroe some years later.

JOHN TYLER
March 29, 1790–January 18, 1862
37 32 02 N 77 27 23 W

John Tyler was the tenth president of the United States and one of the few who never actually ran for the office. Tyler was born at Greenway Plantation in Charles City County, Virginia, to John Tyler Sr. and Mary Armistead. His mother died when he was seven and his father, who was governor of Virginia from 1808 to 1811, raised him. Following in his father's footsteps, Tyler embarked on a career in politics and served two terms in the House of Representatives; he was then elected governor of Virginia, serving from 1825 to 1827. He was originally a member of the Democratic-Republican Party but was drawn to the Whig Party and ran as the party's vice presidential candidate alongside William Henry Harrison in 1840. The campaign used two memorable slogans, "Log Cabins and Hard Cider"

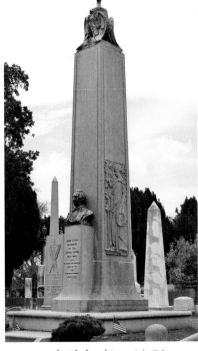

John Tyler

and "Tippecanoe and Tyler too." Tippecanoe was a battle fought in 1811, pitting United States forces led by Harrison against

John Tyler

Indian forces. The slogan "Tippecanoe and Tyler too" was derived from a song originally published as "Tip and Ty" that sang the praises of Harrison and Tyler while denigrating incumbent president Martin Van Buren.

Harrison and Tyler won the election and were sworn in on March 4, 1841. Harrison took ill after the swearing in and died of what was probably viral pneumonia on April 4, 1841. Tyler was sworn in the day Harrison died, the first vice president to assume the office after the death of a president. Although the spirit of the Constitution suggested that the vice president should assume office after the death of the president, there was much bickering about what the new president's official title should be. His presidency was not taken very seriously, and he was often referred to as the "Acting President" or "His Accidency." Because of the circumstances in which he attained office, he accomplished little and did not seek a second term. His one claim to fame was the annexation of Texas, which he accomplished in 1844.

After leaving the White House, Tyler and his second wife spent the rest of their years at Sherwood Forest, his plantation on the James River below Richmond. The plantation had originally been named Walnut Grove, but Tyler renamed it Sherwood Forest because he felt the Whig Party had turned him into an outlaw like Robin Hood. He owned about seventy slaves who worked the corn and wheat fields on the sprawling estate. Tyler became an outspoken secessionist and was elected to the House of Representatives of the Confederate Provisional Congress. On January 18, 1862, with the war raging, he was giving a speech in front of the Exchange Hotel when he suffered a stroke and was taken to a room where he died at the age of seventy-one. His body lay in state in the Confederate Congress, wrapped in a Confederate flag. His funeral was held in St. Paul's Episcopal Church, and a large procession of carriages carrying mourners, including Confederate President Jefferson Davis, escorted his remains to Hollywood Cemetery. Thus, John Tyler became the only United States president to die outside the United States, not to be officially mourned in the United States because of his Confederate ties.

Although John Tyler's last journey was to Hollywood Cemetery, it took a while to determine where he would actually be buried. It was clear that he would be buried in Dignitaries Circle, but there weren't any lots that were officially available. After some negotiations, enough land was carved out to house Tyler's remains, and an additional plot was put on hold for his wife (she eventually purchased it). Unfortunately, funds were tight at the time and, despite a resolution by the Virginia House of Delegates that it provide money for a monument, only $110 was appropriated, just enough to purchase the plot. Fifteen years later, in 1877, a reporter wrote that he could not find Tyler's grave when he visited the cemetery, prompting the cemetery to put up better

signage pointing to his grave; still, Tyler's grave was unmarked. Finally, in 1906, forty-four years after Tyler's death, the cemetery directors appropriated funds to put a simple tablet on Tyler's unmarked grave. On October 12, 1915, a formal monument in the style of an obelisk was erected over President John Tyler's grave.

CONFEDERATE SOLDIERS MONUMENT
37 32 26 N 77 27 20 W

The tallest and most prominent monument in Hollywood Cemetery is the Confederate Soldiers Monument. During and after the Civil War, thousands of soldiers, including a handful of Union soldiers, were buried at Hollywood. Much of the care and maintenance of the Confederate graves was attended to by the women of the Hollywood Memorial Association. It was a huge undertaking trying to take care of thousands of graves. The members of the association wanted to expand their role from tending the graves to erecting a substantial memorial. The group hosted a number of fundraising events, and by the end of 1867, they had amassed more than $18,000. Calls went out for a suitable design, and the association selected a design by Charles H. Dimmock, whose

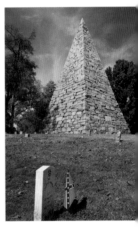

Confederate Soldiers Monument

plan called for the construction of a 90-foot tall rough-hewn pyramid out of rock quarried from the nearby James River. The cornerstone for the monument was put in place on December 3, 1868. It contained Confederate buttons and money, the first Confederate flag to fly in Richmond, photographs, musket balls, and other items associated with the Civil War. The Hollywood Memorial Association also included a Bible and a Masonic textbook (several Freemasons participated in the ceremony). Construction of the monument continued through much of 1869, and on November 6, 1869, Thomas Stanley, a convict who was working on the job, shimmied up the steep sides of the pyramid and guided the capstone into place. The monument became an instant tourist and local attraction, and the struggling cemetery company soon had a flood of buyers for cemetery plots.

J. L. M. CURRY
1825-1903 37 31 56 N 77 27 36 W

Buried near Jefferson Davis is noted orator and politician Jabez Lamar Monroe Curry, best known as J. L. M. Curry. Born in Georgia, he served with the Texas Rangers in the

J. L. M. Curry

Mexican-American War, became a U.S. Representative from Alabama from 1857 to 1861, and eased into the same role as a Confederate States representative from Alabama. He served in the Confederate Army as a colonel, became a Baptist minister as well as the president of Howard College, served as the minister to Spain from 1885 to 1888, and then was appointed as Ambassador Extraordinary to Spain in 1902. A statue of Curry carved by Dante Sodini represents Alabama in the Hall of Columns in the U.S. Capitol Building.

The centerpiece of the Curry plot is a curved bench called an exedra. Typically, a statue or architectural feature with the family name is at the center of the exedra and bench seats are on either side, although there are some examples that are simply a bench. The heyday of the exedra was from the late nineteenth century until the 1920s. They are still popular today but usually used in public areas rather than as monuments for individuals or families.

JAMES RIVER
37 32 01 N 77 27 22 W

The mighty James River roars by Hollywood Cemetery and forms its western boundary. When plans for Hollywood Cemetery were first presented to the Richmond city fathers, a number

James River

of objections arose; many felt that the land the cemetery wanted to set aside for the dead would be better used for spectacular view homes for the living. The cemetery owners prevailed, and more than 150 years later, the views are preserved for all to enjoy.

NEWFOUNDLAND DOG
37 32 22 N 77 27 19 W

What is clear is that a cast-iron Newfoundland dog was manufactured by Hayward, Bartlett and Company of Baltimore, Maryland. But nobody is exactly sure why it is in Hollywood Cemetery. The dog, which gets a regular coat of paint to keep it rust free and shiny, is one of the most popular monuments

Newfoundland Dog

in the cemetery—no small feat for the metal mutt since it competes with the monuments to Presidents James Monroe and John Tyler, numerous Confederate monuments, and the grave of Jefferson Davis.

One story about the dog's presence in the cemetery says that it graced the storefront of a building on Richmond's Broad Street and was very popular with children,

especially one little girl. When the girl died unexpectedly, the storeowner had the cast-iron canine moved to the grave of the girl so the dog could symbolically keep her company and guard her grave. Another less romantic story is that during the Civil War, ornamental iron was collected and melted down to reemerge as military equipment. Fearing the approbation of the Newfoundland dog, the owner had it moved to the cemetery for safekeeping. Whatever the story, it has stood regally at the corner of Cedar and Confederate Avenues for almost 150 years and will no doubt maintain its vigil for eons to come.

JAMES EWELL BROWN (J.E.B.) STUART
February 6, 1833–May 12, 1864 ⚭ 37 32 15 N 77 27 16 W

J. E. B. Stuart was a soldier from Virginia and a Confederate States Army general during the Civil War. Nicknamed "Jeb" by his friends, Stuart was a cavalry commander known for his mastery of reconnaissance and his use of cavalry in offensive operations. While he cultivated a cavalier image (red-lined gray cape, yellow sash, hat cocked to the side with a peacock feather, red flower in his lapel, often sporting cologne), his serious work made him Robert E. Lee's eyes and ears, and inspired Southern morale. He was killed in May 1864 at the battle of Yellow Tavern during the Overland Campaign.

James Ewell Brown (J.E.B.) Stuart

MAGNOLIA CEMETERY
CHARLESTON, SOUTH CAROLINA

*I*t's hard to imagine a cemetery more atmospheric than Charleston's Magnolia Cemetery. Its 150 acres contain a funereal encyclopedia of Charleston's movers and shakers and just plain folks. The land that eventually became Magnolia Cemetery was originally a rice plantation named Magnolia Umbria Plantation, established by Colonel William Cunnington in the late 1700s. The land went through a series of owners in the next few decades. Then in 1851, owner Edward Sebring deeded it to Magnolia Cemetery. The land was subdivided in subsequent years and pared down to its present 150 acres.

In 1850, before the cemetery had been officially established, noted architect Edward C. Jones did survey and design work, and laid out a cemetery based on the popular garden/rural cemetery aesthetic of the time. To commemorate the design and no doubt to aid in marketing, South Carolina poet laureate William Gilmore Simms penned the 5,000-word poem "The City of the Silent."

Owing to Charleston's prominent place in the Civil War, there are five Confederate generals buried in Magnolia as well as 1,700 soldiers, including eighty-four South Carolinians who were killed at Gettysburg and later reinterred at Magnolia. One of the best-known Civil War memorials at Magnolia is the one for the seven crew members of the submarine *Hunley*, who perished when the *Hunley* was lost at sea. The *Hunley*, which ran a number of missions from 1863 to 1864, was the first truly operational combat submarine.

Magnolia is still an active cemetery and has ample land to accommodate new burials. For the cemetery tourist, the most interesting sections are the Islands, which are interspersed with lagoons. Newer sections are known as Belvedere, the North Section, and Green Hill. In 1954, a trust was formed to take over the management of the cemetery and to work on preserving, reconstructing, and maintaining Magnolia's beauty. Magnolia suffered a major blow when Hurricane Hugo tore through Charleston in 1989. But the cemetery survived, and through the actions of the trustees, an endowment has been established to aid with the ongoing preservation efforts.

CONFEDERATE SECTION

32 48 58 N 79 56 38 W

Near the cemetery entrance is the Soldiers Ground. There are over 850 burials here, including eighty-four soldiers who fell at Gettysburg. The reinterment of the soldiers from Rose's Farm in Gettysburg to Magnolia occurred in 1871 and was funded by the Ladies Memorial Association (LMA). At the center of the

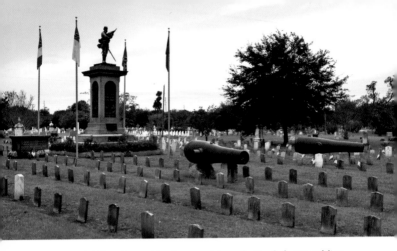

Confederate Section Soldiers Ground is a bronze statue of a Confederate soldier carrying the Confederate flag, frozen forever marching north.

THE HUNLEY CREWS
32 48 57 N 79 56 28 W

The Hunley Crews

One of the South's greatest technological achievements during the Civil War was the development of the submarine (www.hunley. org). An area of Magnolia known as the King's Circle honors the *Hunley's* crews. The first crew went down on August 29, 1863, when the *Hunley* was preparing for a dive and the wake of a passing ship flooded the open hatch. Five of the eight crew members were killed. Those men were originally buried at Seamen's Cemetery but were reinterred in Magnolia in 2000. In October 1863, the second crew of the *Hunley* went down while on a practice run. They were buried at Magnolia. Then in 1864, the third crew of the *Hunley* went down after successfully attacking and sinking the USS *Housatonic*, making the *Hunley* the first successful combat submarine. In 2001, the *Hunley* was brought up from its watery grave, and the crew members were given what has been called "The Last Confederate Funeral." Over 50,000 people attended the ceremony in 2004 when the last of the *Hunley* crews was buried with full military honors.

THE PLANTATION HOUSE
32 48 57 N 79 56 35 W

The Plantation House

The bones of the cemetery's office date to around 1800, when it was the plantation house for the original

Magnolia Umbria Plantation. The two-story structure was built in the Federal style. Additions were made in the mid-1850s, when it became the cemetery office, and again at the end of the nineteenth century. The plantation house suffered extensive damage during Hurricane Hugo in 1989 and had ongoing maintenance problems brought on by the ravages of time. However, the cemetery trustees felt the plantation house was worth preserving and undertook that restoration in the early 1990s. In 1994, both the plantation house and the gatehouse at the entrance to the cemetery were honored with Carolopolis Awards presented by the Preservation Society of Charleston.

RECEIVING TOMB
32 49 02 N 79 56 35 W

Most older cemeteries have a receiving tomb. These tombs were designed to house bodies while a crypt was being prepared. In colder climes, receiving tombs were used to house bodies in the winter when the ground was frozen and could not be easily dug up. Occupants of the receiving tomb would have to wait until the spring thaw when they could be moved to their final resting place. The receiving tomb in Magnolia has not been used in many years and has been filled with concrete rounds to prevent vandalism and to stabilize the structure.

Receiving Tomb

JUDGE HENRY EDWARD YOUNG
1831–1918 † &c 32 48 59 N 79 56 27 W

Henry Young and a number of members of his family are buried

around this elaborate monument. Young was Judge Advocate General on the staff of General Robert E. Lee. He was offered the job of Judge Advocate General of the Confederacy when South Carolina seceded from the Union but decided to stay on General Lee's staff.

Judge Henry Edward Young

Smith/Whaley Mausoleum

SMITH/WHALEY MAUSOLEUM
32 48 59 N 79 56 29 W

This magnificent pyramid mausoleum houses a number of members of the Smith and Whaley families. Egyptian architecture is the most funerary-appropriate architecture, since almost all architecture in ancient Egypt had something to do with death and the afterlife. However, the pagan aspects of Egyptian architecture didn't

Vanderhorst Mausoleum

always sit well with cemetery superintendents, and tomb designers usually added a Christian accessory such as crosses or biblical statues to soften the pagan overtones.

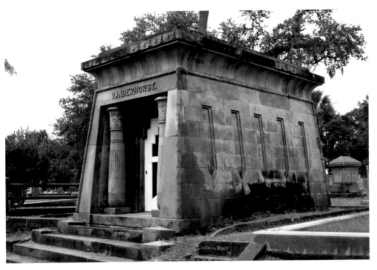

VANDERHORST MAUSOLEUM

Ca. 1864 ❧ 32 48 57 N 79 56 25 W

The Vanderhorst mausoleum is built in the Egyptian Revival style. Since Egyptian architecture doesn't use arches for strength, walls need to be battered at an angle of approximately 70 degrees to make the building structurally sound. A Christian cross, designed to soften the pagan overtones of the mausoleum, is set into the door. The cross is flanked with twin lotus columns.

Robert Barnwell Rhett

ROBERT BARNWELL RHETT

October 21, 1800–September 14, 1876 ❧ 32 49 00 N 79 56 36 W

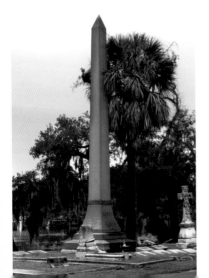

The graves of a number of fallen Rhetts pepper the grounds surrounding the obelisk honoring Robert Barnwell Rhett. Known as the Father of Secession, he was born into a well-to-do aristocratic Southern family. He was a member of a radical group called the Fire-Eaters, who believed slavery should be adopted nationwide. When Abraham Lincoln was elected president in 1860, Rhett knew that his plans for nationwide slavery would never succeed, and he started drafting the Ordinance of Secession. Rhett was briefly considered for the presidency of the Confederacy, but his views were considered too

extremist; the more moderate Jefferson Davis was elected. Rhett was the owner-editor of the *Charleston Mercury* newspaper, and in that position, he made known his fiercely critical views of Davis. Robert Barnwell Rhett never asked for a pardon after the Civil War; he died in St. James Parish, Louisiana.

HUGH SWINTON LEGARE

January 2, 1797-June 20, 1843
32 49 00 N 79 56 36 W

This magnificent marble monument marks the grave of Hugh Swinton Legare. He was originally buried in Mount Auburn Cemetery near Boston but was, according to the lettering on the monument, "removed from Mount Auburn Cemetary [*sic*], September 30, 1857" and "deposited at Magnolia

Hugh Swinton Legare

Cemetary [*sic*] on October 8, 1857." The monument was funded by a group of friends and manufactured by the W. T. White Steam Marble Works in Charleston. Legare was somewhat of a child genius. He entered South Carolina College at age fourteen and then went abroad to study law. After returning to South Carolina, he served several terms as a state legislator before moving on to become South Carolina Attorney General in 1830; he was elected to Congress in 1836. In 1841, President Tyler appointed him as United States Attorney General. Legare was a strong proponent of states' rights but thought that a compromise could be reached instead of going to war.

ROSALIE RAYMOND WHITE

January 27, 1882-September 5, 1882 🕸 32 49 01 N 79 56 40 W

Death was an all-to-frequent visitor in nineteenth-century households. This unique monument marks the grave of Rosalie Raymond, daughter of B. L. and R. R. White.

Rosalie Raymond White

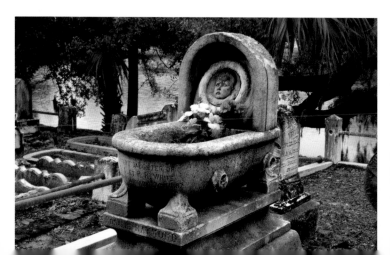

MOUNT HOLLY CEMETERY
LITTLE ROCK, ARKANSAS

Maps are available at the Bell House.
Since this is a very small cemetery, individual graves are easy to find.
34 44 16 N 92 16 38 W

Mount Holly Cemetery in Little Rock, Arkansas, touts itself as "The Westminster Abbey of Arkansas." Since there is no cathedral on the grounds, what Mount Holly's promoters are referring to is the number of Arkansas dignitaries who call the cemetery their permanent home. Interred at Mount Holly are eleven Arkansas governors, fourteen state supreme court justices, five Confederate generals, twenty-two Little Rock mayors, and a host of physicians, attorneys, military heroes, and other notables. The compact four-square-block cemetery was established in 1843 on land donated by Roswell Beebe and Senator Chester Ashley. That was a generous amount of land considering that as late as 1860 Little Rock's population was less than 4,000 souls. However, by 1870, thanks largely to an influx of people from rural areas, Little Rock's population tripled to over 12,000.

Although Mount Holly was designed with an eye toward the prevailing rural or garden cemetery aesthetic, its narrow carriage lanes were laid out in a grid rather than with winding roads that garden cemeteries usually had. Family lots originally sold for $2.50 to $5 each, and many were snapped up by the early subscribers as investments. By 1850, lots were selling for $10 each, and by 1870, the price climbed to a whopping $50. Unlike many cemeteries in the South, Mount Holly was not segregated. A summary of burials compiled in 1869 tallied "Citizens (white and colored): 1,067, Confederate Soldiers: 646, Government employees (colored) 148." Little Rock's Jewish community purchased four lots as "burying ground for the Israelitish." The Jewish graves were disinterred by 1916 and moved to a large Jewish section in Little Rock's Oakland Cemetery.

Over the years, Mount Holly gradually filled up. Currently there are about 5,000 people interred in 1,300 plots. Although all of the plots have long since been sold, there are occasional burials at Mount Holly in existing family plots. Since lots were originally designed to be largely maintained by the families that purchased them, many areas fell into disrepair as families fractured or moved away. It seemed that Mount Holly would suffer the fate of many other nineteenth-century cemeteries and slowly crumble away. However, in 1915, forward-thinking citizens formed the Mount Holly Cemetery Association, which was dedicated to the operation and preservation of the cemetery. The association, which is composed entirely of women, is active to this day. The women of the association have been responsible for much of the upkeep of the cemetery. They instituted a lot tax, a perpetual care program, and the construction of a community mausoleum on the grounds; eventually they got the city to levy a small tax for continued upkeep of the cemetery.

BELL HOUSE

Bell House

The centerpiece of the cemetery is the Bell House (originally called the Pavillion [*sic*]). This little gem of a building was constructed in 1888–1889 in the Carpenter Gothic style. Its working bell is rung during funerals. There is a buzzer at the Bell House to call the sexton, and free brochures detailing the cemetery are available.

Basham Family Plot

BASHAM FAMILY PLOT

Martha Parma Basham
December 3, 1882-August 10, 1887
Pearl Reed Basham
July 22 1880-November 7, 1886

The Basham family plot features the two little Basham girls dressed in the clothing they would have worn at the time. The sculptures were carved in Italy for the local monument company owned by William L. Funston. When the sculptures arrived, the family wasn't pleased with the likenesses and had them sent back to Italy for a better rendering. The children's statues are fronted by cradle markers—a device used for planting flowers.

MARY WATKINS

Mary Watkins

Death was an all-too-frequent visitor to young people in the nineteenth century. This monument memorializes sixteen-year-old Mary Watkins, daughter of George Claibourne Watkins and Mary Crease Watkins. On the base of the monument is this verse:

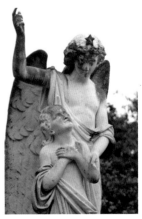

Why seek ye the living among the dead
She is not here, but is risen
In the bloom of youth, the spring of life
She heard a voice of Love
It called her from this vale of tears
To rest with God above
Why sound the notes of bitter woe
Why let thine eyes so weep
Our darling livest, oh, blessed thought
This is not death but sleep.

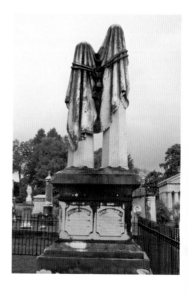

ROBINS MONUMENT
John Robins June 9, 1800-July 27, 1869
Elizabeth Robins August 9, 1811-October 31, 1868
A very unusual, draped, marble double
obelisk marks the grave of John and
Elizabeth Robins, who came to Little
Rock from Pennsylvania in the 1830s.

PIKE FAMILY PLOT
Four broken columns, symbolizing lives cut short, represent
four of the children of Albert and Mary Pike who died in infancy.
Albert Pike personally designed the monument. Surrounding
the words "Our Children" is an ouroboros (a snake eating its
tail), a symbol of immortality. The monument was crafted by
Latvian-born Robert Eberhard Launitz (1806–1870) of New York.
Schooled in Rome, he has been called the father of monumental
art in America. His
specialty was funerary
art and his pieces can
be seen in a number of
cemeteries. The largest
collection is probably at
Green-Wood cemetery
in Brooklyn, New York.

*Robins
Monument*

*Pike
Family Plot*

*Gilchrist
Monument*

GILCHRIST MONUMENT
Ca. 1790-September 5, 1843
The most prominent monument in
the Masonic section of the cemetery
honors William Gilchrist, the first Grand
Master of the Grand Lodge of the State
of Arkansas. The firm of Brownlee
and McMorrin crafted the monument
from one piece of freestone for $800.
Freestone is so called because it could
be cut freely without danger of splitting.
The 16-foot stone sits on a 9-foot base.

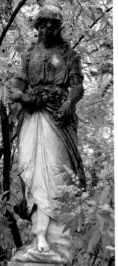

ANNA LEROY POPE GREEN
June 22, 1848-October 26, 1880

This graceful statue of a perfectly proper Victorian woman daintily exposing a bit of ankle is erected over the grave of Anna Leroy Pope Green, the wife of Benjamin W. Green (1846–1924).

CARA PEYTON HANEY
March 23, 1870-October 29, 1872

A mourning child standing atop a monument with a cradle marker commemorates the short life of Cara Peyton Haney, daughter of John and Mary Haney.

Anna Leroy Pope Green

Cara Peyton Haney

MOISE B. SELIGMAN III
September 19, 1946-September 20, 1974

One of the more curious monuments at Mount Holly marks the grave of Moise B. Seligman III. It appears to be vandalized; in fact, it was part of Seligman's collection of mementoes from his travels. The sculpture is a Roman torso executed sometime before AD 79.

Moise B. Seligman III

QUATIE
Birth unknown-February 1, 1839

Quatie

Quatie was the wife of Cherokee leader John Ross. She and thousands of others died on the "Trail of Tears" when U.S. President Andrew Jackson ordered the removal of all Cherokees, Creeks, Choctaws, Chickasaws, and Seminoles from the Southern states after Congress passed the Indian Removal Act of 1830. Quatie was a member of one of the last contingents of Cherokees to leave in the winter of 1839. It's been said she gave her blanket to a child and later died of pneumonia. In 1935, the General George Izard Chapter of the United States Daughters of 1812 placed this marker at Mount Holly in her honor.

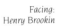

HENRY BROOKIN
1856-1891

Most Victorian-era cemeteries sport a fireman's memorial or two. This bronze figure commemorates the life of fireman Henry Brookin, who died at age thirty-five while fighting a fire. The 2-foot-tall statue sits atop a granite column. The top part of the hose has been lost to deterioration or vandalism.

Facing: Henry Brookin

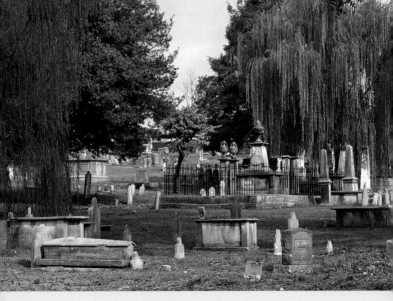

NASHVILLE CITY CEMETERY
NASHVILLE, TENNESSEE

www.thenashvillecitycemetery.org
36 08 55 N 86 46 09 W

Strolling through Nashville City Cemetery is like seeing Nashville's early history unfold. Here you'll see the movers and shakers of early Nashville as well as slaves, teachers, musicians, soldiers, firemen, casualties of diphtheria plagues, and many more. The cemetery was established in 1822, making it the oldest existing cemetery in middle Tennessee. Nashville was settled in 1779 by James Robertson and a group of settlers known as Wataugans. The town was originally called Fort Nashboro, after the American Revolutionary War hero Francis Nash. Nashville quickly grew because of its prime location, its accessibility as a river port, and its later status as a major railroad center. In 1806, Nashville was incorporated as a city and became the county seat of Davidson County, Tennessee.

The first burial ground was established along the banks of the Cumberland River. A few other informal burial grounds were established around the same time. These early cemeteries were little more than places to deposit the deceased. As the town grew, the city fathers saw the need for a more formal permanent cemetery. In 1820, Mayor James Condon and the town aldermen purchased four acres of land slightly south of the downtown area to be developed into a cemetery. Locating the cemetery beyond the main part of the town in a more rural setting reflected the new attitude toward burial grounds. The rural or garden cemetery idea was first seen in Paris, France, in 1804 when park-like Père-Lachaise Cemetery was established. Although Mount Auburn Cemetery in Cambridge, Massachusetts, established in 1831, is credited with being the first garden cemetery in the United States modeled after Père-Lachaise, the Nashville City Cemetery certainly echoes the style of Père-Lachaise.

The first burial on the land that would become Nashville City Cemetery actually occurred as early as 1804. Bodies were moved from other Nashville cemeteries in 1820 and 1821 before the cemetery was officially dedicated in 1822. The new rural cemeteries that were located some distance from town often had a hard time attracting lot buyers, so owners of the cemeteries often used creative sales tactics to attract investors. In Père-Lachaise, the savvy Parisian owners moved some long-deceased celebrities like Moliere (1622–1673), La Fontaine (1621–1695), and the lovers Heloise (1101–1164) and Abelard (1079–1142) to give the cemetery more star appeal. The Nashville City Cemetery's developers moved in Nashville's founder James Robertson, who had died in 1814, and soon the cemetery became a popular permanent destination. By 1836, the cemetery had outgrown its original four acres, and over the next twenty years, the city slowly acquired land until it reached its present size of twenty-seven acres.

In 1843, the cemetery's sexton, Alpha Kingsley, began the process of officially turning Nashville City Cemetery into a formal garden cemetery like Mount Auburn and Père-Lachaise. He designed winding roads and lush planting areas, and started selling family plots, which were intended to generate much-needed maintenance revenue. Unfortunately, there was never enough revenue to adequately keep up the grounds and turn it into a lush garden cemetery. By 1850, 11,000 bodies had been buried at the small cemetery, and by 1860, the once pastoral cemetery was well within the city limits where vandalism and overuse began to take their toll. During the Civil War, hundreds of Union and Confederate soldiers were buried in shallow graves in the cemetery and along the tracks of the nearby railroad, which added to the ragtag look of the cemetery. The city made plans to transfer the soldiers' bodies elsewhere and to open a new cemetery named Mount Olivet. Slowly, Nashville City Cemetery began to fall into disuse and disrepair. In the years after the Civil War, many families moved from the Nashville area and no longer were able to maintain their family plots. Other families purchased plots in Mount Olivet. The last major improvement to the cemetery occurred in 1911 when the South Nashville Women's Club paid for the construction of new stone walls surrounding the grounds.

However, all was not lost. Despite years of vandalism and neglect, the cemetery has made a remarkable turnaround. In the 1950s, Ben West, who was Nashville mayor from 1951 to 1963, led a major restoration project. In 1972, the Nashville City Cemetery was placed on the National Register of Historic Places. In 1998, The Nashville City Cemetery Association was formed to help restore and preserve the cemetery. Visitors today will notice a remarkable number of historic markers that help to illuminate the lives of those who permanently call the cemetery home. The association also hosts special events and fundraisers to help finance the ongoing restoration.

JAMES ROBERTSON
June 28, 1742–September 1, 1814 ❧ 36 08 50 N 86 46 11 W

In 1779, James Robertson led a party of forty men 400 miles from the Watauga Settlement of North Carolina to present-day Nashville. Along the way, a number of families also joined the group, which arrived at their destination on Christmas Day. The following spring, another 150 men, women, and children arrived. They called the spot on the Cumberland River Fort Nashboro in honor of General Francis Nash of North Carolina, who had died in the Revolutionary

James Robertson

War. The town, renamed Nashville, was officially established in 1784. Shortly thereafter, Robertson was made a brigadier general and then appointed as agent to the Chickasaw and Cherokee Indians. He died in Memphis while serving in that post. General James Robertson's body was moved from Memphis in 1825 and reinterred at Nashville City Cemetery. Robertson is known as the Father of Middle Tennessee and the Father of Nashville. In 1913, the Tennessee Women's Historical Association erected a sundial-topped marker to him and his son, Dr. Felix Robertson, "The first white child born in Nashville." Behind the marker is a cast-iron fence enclosing the tombs of the family.

Samuel Read Anderson

SAMUEL READ ANDERSON

February 17, 1804-January 2, 1883 ❧ 36 08 51 N 86 46 10 W

Samuel Read Anderson was the son of Revolutionary War soldier Robert Anderson and Mary Read Anderson. He was a lieutenant colonel of the 1st Tennessee Regiment in the Mexican-American War and then served as a brigadier general in the Civil War. His modest marker is flanked by the markers for his wife Mary (1812–1854), daughter Mary (1845–1847) and son Robert (1842–1854).

WILLIAM CARROLL

March 3, 1788-March 22, 1844 ❧ 36 08 51 N 86 46 10 W

William Carroll was born in Pennsylvania and then moved to Tennessee in 1806 and to Nashville in 1810. Despite his youth, he did well in business, joined the militia, and served under Andrew Jackson in the War of 1812. Utilizing his connection with Andrew Jackson, he served as governor of Tennessee for four terms (1821–1827 and 1829–1835), the longest for any Tennessee governor. His tenure as governor was noted for his institution of a more progressive penal system and the establishment of an ecclesiastically oriented Chancery Court.

William Carroll

William Driver

WILLIAM DRIVER

March 17, 1803-March 3, 1886
36 08 48 N 86 46 11 W

William Driver was a sea captain who sailed vessels out of Salem, Massachusetts. On one voyage, he picked up descendents of the survivors from the *Bounty*, who had moved to Tahiti, and moved them back to Pitcairn Island where they wanted to live. Shortly before his first voyage as a full-fledged captain, his friends, wife, and daughters presented him with an American flag

to fly from the ship. He is said to have exclaimed, "I'll name her Old Glory." That flag accompanied Driver on all his voyages. When Driver retired and moved to Nashville, he would haul out his flag and fly it on patriotic occasions like the Fourth of July and Washington's Birthday. After Tennessee seceded from the Union at the beginning of the Civil War, Driver's wife tucked the flag into a quilt for safekeeping. When Union forces captured Nashville in February 1862, Driver greeted them with his flag in his arms offering to fly it over the state capitol building saying, "Thank God I lived to fly Old Glory on the dome of the Capitol of Tennessee; I am now ready to die and go to my forefathers." Old Glory currently resides in the Smithsonian Institution. It is one of America's most important flags.

Harlan Perry Howard

HARLAN PERRY HOWARD

September 8, 1927-March 3, 2002
36 08 48 N 86 46 10 W

Harland Perry Howard was born in Detroit, Michigan. After spending years working as a laborer in the Los Angeles area, he moved to Nashville in 1960 to try his hand at songwriting. His gamble paid off: in 1961, fifteen of his songs were in the Country Top 40, a feat that has never been equaled. Throughout his career, he wrote over 4,000 songs, 100 of them charting in the top 10. In 1973, he was inducted into the Country Music Hall of Fame. Among his most famous songs are Johnny Cash's "Busted," Ray Price's "Heartaches by the Number," and Patsy Cline's "I Fall to Pieces."

PAMELIA A. KIRK

1780-November 6, 1860 ❧ 36 08 51 N 86 46 10 W

Born in Virginia, Mrs. Pamelia (also seen as Parmilla and Parmelia) Kirk was Nashville's first woman schoolteacher. Her unique marble gravestone depicts her instructing a group of students. A plaque above her grave was erected by the White City Teachers Association in 1961.

Pamelia A. Kirk

ANN RAWLINS SANDERS

1815-1836 ❧ 36 08 51 N 86 46 10 W

This large limestone rock marks the graves of Ann Rawlins Sanders and Marion Steele. Little is known about Steele except that in 1902, cemetery sexton Dan Marlin was quoted as saying

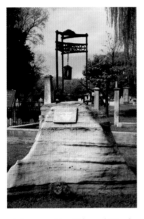

she was beautiful. The name on the plaque on the stone is inscribed with the birth/death dates of Sanders, who is actually interred beneath a boxy false crypt nearby. Ann Rawlins was a member of the First Presbyterian Church in Nashville and was described as "a woman whose piety made her a celestial among mortals." She married Charles Sanders in 1832 at age seventeen and died four years later. Her grave is on a plot owned by Edward Steele, who was probably a relative.

Ann Rawlins Sanders

McNAIRY FAMILY VAULT
36 08 50 N 86 46 11 W

The McNairy family vault holds the bodies of a number of McNairys in its underground crypts, including that of John McNairy, who was a Tennessee supreme court judge, U.S. District Court judge, and Circuit Court judge. Because of its underground vault and proximity to the Confederate hospital nearby, the vault has become fodder for a number of urban legends, including being used as an underground escape tunnel for Confederate prisoners and a place for robbers to hide their booty. None of the legends has held up under close scrutiny.

OBELISKS
36 08 51 N 86 46 13 W

Nashville City Cemetery has a number of obelisks, an architectural form developed in Egypt where it represents a ray of sun. The obelisk was readily adopted by funerary designers because of its obvious verticality stretching towards the heavens and the ways it could be adapted by adding reverential shrouds, flames representing eternal life, and cutoff obelisks representing a life cut short. It's also more than a little obvious that the various sizes of obelisks were meant to show one's status.

McNairy Family Vault

Obelisks

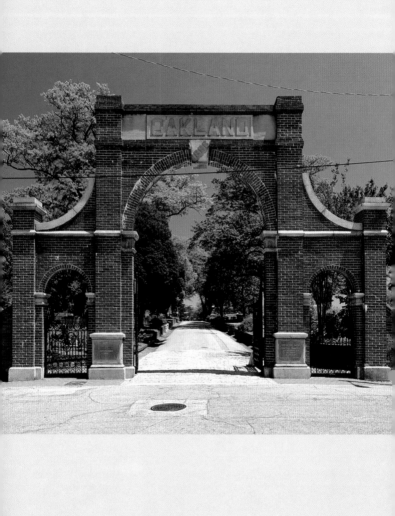

OAKLAND CEMETERY
ATLANTA, GEORGIA

Maps available in cemetery office
www.oaklandcemetery.com
33 44 53 N 84 22 30 W

Although there are many jewels in the Southern cemetery crown, it's hard to find one that is brighter than Atlanta's Oakland Cemetery. After all, Oakland houses the earthly remains of that belle of the South, Margaret Mitchell.

The area that became Atlanta was first developed in 1837 as the terminus for the Western and Atlantic Railroad and simply adopted the name Terminus as the name for the tiny settlement. By 1842, the settlement had grown to six buildings and thirty residents, and required a more dignified name. A series of temporary names followed in the next few years. Then in 1845, J. Edgar Thompson, the chief engineer of the Georgia Railroad, suggested that the area be renamed "Atlantica-Pacifica," touting the optimistic final route of the railroad. The name was quickly shortened to Atlanta.

A small graveyard was established in the center of town, but as the population steadily grew, it became necessary to plan a larger formal cemetery. In 1850, the city fathers purchased six acres of rural land for $75 an acre southeast of the town. Plots went up for sale; the old city graveyard was emptied and many of the bodies were reinterred at the new cemetery. Over the years, a series of annexations increased the size of the cemetery to its current eighty-eight acres. The cemetery was originally named Atlanta or City Cemetery, and then the name was changed to Oakland Cemetery in 1872 to reflect the abundance of oak trees on the grounds.

The grounds and layout of Oakland Cemetery are typical of a Victorian garden cemetery. Winding pathways and lush plantings peppered with evocatively romantic monuments were meant to soften the harsh reality of death, for in the Victorian era, death was seen as a part of the journey of the soul. Death itself was only a chapter and not a finality. By 1884, all of the available plots had been purchased. There have been over 70,000 burials in the cemetery, and some still occur to this day in family plots where space is still available. Oakland Cemetery was never a perpetual care cemetery (families were expected to tend to their plots), so over the years as families moved away, many of the monuments fell into serious disrepair while others were targets of vandalism. Then in 1976, the Historic Oakland Foundation was established, and thanks to the efforts of that group, which secures donations and grants and hosts special events, the former beauty of the cemetery has been restored. The group conducts guided tours of the grounds and runs a well-stocked gift shop and visitor center located in the bell tower.

MARGARET MUNNERLYN MITCHELL MARSH

November 8, 1900-August 16, 1949 ❧ 33 44 55 N 84 22 25 W

Margaret Mitchell was the author of the quintessential Southern novel, *Gone with the Wind*. Mitchell was born into a family not unlike that of Scarlett O'Hara's. Her mother, Mary Isabelle "Maybelle" Stephens, was of Irish-Catholic ancestry. Her father, Eugene Muse Mitchell, an Atlanta attorney, descended from Scotch-Irish and French Huguenots. The family included soldiers who had fought in the American Revolution, Irish uprisings and rebellions, and the Civil War.

The family lived in a number of homes before settling in a stately home on Peachtree Street in Atlanta in 1912. Young Margaret attended private school but did not excel as a student. On one memorable day, she announced to her mother that she could not understand mathematics and would not return to school. Maybelle dragged her daughter to a rural road where plantation houses had fallen into ruin. Maybelle looked at her daughter and reportedly said, "It's happened before and it will happen again and when it does happen, everyone loses every-thing and everyone is equal. They all start again with nothing at all except the cunning of their brain and the strength of their hands."

Chastened, Margaret Mitchell returned to school with a newfound respect for learning. From 1914 to 1918, Mitchell attended the Washington Seminary, a prestigious Atlanta finish-ing school, where she was a founding member and officer of the drama club. She was also the literary editor of *Facts and Fancies*, the high school yearbook, in which two of her stories were featured. She was also president of the Washington Literary Society.

She entered Smith College in the fall of 1918, not long after the United States entered World War I. While at Smith, she attended dances organized for soldiers at nearby military bases. It was there that she met Clifford Henry, a bayonet instructor at Fort Gordon. Before Henry was shipped off to France, the couple was engaged. He was killed in action in France in October 1918. In January 1919, Maybelle Mitchell died from the flu pandemic, and Margaret Mitchell left college to take charge of the Atlanta household of her father and her older brother, Stephens.

Although she made her society debut in 1920, Margaret was far too free-spirited and intellectual to be content with the life of a debutante. She argued with her fellow debs over the proper distribution of the money they had raised for charity. She later scandalized Atlanta society with a sensuous French dance that she performed at the debutante ball with a male student from Georgia Tech.

In the early 1920s, Margaret Mitchell was a headstrong "flap-per" pursued by a number of men, including ex-football player and bootlegger Berrien "Red" Upshaw and lanky newspaperman John Robert Marsh. She chose Upshaw, reportedly because he asked first. The two were married in September 1922. The marriage only lasted a few months although the annulment wasn't finalized until 1924. In 1922, Mitchell landed a job with

the *Atlanta Journal Sunday Magazine*. She used "Peggy Mitchell" as her byline. Her interviews, profiles, and sketches of life in Georgia were well received. During her four years with the *Sunday Magazine*, Mitchell wrote 129 articles, worked as a proofreader, substituted for the advice columnist, reviewed books, and occasionally did hard news stories for the paper.

Mitchell finally married John Marsh on July 4, 1925, and the couple set up housekeeping in a small apartment affectionately called "The Dump." Marsh, originally from Maysville, Kentucky, worked for the Georgia Railway and Power Company as director of the publicity department.

In 1926, to relieve the boredom of being cooped up with a broken ankle, Margaret devoured historical novels. After a while, her husband suggested that she write a novel. Thus began *Gone with the Wind*. She wrote the last chapter first and the other chapters in no particular order. Stuffing the chapters into manila envelopes, she eventually accumulated almost seventy chapters. However, she kept her novel a secret from most friends.

In April 1935, Harold Latham, an editor for the Macmillan Publishing Company in New York City, toured the South looking for new manuscripts. Latham heard that Mitchell had been working on a manuscript and asked her if he could see it, but she denied having one. When a friend commented that Mitchell was not serious enough to write a novel, Mitchell gathered up the envelopes and took them to Latham at his hotel. He had to purchase a suitcase to carry them. He read part of the manuscript on the train to New Orleans, Louisiana, and sent it straight to New York. By July, Macmillan had offered her a contract. She received a $500 advance and 10 percent royalties.

As she revised the manuscript, Mitchell cut and rearranged chapters, confirmed details, wrote the first chapter, changed the name of the main character (originally called Pansy), and struggled to think of a more appropriate title. Among those considered were Tomorrow Is Another Day, Tote the Weary Load, Milestones, Ba! Ba! Blacksheep, Not in Our Stars, and Bugles Sang True. Finally, she settled on a phrase from a favorite poem by Ernest Dowson: "I have forgot much, Cynara! gone with the wind, / Flung roses, roses riotously

Margaret Munnerlyn Mitchell Marsh

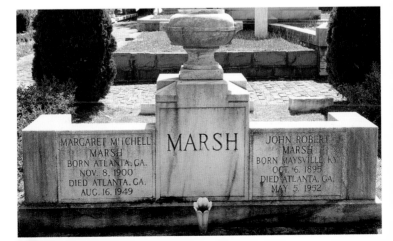

with the throng." When completed, *Gone with the Wind* was 1,037 pages long and priced at $3. It went on sale June 30, 1936. They had hoped for a sale of 5,000 copies. On one day that summer, it sold 50,000 copies. Exact publishing figures for books are next to impossible to calculate, but before the Harry Potter phenomenon, *Gone with the Wind* was often touted as the best-selling nonreligious book of all time.

The book won the Pulitzer Prize in 1937. Mitchell received an honorary degree from Smith College, medals, and decorations, and was besieged for her autograph and the story of her life. Two years after the book was published, when she granted her first formal interview to New York reporters, she was asked if she was writing anything else or intended to. She said she had been so busy answering the phone, the doorbell, and fan mail that she had not had time. It was widely reported that she never wrote another word of prose. Shortly after the book's publication, the movie rights were sold to David O. Selznick for $50,000, the highest amount ever paid for a manuscript up to that time. The movie debuted in 1939 with Mitchell in attendance.

On August 11, 1949, while crossing the intersection of Peachtree and 13th—only three blocks from "The Dump"—Margaret Mitchell was struck by a car driven by an inebriated off-duty cabdriver. She died five days later and is buried in Atlanta's Oakland Cemetery with other members of her family. The tombstone is marked "Marsh."

For decades it was thought that Mitchell had only written one complete novel. But in the 1990s, a manuscript by Mitchell of a novel entitled *Lost Laysen* was discovered among a collection of letters Mitchell had given to a suitor named Henry Love Angel in the early 1920s. The manuscript had been written in two notebooks in 1916. In the 1990s, Angel's son discovered the manuscript and sent it to the Road to Tara Museum, which authenticated the work. A special edition of *Lost Laysen*—a romance set in the South Pacific—was edited by Debra Freer, augmented with an account of Mitchell and Angel's romance, including a number of her letters to him, and published by the Scribner imprint of Simon & Schuster in 1996.

CONFEDERATE SECTION

33 44 52 N 84 22 19 W

The Confederate section of Oakland contains a large obelisk, 6,000 burials (3,000 unknown), and an evocative Lion of the Confederacy monument. During the Civil War, several of the largest military hospitals in the area were within

Confederate Section

a half mile

UNKNOWN CONFEDERATE DEAD

of Oakland. Many soldiers who died from their wounds were buried here. After the war, a few thousand soldiers who were killed in the Atlanta Campaign and were previously buried in battleground graves were moved to Oakland. The large 65-foot-tall monument known as the Confederate Obelisk is made from granite quarried from Stone Mountain. It was dedicated on April 26, 1874, the anniversary of Joseph E. Johnston's surrender to William Sherman, which essentially ended the Civil War. For a number of years, the Confederate Obelisk was the tallest structure in Atlanta. Also located in the Confederate section is the Lion of the Confederacy, or Lion of Atlanta monument. The lion, which marks an area containing the remains of unknown Confederate and Union dead, was carved by T. M. Brady in 1894 out of the largest piece of marble quarried from north Georgia up to that time. Though Brady claimed that the design was original, it is strikingly similar to the Lion of Lucerne in Lucerne, Switzerland, carved by Bertel Thorvaldsen. That monument commemorates the hundreds of Swiss Guards who were massacred in 1792 during the French Revolution, when the mob stormed the Tuileries Palace in Paris.

MARY GLOVER THURMAN

February 11, 1829–
June 15, 1916
33 44 55 N 84 22 27 W
One of the most
beautiful sculptures
at Oakland Cemetery
marks the grave
of Mary Glover
Thurman. Thurman
was known as "The
Angel" because
of her frequent
flower-bearing visits
to local hospitals.

Mary Glover Thurman

The sculpture was obviously inspired by the Kinsley monument in Woodlawn Cemetery in New York, carved by Daniel Chester French. His best-known work is the sculpture of a seated Abraham Lincoln at the Lincoln Memorial in Washington, D.C.

RICHARDS MAUSOLEUM

33 44 58 N 84 22 323 W
The magnificent Richards mausoleum is one of Oakland's finest. As is common with much funerary architecture, it is a combination of architectural styles. The vertical emphasis and the bat-winged gargoyles are reminiscent of Gothic architecture while the rounded windows and doorway (with a hint of a Gothic peak) are more suited to Romanesque architecture. The mausoleum was designed by renowned funerary architect H. Q. French of New York City. He designed a very similar mausoleum in Oakwood Cemetery in Syracuse

Richards Mausoleum

New, York. Robert H. Richards, who died on September 16, 1888, was the co-founder of Atlanta National Bank.

GRANT MAUSOLEUM
33 44 52 N 84 22 23 W

The Grant mausoleum has elements of Classical Revival (the basic form, proportions, and column capitals), Richardsonian Romanesque (the rusticated stone), and even Egyptian (the pyramid-like roof). Architects saw mausoleums as an opportunity to be more creative and playful than their other work since they didn't have to be concerned with things like electrical outlets, plumbing, views, and traffic flow from one room to another. Mausoleums are truly a testament

Grant Mausoleum

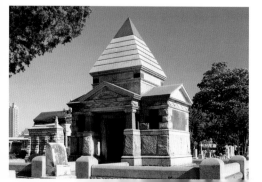

to function following form since they had but one simple function: to house bodies. The mausoleum houses a number of bodies, including contractor John T. Grant, who died in 1887; William D. Grant, who built the Grant Building in downtown Atlanta; John W. Grant, a real estate tycoon who died in 1938; and Georgia Governor John Marshall Slaton, who died in 1955.

FOUNTAIN
33 44 52 N 84 22 22 W

Across from the bell tower and visitor center is this recently restored fountain. The J. L. Mott Ironworks in New York City crafted the bronze fountain, named *Out in the Rain*, in 1913. The sculpture was installed as the centerpiece of a small pool. According to cemetery records, the remains of Atlanta's first mayor, Moses Formwalt (1820–1852), were "cemented in the fountain" on May 26, 1916. Formwalt, who made his living as a tinsmith, primarily building stills, was elected mayor at age twenty-eight in January 1848, garnering the majority of the 215 votes cast. He was said to have been the candidate of the Free and Rowdy party. Two years after leaving office, he became a deputy sheriff. Alas, his life was cut short when he was stabbed to death by a prisoner.

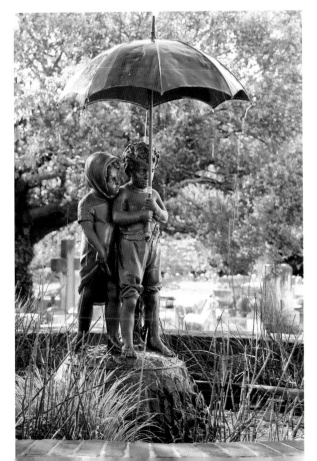

Fountain:
Out in the Rain

AUGUSTUS THOMPSON
July 8, 1837–March 12, 1910 ❧ 33 44 54 N 84 22 14 W

The black section was established in 1867. The number of substantial monuments in this section of Oakland Cemetery reflects their relative prosperity. This anvil-topped tombstone marks the grave of Augustus Thompson, who was a blacksmith. The three links of a chain indicate he was a member of the Odd Fellows. Although most fraternal societies were segregated, African Americans simply borrowed their names and formed their own groups. In 1871, Thompson became a founder of the St. James Lodge of the Grand Union Order of Odd Fellows (GUOOF).

GRAVES MAUSOLEUM
33 44 54 N 84 22 13 W

The only mausoleum in the African American area was erected after the death of prominent Atlanta

Augustus Thompson

realtor Antoine Graves in 1941. Antoine and Catherine Graves had five children (one died in infancy). All of the children were well educated. Antoine Jr. was a dentist and talented concert violinist. The child who died in infancy was Lena Louise Graves. Her cousin, entertainer Lena Horne, was named in her memory.

Graves Mausoleum

ROBERT TYRE "BOBBY" JONES
1902–1971
33 44 48 N 84 22 19 W

Tucked up against the cemetery's south wall is the grave of "Bobby" Jones, often called the greatest amateur golfer of all time. He was a child prodigy and won his first children's tournament at the age of six. In 1923, he won the U.S. Open and went on to win thirteen major championships in twenty tries from 1923 through 1930. In 1930, he won the Grand Slam of Golf, taking victories at the U.S. Open, U.S. Amateur, British Open, and British Amateur. After retirement, he founded the Augusta National Golf Club and the Masters

Robert Tyre "Bobby" Jones

Tournament. His grave is usually peppered with golf balls and, occasionally, golf clubs (bent and otherwise).

KONTZ MONUMENT

33 44 50 N 84 22 24 W

Cemetery superintendents have had a schizophrenic attitude towards Egyptian Revival architecture. Since almost all Egyptian architecture had something to do with death and the afterlife, it seems a natural fit for a cemetery, but Egyptian architecture's pagan roots don't sit well in areas with a passionate Christian population. The rule of thumb is that the closer the cemetery is to America's Bible Belt, the less Egyptian architecture. Atlanta's Oakland Cemetery has one such monument, but a fine one it is. The Kontz monument is inscribed with the names of a number of members of the Kontz family. It was commissioned by Christian Kontz, a German-born immigrant. Highlights of the monument include lotus flowers representing resurrection and a cavetto cornice (flared with curve) containing a winged disk with vulture wings (maternal care), cobras (protection), and the sun (eternal life). The winged disk is associated with the god Horus. To soften the pagan symbols, the designer has carved a Christian cross with crown into the bottom face of the arch.

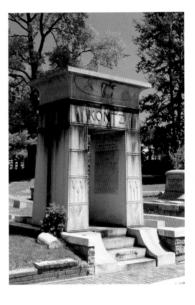

Kontz Monument

JEWISH SECTION

33 44 49 N 84 22 16 W

Members of Atlanta's Jewish community first purchased land in Oakland Cemetery in 1878 and then acquired more land in 1892. Later, in 1892, a large section of the Jewish plots was sold to the Ahavath Achim Congregation, whose members were primarily of Eastern European descent. Many of the gravestones are topped with pebbles, a Jewish tradition to note that someone visited the grave. There is also a small section of graves for members of the Kadish Society, a mutual benefit society that, among other things, provided sick benefits and burial plots.

Jewish Section

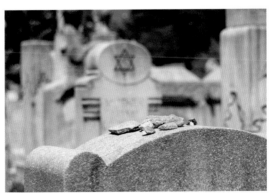

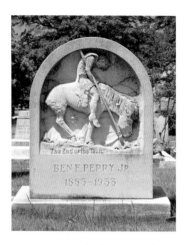

BEN F. PERRY JR.
1883-1933 🕸 33 44 52 N 84 22 25 W
This homage to James Earle Fraser's famous *End of the Trail* sculpture marks the end of the trail of Ben F. Perry Jr. Fraser's most widely circulated work was the Buffalo nickel, which he created in 1913.

JASPER "JACK" NEWTON SMITH
1833-1918 🕸 33 44 52 N 84 22 29 W
Much can be said about Jasper "Jack" Newton Smith, who died in 1918 at the ripe old age of eighty-five. He owned a brickyard, was a real estate developer,

Ben F. Perry Jr.

built a men-only apartment house named the Bachelor's Domain, and had a noted aversion to ties. The story goes that when he had his portrait painted, the painter adorned him with a tie, figuring that Jack just didn't want to wear one for the sitting.

Jasper "Jack" Newton Smith

Jack had a fit and had the painter execute a new tie-less one. When it came time to build his mausoleum, Smith personally supervised the construc-

tion and kept a keen eye on sculptor C. C. Crouch to make sure the seated statue did not sport a tie. The mausoleum is just to the left of the cemetery entrance, and Jasper "Jack" Newton Smith is positioned in such a way that he can view visitors as they come and go.

NEAL MONUMENT
33 44 51 N 84 22 23 W
The Neal monument is awash with symbolism. The circular shape of the wreath can mean immortality (doubly so if it is laurel). Palm fronds are a symbol of victory and, in funerary art, victory over death. An open book can be compared to the human heart, its thoughts and feelings open to the world and God (and also a favorite device to record the names and birth/death dates). A closed book represents a life completed and can also represent the Bible. The entire assemblage is backed by an imposing Celtic cross. Of the dozens of varieties of crosses, the Celtic cross is most intensely associated with a person's roots. A vast array of sizes and styles of Celtic crosses adorn the graves of Irish and Scottish families. In fact, most Scots have a cross that is particular to their clan. The basic form is a cross enclosed in a circle (nimbus). The crosses are often adorned with a variety of symbols.

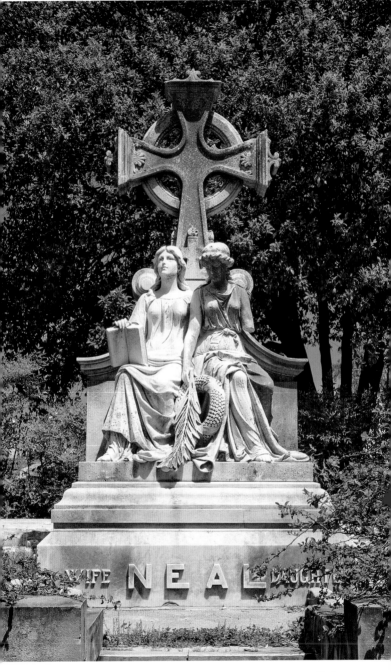

Neal
Monument

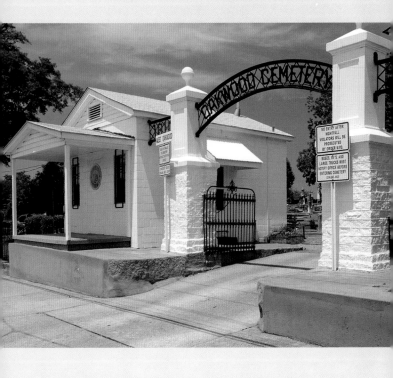

OAKWOOD CEMETERY
MONTGOMERY, ALABAMA
Maps available in cemetery office
32 22 57 N 86 17 49 W

The beginnings of Oakwood Cemetery can be traced to the original City Cemetery that was begun in 1817 from lands donated by Andrew Dexter and by General John Scott in 1818. Dexter and Scott had both founded villages that eventually grew together to become Montgomery, Alabama. The cemetery was originally called Scott's Free Burying Ground. Although new burials do occur from time to time, all of the available lots in the 140-acre cemetery have been sold. Oakwood is a rather egalitarian cemetery.

Spending all eternity along with its notable citizens, statesmen, and war heroes are an assortment of ordinary citizens, criminals who met their end dangling from a rope, and unknowns. The City of Montgomery tends to the cemetery as well as four adjoining cemeteries. The Oakwood Cemetery Complex consists of Oakwood Cemetery, Oakwood Cemetery Annex, St. Margaret's Catholic Cemetery, Eternal Rest Jewish Cemetery, and the Land of Peace Jewish Cemetery. Oakwood's most visited resident is singer and songwriter Hank Williams. His imposing grave is in Oakwood Annex.

Many of the earliest graves at Oakwood were ringed with bottles containing water, a nod to the European superstition that water should be available for the dead.

HIRAM "HANK" KING WILLIAMS
September 17, 1923-January 1, 1953 32 23 07 N 86 17 27 W (grave)
Oakwood Cemetery Annex 32 22 59 N 86 17 28 W (cemetery annex entrance)

Hiram "Hank" King Williams

Hank Williams had the perfect attribute to become a country music icon: a tormented soul. He was born in Mount Olive West, Alabama, the second child of Elonzo "Lon" and Lillie Williams. He was a small and frail child with undiagnosed spina bifida, a painful back condition of which self-treatment was at least partly responsible for his drug and alcohol dependency. Hank's father spent most of Hank's youth in a veterans' hospital because of a brain aneurysm that resulted in partial paralysis. Hank's mother worked a series of jobs to keep the family afloat. In 1932, his mother moved the family to Fountain, Alabama. While there, the ten-year-old Hank learned

to play guitar from his Aunt Alice McNeil and (some say) learned to drink whisky from his sixteen-year-old cousin J. C. McNeil. After a year in Fountain, the family moved to Georgiana where Hank met black blues-musician Rufus "Tee-Tot" Payne. Tee-Tot had a major influence on Williams' distinctive style.

By the late 1930s, Williams had formed a band named the Drifting Cowboys. It traveled all over southern Alabama and the Florida panhandle. Before long, the Drifting Cowboys, under the management of Lillie Williams, was getting a lot of attention. Unfortunately, some of that attention came from Hank's drinking and unreliability. Around that time, he met his idol, Grand Ole Opry star Roy Acuff, who concisely accessed Hank's talent and drinking when he told Hank, "You've got a million-dollar voice[,] son, but a ten-cent brain." In 1943, Williams met Audrey Sheppard, and they were married in 1944. Shortly thereafter, Audrey became his manager and thus began a long battle with former manager and mother, Lillie. Already a local celebrity, in 1948 he recorded "Move It on Over," which became a massive Country hit. In 1949, he released his version of Rex Griffin's song "Lovesick Blues," which became a crossover hit, and Hank Williams was launched onto the national stage.

Unfortunately, despite his success, Hank's drinking kept increasing, so much so that Audrey filed for divorce. Records are a bit sketchy, but it appears that the divorce was granted in 1948 and then the couple reconciled and remarried in 1949. Hank then began to record more gospel-oriented songs under the name of Luke the Drifter. These religious-oriented songs, such as "I Saw the Light," were a hit, but Audrey and Hank's marriage continued to skid downhill. In 1952, Audrey filed for divorce again, and this time they remained divorced. On October 18, 1952, he married Billie Jean Jones Eshliman and also had a love affair with Bobby Jett that produced a daughter, Jett, who was born after Hank died. (Jett records under the name Jett Williams.) Still, he continued to roll out more songs, including "You're Gonna Change (Or I'm Gonna Leave)," "Why Don't You Love Me," "Cold, Cold Heart" and his posthumously released hits "Your Cheatin' Heart," "Take These Chains from My Heart," and the apocryphal hit "I'll Never Get Out of This World Alive."

Hank Williams died of an apparent heart attack (probably induced by morphine) early on New Year's Day 1953. The monument at Oakwood Annex was unveiled in April 1954. Over 30,000 people attended the ceremony that was held at Patterson Field across the street. Audrey Williams died on November 4, 1975, at age fifty-two. She was also a victim of alcoholism. Her monument was erected a few years after her death.

JOHN SCHOCKLER
1811-1855 ❧ **32 22 57 N 86 17 52 W**

One of the most evocative and mournful graves at Oakwood is that of John Schockler. It appears that he did not heed the warnings about the dangers of the nearby Alabama River. He drowned in its waters on May 27, 1855. His tombstone is shaped

like a wave, and his epitaph, a warning to others, is carved on the top:

Stop as you pass by my grave here. I John Schockler. R EX rest my remains, I was born in New Orleans on the 22nd of Nov. 1811, was brought up by friends: not taking their advice, was drowned in this City in the Ala. River the 27th of May 1855. Now I warn all young and old to beware of the dangers of this River, see how I am fixed in this watery Grave. I have got but two friends to mourn.

John Schockler

GOVERNOR WILLIAM CALVIN OATES

1833–1910 ∞ 32 23 06 N 86 17 38 W

If the statue hadn't been so well executed, it would appear that the right hand of Alabama Governor William Calvin Oates had been lopped off by a vandal. In fact, Oates' right arm had been shattered by a minié ball at Petersburg in August 1864, and his entire arm had to be amputated. Oates was born into a poor Alabama family, but thanks to a scrappy personality (he was a gambler and ladies' man, and seemed prone to getting

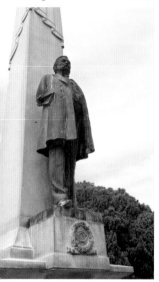

into fistfights), he rose to prominence. After wandering around Texas in his youth, he turned his life around and became a lawyer. When the war broke out, he served as a colonel in Alabama's 15th Regiment. After the war, he went back to practicing law and then served as a legislator, as a congressman, and eventually as a governor of Alabama from 1894 to 1896. When he died on September 9, 1910, one Birmingham newspaper reporter wrote, "A great figure in our history has passed, for he made his record on the battlefield, in the capitol

Governor William Calvin Oates

at Washington and in the historic state capitol in Montgomery." Another newspaper obituary simply said, "He was full of pluck!"

HILL MONUMENT

Multiple Burials ∞ 32 23 00 N 86 17 49 W

Scarlet fever, a serious childhood illness, is often referred to in nineteenth-century literature; by the twentieth century, antibiotic treatments made it less threatening. During a scarlet fever epidemic in 1856, Luther Hill's wife, Mary, and a few of

their children succumbed to
the disease. The names of
all the children are inscribed
on lower panels of the gothic
monument. Mary's epitaph reads,

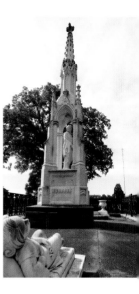

A nobler, woman never lived on earth:
A purer, could not die.
Heaven alone to such gives birth:
It claimed its own. She is now on high.

And on another face,

Here Mary sleeps, her children too:
And must I say to them adieu
No, no dear savior they are thine
Oh: let them be for ever mine.

*Hill
Monument*

CONFEDERATE SECTION
Multiple Burials &c 32 23 03 N 86 17 47 W

Many Confed-
erate soldiers are
buried in private
plots in Oakwood
and still more are
buried in the spe-
cial Confederate
section. Approxi-
mately 750
burials were
those who died
in Montgomery's
Confederate
hospitals. Many

*Confederate
Section*

of the graves are marked Unknown and are denoted by a number.
The original carvings on many of the marble tombstones have
become unreadable and a number were replaced in 1980.

GRAND ARMY OF THE REPUBLIC (GAR) SECTION
Multiple Burials &c 32 23 08 N 86 17 43 W

A rather imposing monument marks the GAR section for
Union soldiers buried here and elsewhere in the cemetery.
The monument lists the names of seven Union soldiers and
also notes eighteen unknown Union soldiers buried here.
On the other faces of the monuments, the names of other
Union soldiers who are buried in Oakwood and St. Margaret's
Catholic Cemetery are recorded. Six of the soldiers are buried
in the original Scott's Free Burial Ground. The location of
their graves denoted in the number of feet north and west of
the cemetery's main gate is inscribed on the monument.

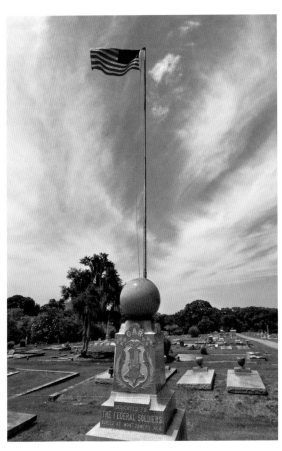

Grand Army of the Republic (GAR) Section

Unlike such Confederate organizations as the Sons of Confederate Veterans or the Daughters of the Confederacy that still thrive today, the GAR was a self-extinguishing organization. It was only open to those who served in the Union military in the Civil War. The GAR's last member, Albert Woolson, died in 1956 at the age of 109.

John Gindrat

JOHN GINDRAT
1777-1851 32 23 03 N 86 17 52 W

The use of cast iron in the decorative arts was all the rage in the middle of the nineteenth century. Unlike marble or granite, cast iron could easily be duplicated. Unfortunately, in cemeteries where maintenance could not be counted on, once family members moved away, unprotected cast-iron deteriorates and oxidizes rapidly. This cast-iron monument marks the final resting place of John Gindrat, who was a banker and a member of the board of directors of the Montgomery and Chattahoochee Railroad Company. The square and compass emblem denotes that he was a Freemason.

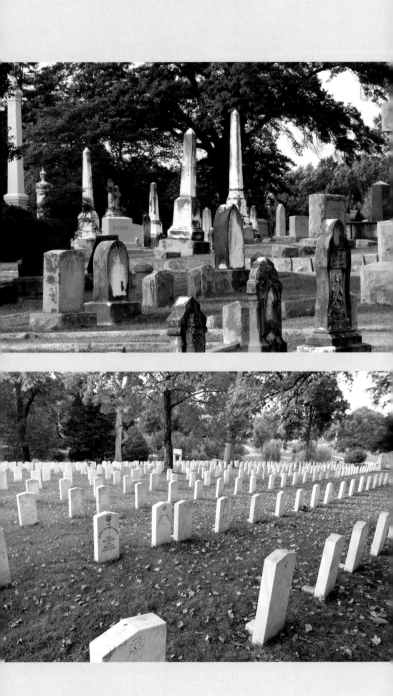

OAKWOOD CEMETERY
RALEIGH, NORTH CAROLINA

Maps available in office
www.historicoakwoodcemetery.com
35 47 05 N 78 37 45 W

Oakwood Cemetery was established in 1869 by the Raleigh Cemetery Association on land acquired from Henry Mordecai. The land was part of a larger tract of pines and native oaks known as Mordecai's Grove. Mordecai was appointed the first cemetery superintendent and was also given the task of naming the cemetery, which he called Oakwood. Oakwood adjoined and later annexed Raleigh's 2.5-acre Confederate Cemetery, which was established two years earlier. Over the years, the Cemetery Association has acquired additional land to its present size of 102 acres. Unlike many historic cemeteries, Oakwood still has plenty of land to accommodate burials for decades to come. Early on, the cemetery's officers enacted a perpetual care program and set aside a portion of the plot purchase price to be placed in an endowment that funds the ongoing care and maintenance of the cemetery grounds.

BERRIEN KINNARD UPSHAW
[AKA RHETT BUTLER]

March 10, 1901-January 13, 1949 ⚰ 35 47 07 N 78 37 25 W

Berrien Upshaw was, by all accounts, a rascal. Not much is known about Upshaw's early life except that he was the oldest of five sons and two daughters of the Upshaw family of Raleigh. Apparently Upshaw found that making a living gambling, scheming, and doing less than legal activities such as bootlegging suited him. In the early 1920s, he met a headstrong flapper named Margaret Mitchell (see page 86). Her rebellious nature and Upshaw's marginal lifestyle combined to make a torrid, if impractical, relationship. The couple married on September 2, 1922, much to the distress of Mitchell's family. The union was stormy, volatile, and fraught with problems and bickering from the start. Upshaw's unpredictable income eventually forced Mitchell into getting a job at the *Atlanta Journal Sunday Magazine*, where she earned a small but steady income. While

Berrien
Kinnard
Upshaw

at the paper, Mitchell renewed a friendship and then started a surreptitious courtship with editor John Marsh, who she later married. In October 1924, Mitchell and Upshaw divorced.

In 1926, Mitchell started picking away at a story about the Civil War. One of the central characters was a lovable gunrunning scallywag named Rhett Butler. Those familiar with the Upshaw-Mitchell relationship knew that the Rhett Butler character was based on Berrien Upshaw.

Little is known about Upshaw's life from his divorce from Mitchell to his death in 1949, except that he apparently continued gambling while working as a ship's fireman. What is known for sure is that he died on January 13, 1949, after plummeting five floors from the Alvin Hotel in Galveston, Texas. The coroner ruled that his death was an apparent suicide. Berrien Kinnard Upshaw's body was returned to his hometown of Raleigh on January 15 and buried in Oakwood. His marker is quite small and a bit hard to find. All things considered, he probably doesn't give a damn.

MADELINE JANE JONES PROCTOR
January 10, 1894–May 7, 1975 &c 35 47 06 N 78 37 27 W

While Madeline Jane Jones was living in Grafton, West Virginia, she accompanied her friend Anna Jarvis to Madeline's hometown

Madeline Jane Jones Proctor

of Philadelphia one Saturday in May to distribute carnations. The duo brought a washtub full of red and white carnations and were charged with the mission of standing on a street corner and giving the carnations away. Jones and Jarvis told the recipients of the carnations to wear a red one if their mother was living or a white one if she was not. They also told the recipients to write a letter to their mothers. Jarvis was actually carrying on the work of her mother, Anna Reese Jarvis, who had been campaigning for years for a Mother's Day to be established. Jarvis and Jones took their mother-honoring mission all over the country, with stops in New York, Los Angeles, San Francisco, Atlanta, and Chicago. Their floral enterprise got the press they had hoped for, and in 1914, President Woodrow Wilson declared Mother's Day a national holiday.

Her mission accomplished, Madeline Jones married noted Raleigh obstetrics pioneer Dr. Ivan M. Proctor. She eventually had four children and became the grandmother to sixteen. Her first child, a boy, was given the middle name Jarvis, a homage to Anna Jarvis. When it looked like the birth of her second child, a girl, was going to be close to Mother's Day, Madeline later confessed that she took a large dose of castor oil to induce labor, and the child was born on Mother's Day.

Although Anna Jarvis is officially listed as the founder of Mother's Day, the title rightly goes to both women.

HOOD PRIKRYL MONUMENT

Ouida Estelle Emery Hood 🕸 September 19, 1883-February 27, 1930
35 47 06 N 78 37 27 W
Franklin Stanley Prikryl 🕸 May 4, 1886-July 17, 1962
(buried at Forest Lawn Memorial Park, Glendale, California)

There isn't anything quite as tragic as unrequited love. Such
was the fate of Franklin Stanley Prikryl and Ouida Hood. Ouida
Estelle Emery Hood was by all accounts a beautiful Southern
Belle. She had many suitors and ultimately chose Wallace
Hood, a native North Carolinian who worked in Michigan as
an automobile designer. The Hoods spent most of their time
in Raleigh. In the 1910s, there was a military base near Raleigh
that prepared soldiers for duty in World War I. Stationed at the
base was a man named Stanley Prikryl, who was a successful real
estate developer from Michigan. The Hoods and Prikryl struck
up a friendship and, ultimately, Prikryl offered Wallace Hood a
job if Ouida and Wallace would move to Michigan. After the war,
the Hoods moved to Detroit and, after a couple years, moved to
the smaller, more rural community of Frenchtown, Michigan.

Eventually, with the backing of investors, Wallace Hood
established the Hood Truck Company. All was seemingly well
except for one unusual aspect of the Hood-Prikryl relationship:

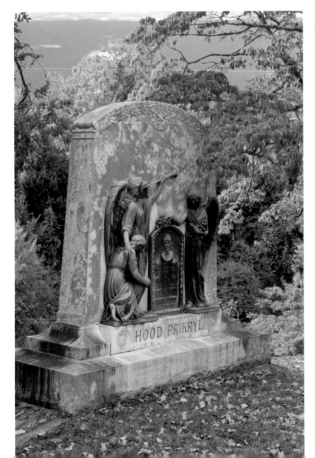

*Hood Prikryl
Monument*

all three of them lived together. Little is known about the nature of the relationship except that one day, Wallace Hood left and was never heard from again. However, before he left, he deeded the Hood house to Ouida. Prikryl continued to live in Ouida's house, and as time went on, they were seen more and more together, especially at social functions organized by Ouida. Then one day in 1930, Ouida suffered an intense nosebleed (the first she ever had), and then suffered another a couple days later that unfortunately proved fatal.

Prikryl was devastated by Ouida's death and laid plans for an elaborate monument to be erected in her honor in her native Raleigh, plans that would also include space for his name on the monument and a place beside her in the plot. The monument cost a tidy $75,000, a large sum in those Depression-era times. Much of the cost of the monument came from funds realized from the sale of Ouida's house (which she had willed to Prikryl). He even paid to have eighty barrels of dirt from Michigan sent to Raleigh so Ouida could be buried in Michigan soil. Thanks to Prikryl's preparations, he was assured he would spend eternity with Ouida. Apparently his resolve softened over the years. He moved to Los Angeles and spent his final years with his sister. When death seemed near, he told his sister that he wanted to be buried in Los Angeles and didn't want to even talk about his pre-existing plot in Raleigh. Despite the best intentions and preparations, Stanley and Ouida are spending eternity 3,000 miles apart. Stanley Prikryl did pen a heartwarming epitaph for Ouida:

To the great glory of God
And in loving memory of a true daughter of the old north state
Ouida Estelle Emery Hood
Born Raleigh, N.C. Sept. 19th 1883
Died Monroe, Mich. Feb. 27th 1930.
A magnificent and wonderful woman of noble deeds and high
attainment, and devoted Christian; trusting in God's goodness and
mercy, whose life was dedicated to untiring service to humanity.
Her memory will endure as a priceless heritage.
Patient, cheerful, and unselfish. A faithful, true, and admirable friend;
a loving companion. A lover of her country, courageous and unafraid;
through her did all my achievements come; to God I owe all.
Placing my trust in God I wait; setting my face to the dawn of that
new day when the shadows will lift and we shall be again united.
Franklin S. Prikryl

BAUER MONUMENT
Rachel B. Bauer &? 1871-1897
Adolphus Gustavus Bauer &? 1858-1898
35 47 08 N 78 37 34 W

Architect A. G. Bauer designed this unusual monument for his wife, Rachel. He was the chief draftsman and principal assistant to Samuel Sloan, who designed North Carolina's executive mansion in Raleigh. In the 1890s, he became an architect in his own right and designed a number of buildings, including

the Western School for the Deaf and
Dumb in Morganton, North Carolina,
and the Park Hotel, Pullen Building,
and Baptist Female University in
Raleigh. One of his last designs
was this monument to Rachel.

BARTHOLOMEW F. MOORE

January 29, 1801–November 27,
1878 ❧ 35 47 10 N 78 37 31 W
Bartholomew F. Moore is buried
beneath this aedicule-like Gothic
monument in the State lot. Known
as the father of the North Carolina
Bar, Moore served as North Carolina
attorney general and as a legislator.
His epitaph reads as follows:

Citizen: Lawyer: Statesman:
To Himself. His Family and His Country.
He was true. To evade a duty, was to him impossible. In the discharge of
duty, he was dilligent [sic] Difficulty intensified his effort. Danger rendered
his resolution more firm. A devoted son of North-Carolina. A never
failing friend and liberal benefactor to her interests. An uncompromising
foe to oppression. A profound jurist and a fearless patriot.

Bauer
Monument

Bartholomew
F. Moore

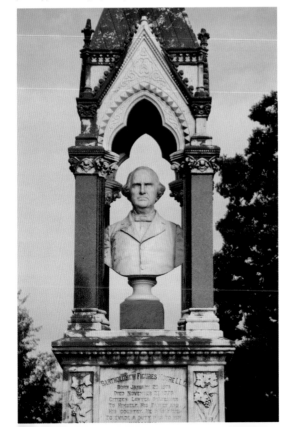

WADE EDWARDS
July 18, 1979–April 4, 1996 ❧❧ 35 47 13 N 78 37 35 W

Oakwood is still a very active cemetery with enough space to accommodate decades of burials. This unique 10-foot-tall marble sculpture depicts an angel cradling the face of Wade Edwards, who died when the Jeep he was driving overturned. Wade Edwards was the son of John Edwards and his wife, Elizabeth. (John Edwards, who was a U.S. senator, ran for vice president of the United States on the Democratic ticket in 2004.) In front of the monument is a bench that reads:

The grace of his written word eclipsed only by the purity of his heart, the honor in his conduct and the sound of his laughter.

Wade Edwards

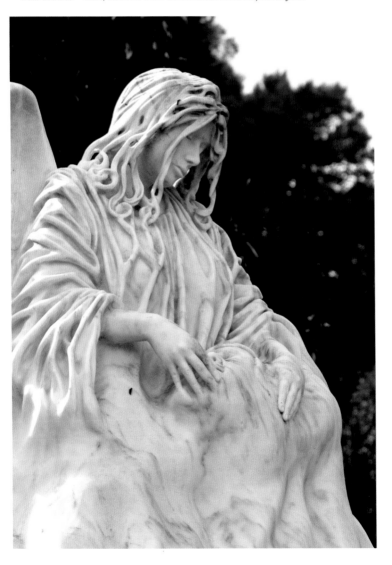

*Confederate
Section*

CONFEDERATE SECTION AND
HOUSE OF MEMORY
35 47 07 N 78 37 40 W

During the Civil War, both Union and Confederate soldiers
were buried in a cemetery on Rock Quarry Road in Raleigh.
In the winter of 1867, Union officials declared the cemetery
to be the official Federal cemetery and ordered all of the
Confederate soldiers removed or their bodies would be dug
up and placed on the public road. Raleigh's citizens rallied and
removed the bodies of 447 soldiers to a tract of land known
as Oak Grove. In 1869, the 2.5-acre cemetery became part of
Oakwood. There are now approximately 1,500 Confederate
soldiers buried in the Confederate section of Oakwood.

The Gothic Revival House of Memory was erected in
1935. Although built to honor soldiers who served in all
wars, it has a clear Civil War slant. Inside the structure,
there are a number of plaques and benches. Three
of the benches are inscribed with these words:

*'Tis the Cause
That is Glorious
Not the Fate of the Cause*

HELMS PLOT
Jesse Helms ❧ October 18, 1921–
Dorothy Jane Coble Helms ❧ March 25, 1919–

It never hurts to plan ahead when commissioning a monument. *Helms Plot*

You'll always know
where you'll be spend-
ing eternity. This is the
future burial site of
the irascible, longtime
North Carolina
senator Jesse Helms
and his wife, Dorothy
Jane Coble Helms.

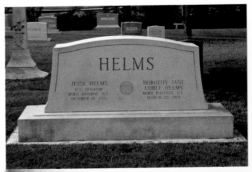

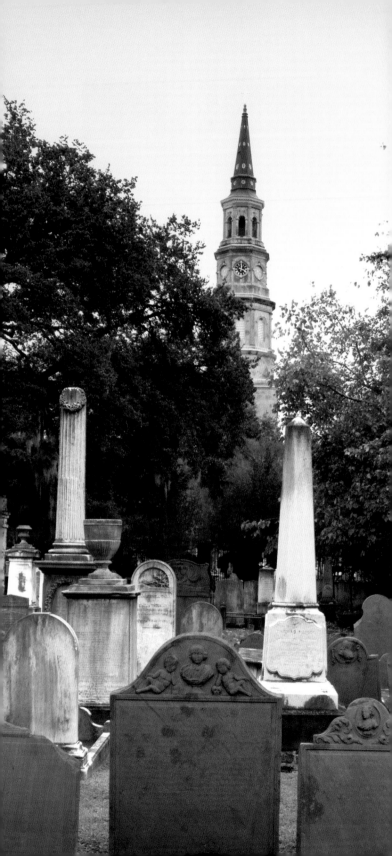

CHARLESTON CHURCHYARDS
CHARLESTON, SOUTH CAROLINA

Charleston has a long, rich history in its churchyard cemeteries that is well documented. In 1663, King Charles II of England granted land and settlement rights to an area known as "Carolina in America" to eight members of British royalty. Those eight became the colony's Royal Proprietors. Six years later in 1669, three ships set sail from England with English and Irish colonists bound for Carolina. Two of the three ships were lost in a hurricane, but survivors piled into the third ship, the *Carolina*, and completed the journey. The first settlement was established the following year, and then in 1679, the city of Charles Town—in honor of King Charles—was established on the present site of Charleston.

The first graveyards in Charles Town were ramshackle affairs that used wooden markers, none of which has survived. But by the end of the 1600s, more durable gravestones started to appear. The earliest examples, usually carved from slate, were imported mostly from New England, but a few came from as far away as Europe. All through the next century, prosperous Charleston residents imported a variety of gravestones. The easiest eighteenth-century motifs to identify are the varieties of death's heads and soul effigy gravestones. Death's heads are a skull with wings, while soul effigies have a human face with wings. When surveying early churchyards in New England, one can roughly approximate the age of a gravestone by looking at the evolution of the death's head. Before the development of the death's head, gravestones often had a skull and crossbones or a skeleton; next was the death's head followed by the soul effigy, and, finally, in modern cemeteries we see a cherub's head with wings. The evolution of the death's head roughly corresponds to the waning influence of the Puritans. The more influence the Puritans had on a community, the more grim one's outlook on death and the afterlife was reflected on the gravestones—hence, the skull and crossbones when the Puritan influence was at its height. As the Puritan influence began to wane, the skull sprouted wings, which suggested the presence of a soul. Then the skull was replaced by a human face as society's attitudes about the afterlife changed. By the early nineteenth century, death was seen as merely part of the journey of the soul, and all the grim images of death were replaced with more romantic ones such as the winged cherub. However, in Charleston's churchyards, the skull and crossbones, death's heads, and soul effigies were freely mingled. The strict Puritan faith had little influence on the more religiously liberal Charleston citizens. After all, King Charles I was beheaded by the Puritans in 1649 and that left a bad taste for Puritans by Charleston's citizens. The design of the gravestones in Charleston's churchyards had more to do with how much money one wanted to spend and with their artistic sensibilities than with their religious beliefs. In fact, many of the

Facing:
Circular
Congregational
Churchyard

gravestones executed by carvers in Massachusetts and Rhode Island and imported to Charleston are more finely detailed than their New England counterparts, suggesting that Charleston's upper crust was willing to spend more for quality stone carving.

The churchyards of Charleston also have a number of box tombs, standard tablet markers, and even a couple of mausoleums. Despite their compact size, the churchyards still see modern burials now and then. It seems that spending eternity with the founders of Charleston still has an enduring appeal.

There are ten churchyards within Charleston's historic district, and all of them have their own distinctive appeal. Scholars have designated the Circular Congregational Churchyard as "the richest depository of eighteenth century iconic gravestones in the country." St Philip's Churchyard contains a host of early political figures, including two signers of the Declaration of Independence. St. Michael's Episcopal Churchyard has one of the original architects and signers of the United States Constitution. The Unitarian Churchyard is left purposely overgrown and has the feel of an urban wilderness. The First (Scots) Presbyterian Churchyard has a unique sandstone gravestone. The Baptist (oldest in the South), Jewish, and Roman Catholic graveyards all have symbols unique to those religions.

Except for the Jewish graveyard, addresses and coordinates are for church offices, which are in close proximity to their graveyards.

St. Philip's Church (Anglican)
142 Church Street
Contains East and West Churchyards
www.stphilipschurchsc.org
32 46 43 N 79 55 45 W

Circular Congregational Church
150 Meeting Street
www.circularchurch.org
32 46 44 N 79 55 52 W

Unitarian Church
4 Archdale Street
www.charlestonuu.org
32 46 40 N 79 56 04 W

St. John's Lutheran Church
5 Clifford Street
www.stjohnscharleston.org
32 46 45 N 79 55 59 W

French Huguenot (Protestant) Church
44 Queen Street
www.frenchhuguenotchurch.org
32 46 42 N 79 55 47 W

First Baptist Church
48 Meeting Street
www.fbcharleston.org
32 46 25 N 79 55 50 W

First (Scots) Presbyterian
53 Meeting Street
www.first-scots.org
32 46 27 N 79 55 50 W

St. Michael's Episcopal Church
71 Broad Street
www.stmichaelschurch.net
32 46 35 N 79 55 50 W

St. Mary of the Annunciation
Catholic Church
89 Hasell Street
www.catholic-doc.org
32 46 55 N 79 55 57 W

Kahal Kadosh Beth Elohim Temple
86 Hasell Street (office)
189 Coming Street (graveyard)
32 47 23 N 79 56 34 W (graveyard)

St. Philip's Churchyard &

In St. Philip's Churchyard, damaged tombstones have been cleverly given a new life by incorporating them into a walkway and affixing them to one of the church's walls.

St. Philip's Churchyard

EDWARD RUTLEDGE
November 23, 1749–January 23, 1800
St. Philip's Churchyard

At age twenty-six, Edward Rutledge is credited as the youngest signer of the Declaration of Independence. After the signing, Edward returned home to South Carolina to help defend his state. In the spring of 1780, the British captured him during the siege of Charleston. He was a prisoner of war in Florida for one year. After the war, he served in the South Carolina state legislature and as governor of South Carolina (1798–1800). When George Washington died on December 14, 1799, the news of his death so upset Governor Rutledge that he suffered a stroke and died.

Edward Rutledge

CHARLES PINCKNEY
October 26, 1757–October 29, 1824
St. Philip's Churchyard

Charles Pinckney was one of the signers of the U.S. Constitution. He also served as U.S. senator (1798–1801), minister to Spain (1801–1805), congressman (1819–1821), and governor of South Carolina (1789–1791; 1791–1792; 1796–1798; 1806–1808). Many historians credit Pinckney with fighting to make sure citizens' religious liberties would be protected by the Constitution.

Charles
Pinckney

JOHN CALDWELL CALHOUN
March 18, 1782–March 31, 1850 &c: **St. Philip's West Churchyard**

John Caldwell Calhoun was the seventh U.S. vice president, U.S. congressman, U.S. senator, secretary of war, and secretary of state. He was one of the earliest and strongest proponents of secession from the Union and resigned his position as vice president under Andrew Jackson to serve as a U.S. senator (where he had more power) to lead the fight for secession. In order to be buried in the East Churchyard next to the church, one must have been born in Charleston; consequently, Calhoun is buried in St. Philip's West Churchyard. His wife, who was born in Charleston, is buried in St. Philip's East Churchyard.

Circular Congregational Churchyard &c:

Charleston's oldest cemetery, has about 500 grave markers containing more than 700 names. More than 150 grave markers predate the Revolutionary War. The churchyard contains Charleston's oldest grave, dating from 1675, and a round-top burial vault dating from the 1690s.

 Circular Congregational Churchyard contains an unusually large and well-preserved assortment of death's heads, soul effigies, and portrait gravestones. Much of the quality and diversity

John Caldwell
Calhoun

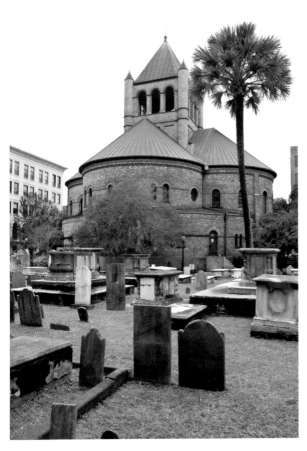

Circular Congregational Churchyard

of the gravestones and grave markers can be attributed to the diversity of the parishioners, who can be roughly lumped together as "dissenters" (those disagreeing with the Church of England). The dissenters, as seen in the Circular Churchyard, consisted of Congregationalists, Presbyterians, French Huguenots, and independent denominations from France, Scotland, and Wales.

Circular Congregational Churchyard

MARTHA PERONNEAU

Ca. 1733–December 14, 1746

An amazingly well-crafted soul effigy graces the gravestone of Martha Peronneau, who, according to her epitaph, was "Daughter of Mr. Henry and Mrs. Elizabeth Peronneau Departed This Life December ye 14th 1746 Aged 13 Years." The quality of the carving, especially the details of the hair, mouth, and dimples, are testament to the relative wealth of the prominent citizens of Charleston who were willing to pay a bit more for quality work. The manufacture of the tombstone has been attributed to Boston carver William Codner.

Martha Peronneau

Unitarian Churchyard &c;

Established in 1774, this churchyard was an offshoot of the Circular Congregational Church. The churchyard is kept in a somewhat bedraggled form resembling an urban wilderness.

Unitarian Churchyard

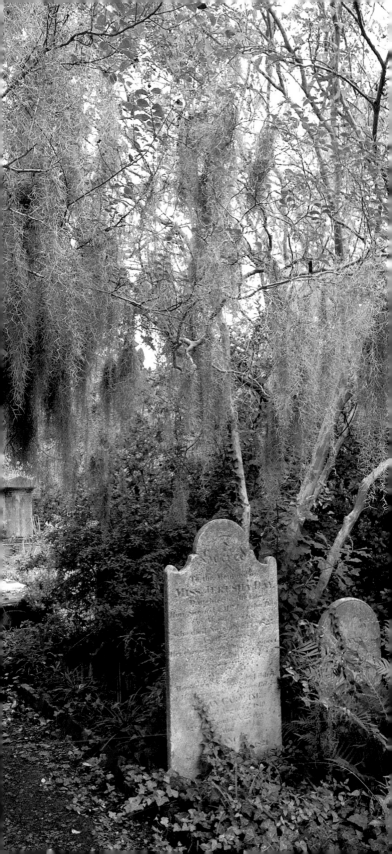

KEY UNDERWOOD COON DOG MEMORIAL GRAVEYARD
NORTHWEST ALABAMA, NEAR TUSCUMBIA

www.coondogcemetery.com
34 37 44 N 87 57 56 W

When people visit cemeteries, they rarely talk to other visitors. Grief over the death of a loved one, it seems, is a private matter. Not so at pet cemeteries. Pet cemetery owners say that when a person sees someone else at a pet cemetery, there is a good chance they'll come up to them and talk, usually sharing stories of the exploits of a favorite pet. Pet cemeteries tend to be fairly egalitarian (and certainly nondenominational). Dogs, cats, canaries, rabbits, and even horses spend all eternity in a postmortem menagerie—except, that is, for one very specialized cemetery. Nestled into a small glen in the Freedom Hills near Tuscumbia, Alabama, is the one-of-a-kind Key Underwood Coon Dog Memorial Graveyard.

Coon dogs (more properly known as coonhounds) are no ordinary breed, as any coon dog owner will tell you. The baying hounds are distinctly American. Their roots can be traced to America's Colonial period when foxhounds were imported for sport foxhunting. Foxhounds were not particularly adept at corralling animals that "went to trees," like raccoons, opossums, cougars, and bears. Hunters then bred the foxhounds with other breeds like bloodhounds and French hounds to develop a breed better adapted to American game and the American style of hunting. Among the most common coonhound breeds are Black and Tan Coonhounds, Redbone Coonhounds and Blue Tick Coonhounds.

The tidy cemetery was established on Labor Day 1937 when coon hunter Key Underwood buried his faithful coon dog Troop. Underwood paid $75 for Troop in 1932, a hefty sum in those Depression-era days. Troop became a legendary coon dog in the Tennessee Valley. He was half Redbone and half Birdsong, and was known to be "cold-nosed," meaning he could follow cold coon tracks until they turned fresh. His hunting skills were legendary, and it wasn't long before Underwood was able to use ol' Troop as a stud dog as well as a hunting dog. When Troop died on September 4, 1937, Underwood put him in a cotton pick sack and buried him in a shady glen that had been used for years as a rendezvous and camping spot for coon hunters all over the Tennessee Valley. It seemed only fitting that Troop should be laid to rest in one of his favorite spots.

Then Underwood used a hammer and screwdriver to etch a tombstone from a large rock salvaged from a nearby chimney. He carved a hole in the tombstone and inserted a picture of Troop. The picture remained for many years but is no longer there. Not long after laying Troop to rest, other coon dog owners asked Underwood if they could bury their deceased hounds alongside Troop. Underwood said yes and the coon dog cemetery was

born. Close to 200 coonhounds have been buried there over the years. The epitaphs carved in their tombstones are every bit as personal as epitaphs in human cemeteries. The Key Underwood Coon Dog Memorial Graveyard (the official name for the cemetery) is administered by the Tennessee Valley Coon Hunters Association. To qualify for burial, the dog's owner must claim their dog is an authentic coon dog, a witness must verify that information, and a member of the Coon Hunters Association must be allowed to view the expired coonhound.

Every Labor Day, the Tennessee Valley Coon Hunters Association hosts an event at the cemetery, which includes music, dancing, and food. Vendors sell such coon dog merchandise as official T-shirts and hats. To get to the Coon Dog Cemetery, go 7 miles west of Tuscumbia on U.S. Hwy 72, turn left on Alabama Hwy 247, proceed for 12 miles, turn right on Coondog Cemetery Road, and travel 3.1 miles to the entrance.

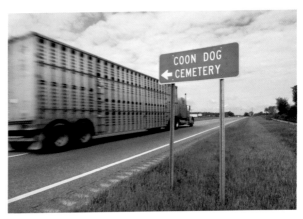

The Key Underwood Coon Dog Memorial Graveyard is one of Tuscumbia, Alabama's top tourist attractions. A re-creation of the cemetery appears in the 2002 movie Sweet Home Alabama, *featuring Reese Witherspoon, Josh Lucas, and Patrick Dempsey. Other Tuscumbia attractions include Helen Keller's birthplace and the Alabama Music Hall of Fame.*

The Coon Dog Cemetery has become so popular that the road leading to it has been renamed the Coondog Cemetery Road.

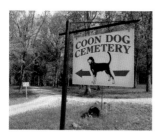

The entrance to the cemetery is 3.1 miles down Coondog Cemetery Road.

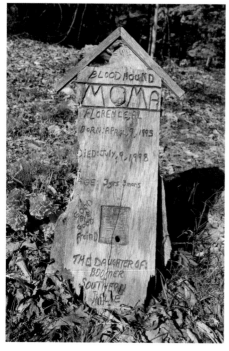

This plaque details the life of Blue Kate, a purebred "PR" (purple ribbon) coon dog, who met her end when she was run over by a car while tracking a raccoon.

The cemetery has a mixture of markers ranging from durable materials like stone and granite to less permanent markers made of pine and plywood. Moma, the "daughter" of Boomer and Southern Belle from Florence, Alabama, had a short tenure in this earthly realm: she only lived for three years and three months.

Despite its relatively small size (less than 200 burials) and remote location, the cemetery gets a lot of visitors. These two men were from the state of Washington; they had been working on a job in nearby Huntsville, Alabama, but took some time off to visit the cemetery before heading home.

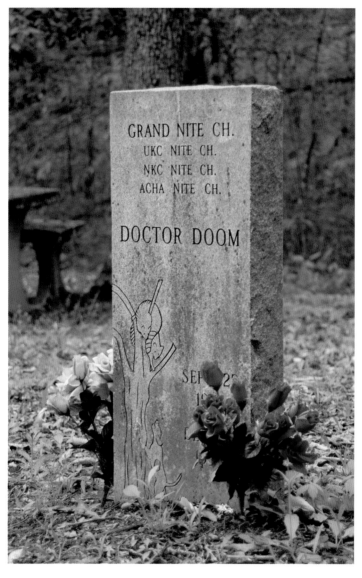

Doctor Doom's (1977–1990) granite tombstone depicts the Doctor treeing two raccoons and features his Nite Hunting championships.

Facing: Tombstones have a finite amount of real estate available to pen epitaphs, birth/death dates, and other information. Thus, tombstone inscribers sometimes have to resort to shorthand, usually by using acronyms to get across their message. The "PR NT" on this tombstone means that a dog with a pedigree that has been confirmed as registered with UKC for a prerequisite number of generations earns the Purple Ribbon Pedigree. "NT Champ" probably means the dog was a Nite Champion, a type of coon hunting competition that is conducted after nightfall. "Posey" is the name of the owner, Dennis Posey. The meaning of "Knat Mt. Tom Tom" is anybody's guess.

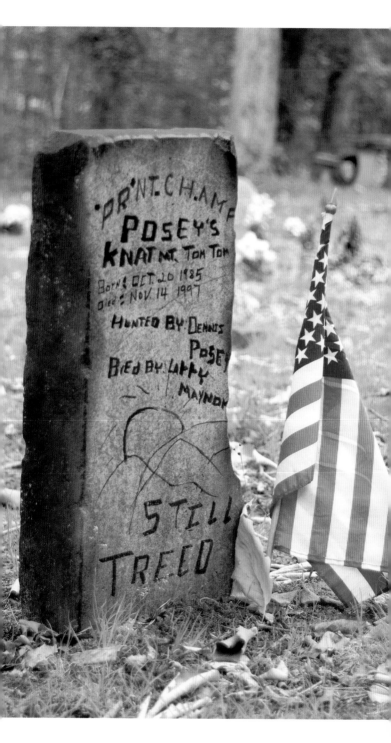

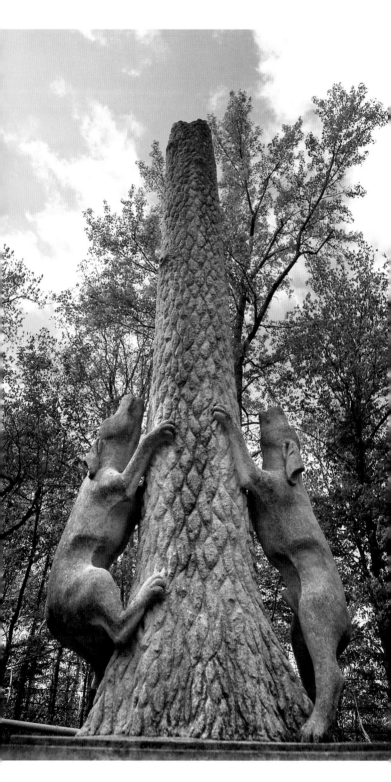

This epitaph, executed by drilling holes in a spade-like wedge of metal, punctuates the idea that man's best friend is the dog:

1976–1989
TRACK
He wasn't the best
But he was the
Best I ever had
Uearl
Devaney

The first interment at the Key Underwood Coon Dog Memorial Graveyard was Troop. Key Underwood carved out Troop's tombstone with a hammer and screwdriver

Just like human cemeteries, some of the tombstones sport photographs of the deceased coon dogs, usually with their owners.

Facing: An elaborate memorial of two coon dogs treeing a raccoon is the centerpiece of the cemetery. Since the cemetery has no security and is located in a little-trafficked area, a rather substantial chain-link fence topped with razor wire surrounds the memorial.

Sometimes dog names are just right for the breed. What name could be better for a baying hound dog than Loud?

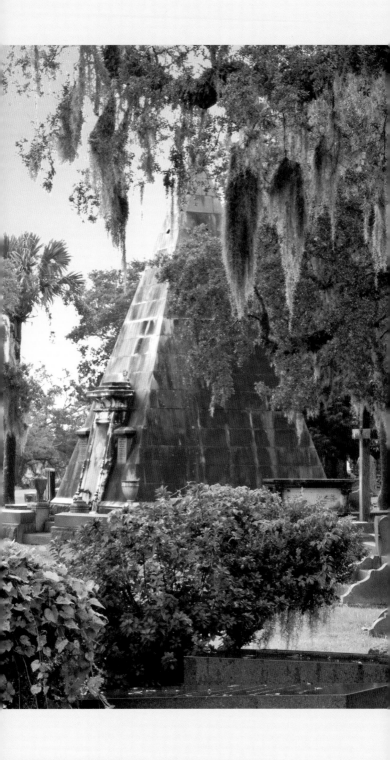

FUNERARY ARCHITECTURE

MAUSOLEUMS AND MONUMENTS

Cemeteries are a vast treasure trove of art and architecture. The fact is, cemeteries are America's most unspoiled resource of historic architecture. It would take many hours of strolling in a city's downtown historic district to find the number of styles of architecture that one can find in a few minutes' walk in most large historic cemeteries.

Most cemetery architecture is a mirror of the urban architecture of the time. Gothic cathedrals, Classical Revival city halls, Art Deco theaters, and rustic cast-iron garden furniture can all find their counterpart in the cemetery. And there are some styles of architecture that can be found only in cemeteries; we'll call this architecture "uniquely funerary."

Up until the Reformation in the sixteenth century, most cemeteries consisted primarily of randomly placed headstones. Wealthy folks purchased their way into being buried within the walls and floors of their church. But a series of edicts and a slow-down of church construction during the Reformation essentially put an end to burial within the church. Moneyed types started looking outside the walls of the church to erect a suitable memorial to themselves and their families. Elaborate statuary, tombs, and monuments slowly began to find their way into formerly stark churchyards and city cemeteries. When garden cemeteries with vast landscaped expanses began to be developed in the early nineteenth century, they became a new architectural frontier for America's architects, artists, designers, and builders.

Although it's hard to put all cemetery architecture in specific categories, most American cemetery architecture can be divided into six broad groups: ancient pagan architecture, such as the tumulus; Egyptian architecture; Classical architecture; Gothic architecture; late-nineteenth and early-twentieth-century architecture, such as Art Nouveau, Art Deco, and modern classicism; and uniquely funerary architecture.

The Tumulus

The tumulus is one of mankind's oldest burial monuments, dating back 4,000 to 5,000 years BC. Examples of tumuli can be seen peppering the landscape all over Western Europe. The foundation of some ancient tumulus-style monuments are assemblages of large rocks known as megaliths. These rock megaliths are not unlike Stonehenge but are smaller in scale. A megalith is transformed into a tumulus with the addition of rubble or earth to form a large imposing mound. At one time, some megaliths seen today were tumuli. Time and erosion have worn away their earth and rubble coverings to reveal their megalithic foundations.

Facing:
Smith/Whaley Mausoleum, Magnolia Cemetery, Charleston, South Carolina

Many large cemeteries will have a tumulus or two. When found in modern American cemeteries, they are often used for members of fraternal societies or military organizations because of their association with warriors. There are also a number of rock assemblages in cemeteries (often

Elks Tumulus, Greenwood Cemetery, New Orleans, Louisiana

containing remains of the members of a fraternal society) that are built in the spirit of the tumulus. These tumulus-like monuments are akin to grottoes, which are miniature cave-like chapels containing small altars and religious statuary. Grottoes are often seen in areas with a large Catholic population.

Egyptian Architecture

While it's debatable if the tumulus can really be called architecture, another tomb style of antiquity, Egyptian, is perhaps the most funerary of all architecture. After all, almost all architecture in ancient Egypt had something to do with death and the afterlife.

American cemeteries have often had a schizophrenic attitude toward Egyptian Revival architecture. While there is no denying that Egyptian Revival architecture is jam-packed with funerary symbolism, its obvious pagan origins have made many a cemetery superintendent bristle at the reaction he might get from the local churchgoing community. Cemetery explorers will find fewer and fewer examples of Egyptian Revival architecture the closer they get to the Bible Belt; thus, it's relatively rare in the South. The best examples can be seen in New Orleans, a city that has a tradition of taking its cultural cues from Europe rather than America.

Egyptian Revival architecture is the easiest architecture to identify, pyramids being the most obvious. Almost every Egyptian Revival tomb is adorned with a pair of vulture wings sprouting from a circle (symbolizing the sun) and flanked by twin cobras

Brunswig Mausoleum, Metairie Cemetery, New Orleans, Louisiana

(symbolizing death). Often a pair of male sphinxes (female sphinxes are Greek) guard the entry to the tomb. Above the entry to the tomb, and usually circling the entire tomb, is an architectural element called a cavetto cornice (flared with curve).

Other hallmarks of Egyptian Revival architecture are the tapered (battered) entry and hieroglyphics. Since Egyptian architecture doesn't make use of the strength of arches or tapering columns, its dimensions are quite massive. To provide strength, the walls of the Egyptian temple-style mausoleums taper in at about 70 degrees.

Kontz Monument, Oakland Cemetery, Atlanta, Georgia

Another very popular form of Egyptian architecture in the cemetery is the obelisk, which is representative of a ray of sunlight. Obelisks were first seen in Egypt during the time of the Old Kingdom, approximately 2650–2134 BC. The earliest excavation of an obelisk, dated around 2500 BC, is at Abu Ghurob. It was a massive, fairly squat pyramidal structure set upon a high plinth and was the focal point of the sun temple. During the time of the Middle Kingdom, approximately 2040–1640 BC, obelisks made of single slabs of Aswan granite became much taller and

slimmer. They were typically erected in pairs in front of selected temples as part of a celebration of a Royal Jubilee. The sides of the obelisk were often inscribed, and the pyramidal top was sheathed in gold to radiate the light of the sun.

To appease the religious community, most designers of Egyptian Revival tombs have added selected Christian symbols in front of or on the tomb to soften the pagan demeanor. Quite often, angels, Jesus, and the Virgin Mary will be found guarding the entrance to these tombs.

Classical Architecture

The most common type of cemetery architecture is Classical Revival. It is easy to identify by its columns and column capitals,

Parks Obelisk, Oakland Cemetery, Atlanta, Georgia

which are classified into "orders," generally recognized as Doric, Tuscan, Ionic, Corinthian, and Composite.

Doric architecture can be divided into Grecian Doric and Roman Doric. The best-known Doric building is the Parthenon, built in Athens around 450 BC. Doric architecture is identified by its tapering fluted columns that rise directly from the base (stylobate) and crowned by plain capitals. Roman Doric columns are also fluted and crowned by plain capitals but have a base. Tuscan architecture is a stripped-down form of Doric architecture. The columns on a Tuscan building are smooth with a notable absence of ornamentation.

Erskine Mausoleum, Maplewood Cemetery, Huntsville, Alabama

Ionic architecture, which was developed around 600 BC, is characterized by relatively slender fluted columns that have a molded base. The column capitals are surmounted by a volute

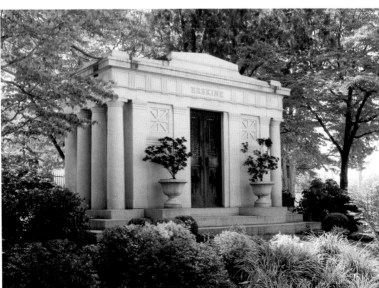

(a spiral scroll-shaped ornament). Architects assign more feminine characteristics to the Ionic form.

The most ornamental of all the orders is Corinthian and its hybrid cousin Composite. The Corinthian order was an Athenian invention from around 500 BC, but it was developed into its full ornamentation by the Romans. In pure examples of Corinthian columns, the column capitals are carved representations of acanthus leaves, one of the plants most often associated with funerary architecture. Its leaves represent overcoming the trials of life and death. Caught up in the allusions to nature in the Corinthian capitals, designers and carvers often added chirping birds, flowers, ferns, and other assorted flora and fauna to the acanthus leaves. When Ionic volutes are added to the design, the capitals officially cross the line from Corinthian to Composite.

Islamic Architecture

Islam originated with the prophet Mohammed, who lived from AD 570 to AD 632. During the next few centuries, Islamic architecture developed gradually. The style has never really died out, and variations of it continue to be used to this day. Developed in Arabia, the architecture spread to North Africa, Spain, India, and much of the rest of Asia. Even though there was not a very large Islamic population when many of America's large mausoleums were built, many fine examples can be found in our cemeteries. Look for onion domes, horseshoe arches, and surfaces adorned with mosaics, carvings, and inlays.

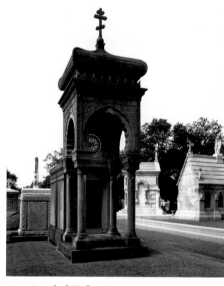

Larendon Mausoleum, Metairie Cemetery, New Orleans, Louisiana

The lobed horseshoe arch of the Larendon mausoleum defines the basic form as Islamic, but the Greek cross topping the tomb is a nod to Byzantine (Christian) architecture.

Byzantine Architecture

Byzantine architecture, which shares many characteristics with Islamic, developed after Constantine established his imperial capital at Byzantium (now Istanbul, Turkey) in AD 330. Since they are Christian, Byzantine churches have a Greek cross as a floor plan. The most famous is the Hagia Sophia, built in what is now Istanbul from AD 532 to AD 537; it is now a mosque. Byzantine architecture usually has flat lacy ornamentation, typically with some sort of a dome. Interiors of mausoleums often have elaborate mosaic tile murals.

Richards Mausoleum, Oakland Cemetery, Atlanta, Georgia

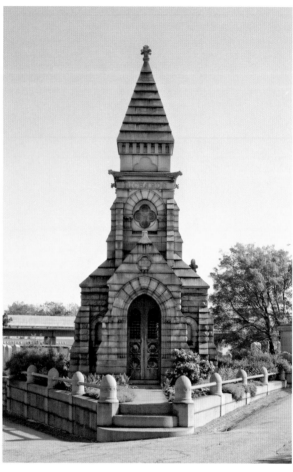

Romanesque Architecture

A few centuries after Byzantine architecture was developed, Romanesque architecture appeared. It is most widely character- ized by rounded arches and intricately carved but judiciously used ornament, which is primarily seen on column capitals, around doors and windows, and on moldings. Near the end of the nineteenth century, American architect Henry Hobson Richardson modified the Romanesque form by using rough rather than smooth stones. This "rusticated" Romanesque architecture, now called Richardsonian Romanesque, has a heavy authoritative look. It was widely used in buildings that demanded respect, such as courthouses, schools, churches, and mausoleums. In the cemetery, many Romanesque structures will have a few Gothic details such as modestly pointed arches.

Gothic Architecture

Perhaps no style of architecture is as closely associated with cemeteries as Gothic. Its towers, spires, and flying buttresses are the stuff of ghost stories, dark and stormy nights, and evil sorcer-

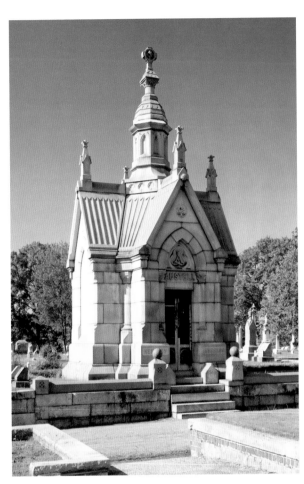

Austell
Mausoleum,
Oakland
Cemetery,
Atlanta,
Georgia

ers. The structural advantages of the Gothic style over other types
of architecture enabled architects and designers to construct
buildings and cathedrals of just about any size their time and
budgets would permit. Because Gothic architecture did not
borrow heavily from any of the pagan Classical styles, it is most
closely associated with Christianity—in fact, it is the first purely
Christian architecture. Gothic architecture is easy to identify by
its vertical emphasis, pointed arches, and heavily ornamented
spires. Funerary architecture in the Gothic style was much more
widely used in the nineteenth century than it is now, simply
because of the significantly higher prices it takes to manufacture
a heavily ornamented Gothic Revival monument or mausoleum.

Venetian Gothic Architecture

Venetian Gothic architecture combines the Gothic lancet arch
with Byzantine and Arab influences. The style originated in
fourteenth-century Venice, Italy, where Byzantine style from
Constantinople was blended with the Arab-influenced style from
Moorish Spain. Venice, understandably, is awash with the style. It

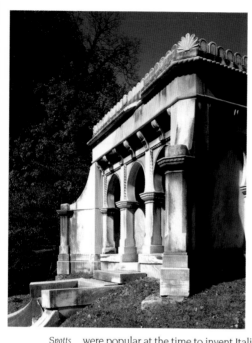

was revived in the nineteenth century, chiefly through the influence of British architectural critic John Ruskin and his three-volume treatise *The Stones of Venice*. Venetian Gothic architecture is relatively rare in American cemeteries; thus, it's always a treat to see.

Italian Renaissance Architecture

During the fifteenth century, Italian architects advocated a return to the Classical styles. They blended Corinthian and Ionic columns, Classic forms, and some of the ornamental styles that

Spotts Mausoleum, Cave Hill Cemetery, Louisville, Kentucky

were popular at the time to invent Italian Renaissance architecture. This new style rapidly took hold and soon spread all over Europe, taking on regional names and mutating to other styles such as German Renaissance and French Renaissance. Unlike today, art and architecture were considered to be essentially the same science. Famous artists like Michelangelo were also trained architects. When they designed the structural elements of a building, paintings and sculpture were included in the overall design. Italian Renaissance architecture was one of the highest achievements in blending art and architecture. Renaissance-style

Cristoforo Colombo Society Mausoleum, Metairie Cemetery, New Orleans, Louisiana

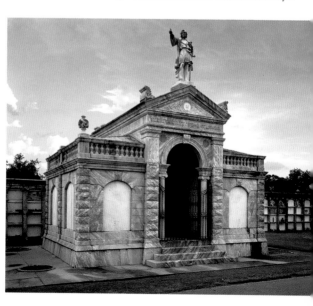

mausoleums and funerary architecture can be identified
by their Classical forms and an abundance of ornament.

Baroque Architecture

By the end of the sixteenth century, Renaissance architecture
gave way to Baroque architecture, which reached its zenith
in the late seventeenth century and was most widely used
in Germany, Spain, and Italy. The most extreme examples of
the Baroque style have a bounty of ornamentation nestled in
flowing forms. More restrained examples of the Baroque style
such as St. Paul's, Christopher Wren's London masterpiece,
were employed by French and British architects. Baroque
architecture in the cemetery is sometimes hard to identify;
some examples lean toward Renaissance architecture while
others lean toward Neoclassical architecture. Look for
mausoleums with an abundance of curves and decoration.

Neoclassical Architecture

By the beginning of the eighteenth century, Western architecture
entered a period that is best described as eclectic. The dominant
architectural styles relied on the classical forms of the past and
are thus termed Neoclassical. But architects of the time often
incorporated elements of other Classical-like styles of architec-
ture. By the nineteenth century, Neoclassicism was the dominant
form. This time period also coincided with the development of
the garden cemetery, and cemetery explorers will find a profusion
of Neoclassical architecture there. Most funerary architecture in
this style is characterized by clean elegant lines and restrained
ornament. By the end of the nineteenth century, the blending
of different Classical
Revival styles of
architecture resulted in
a style of architecture
known as Beaux-Arts.

*Pizzati
Mausoleum,
Metairie
Cemetery,
New Orleans,
Louisiana*

Uniquely Funerary
Hybrid Architecture

Not all architecture
fits into the customary
architectural styles.
Architects often
blended totally
unrelated styles and
sometimes created
styles of their own.
At the end of the
nineteenth century,
modern architecture
was making its first
beginning but not
before an architectural
free-for-all known as

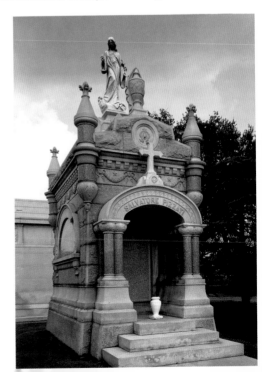

Eclecticism burst upon the scene. Nowhere in this architectural grab bag was this more apparent than in the cemetery. Indeed, many mausoleums and funerary structures are a triumph of form over function. The closest types of architecture that these whimsical structures can be compared to are the "follies" of Victorian architecture. A "folly" is defined by *Penguin's Dictionary of Architecture* as "a costly, but useless structure built to satisfy the whim of some eccentric and thought to show his folly."

Art Nouveau Architecture

Emerging at the end of the nineteenth century from this architectural morass was Art Nouveau. The style had a relatively short run on the scale of world architectural history. The best examples of Art Nouveau, which is described as naturalistic and organic, can be found in European cities such as Paris and Prague and in Buenos Aires, Argentina, where it is sometimes known as the Liberty style.

Harper Mausoleum, Rock Creek Church Yard, Washington, D.C.

But it is quite easy to find a few examples of it in historic cemeteries, since its popularity was in the heyday of the golden age of the mausoleum. At the time, American funerary architects classified almost anything that had a natural look to it as Art Nouveau. Most examples in America look like a rather boxy tomb made of rough-cut stone, while European-influenced examples are quite fluid.

Cambaceres Mausoleum, Recoleta Cemetery, Buenos Aires, Argentina

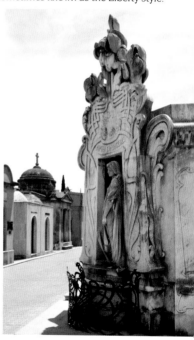

Modern Classicism Architecture

Just as Art Nouveau was gaining a foothold, influential architects advocated a return to Classical architecture. Various forms of Classical Revival architecture exist to this day. Some types almost exactly mirror their two-millennium-old cousins, but most are sleeker, more stripped down. In the cemetery, look for buildings that appear to be scaled-back versions of Classical architecture. There is an absence of or a spartan use of ornament. Columns are modestly scaled or engaged (attached to the structure).

Art Deco Architecture

The Exposition Internationale des Arts Decoratifs et Industriels Modernes, held in Paris in 1925 as a showcase for "new inspiration and real originality," introduced a new architectural and decorative style called Art Deco. This style would soon permeate designs in fabrics, automobiles, appliances, office buildings, and even mausoleums. Architects used a combination of Art Deco and International Style for many mausoleums built in the 1930s.

One of the best places to see intact Art Deco buildings is in Miami Beach, Florida. Art Deco was also wildly popular in Chicago, where examples can be seen in some of the city's cemeteries. Look for mausoleums that have a streamlined look, not the severe lines we associate with modern architecture but the softer lines we think of when we imagine an appliance such as a toaster in a 1930s kitchen.

Jones Mausoleum, Rock Creek Church Yard, Washington, D.C.

Modern Architecture

With the modern age has come a lack of ornament and hard, clean lines. By now, the age of ornament has passed (although, from time to time, a few adventurous architects advocate its return). The range of modern architecture extends from tilt-up concrete buildings to massive glass, steel, and stone structures that look like they belong on a *Star Wars* set. In the cemetery, some of these structures are very utilitarian looking while others seem to be ready to blast off from Earth. Modern manufacturing techniques have made it fairly easy to build mausoleums that

Hollywood Cemetery, Richmond, Virginia

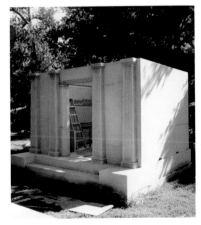

are just about any shape, enabling architects to design some pretty far-out looking structures. With the assistance of lasers, elaborate designs can be etched into the surfaces, but there is usually an absence of external ornament since there are few craftspeople today who can execute such fine work.

SARCOPHAGI, TOMBS, AND MEMORIALS

Cemetery architecture isn't limited to mausoleums. Some of the finest work of renowned American artists and architects can be seen in the form of cemetery tombs, sculptures, and memorials.

Sarcophagi

Besides mausoleums, the most abundant forms of architecture in the cemetery are the various interpretations of one of the oldest funerary monuments—the sarcophagus. The word "sarcophagus" is derived from combining the Greek words *sarco* (flesh) and *phagus* (eater), literally "a flesheater," since the earliest types of these burial vessels, according to ancient scholars Theophrastus and Pliny, were made out of Assius stone from Assos in Asia Minor. Because of its caustic properties, this stone reduced the body to bone in a matter of weeks. In reality, most ancient sarcophagi were used to preserve bodies rather than dissolve them, but the term stuck.

The sarcophagus of Consul Cneius Cornelius Scipio (below) dates from 300 BC.

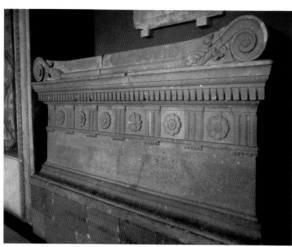

Scipio Sarcophagus, Vatican Museum, Vatican City, Italy

In its simplest and most utilitarian form, the sarcophagus is a container for the body, but unlike a coffin or casket, it is designed to (more or less) last for eternity. It is rare to find a sarcophagus in a cemetery that actually contains a body, because most are ornamental; the body is usually buried in a vault beneath the sarcophagus. Whether the sarcophagus contains a body or not, it looks like it could contain a body. One of the most popular styles of the sarcophagus looks like a heavily decorated claw-foot bathtub with a cover.

Most sarcophagi in cemeteries are made of granite or marble with some notably ornate ones crafted from bronze. Carvers have adapted the sarcophagus as a ready canvas to showcase their talent. Indeed, aside from its need to look like it could house a body, the sarcophagus is really a piece of sculpture. Much of what is included in the broad description of sarcophagi has actually evolved into other forms, and sometimes it's hard to say where the line is between a sarcophagus and an ornamental tomb.

The tomb below is in the style of the Scipio sarcophagus.

Gilmer Sarcophagus, North Laurel Grove Cemetery, Savannah, Georgia

Morse Tomb, The Temple Cemetery, Nashville, Tennessee

Chest Tomb

A chest tomb is the most unencumbered type of sarcophagus-like tomb. It looks like a large trunk or shipping container. The ornament on the tomb looks like it is worked into the tomb rather than applied to it.

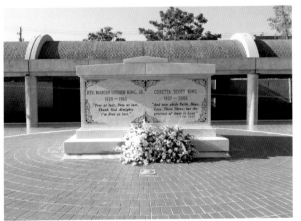

Martin Luther King Jr. Center, Atlanta, Georgia

Altar Tomb

The Temple Cemetery, Nashville, Tennessee

When a chest tomb becomes more ornate and looks like ornament is applied to it, especially on the top, it becomes an altar tomb.

Wall or Oven Vault

St Louis #1 Cemetery, New Orleans, Louisiana

These tombs are found throughout New Orleans and around the Gulf Coast. They serve as both walls and tombs. Contrary to popular opinion, this type of tomb was not originally designed to cope with the high

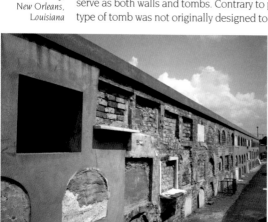

water table but was echoing the aboveground burial style that was popular in Europe at the time. Often they are used for multiple burials (the remains of the previous occupant are pushed to the back or scooped up and sealed in a lead bag).

Barrel Tomb

St. John the Baptist Cemetery, New Orleans, Louisiana

These tombs are rounded on the top. The curved top sometimes extends all the way to the ground.

Bale Tomb

Oakwood Cemetery, Montgomery, Alabama

A hybrid marriage between a barrel tomb and a chest tomb, this tomb looks like a chest tomb with a rounded top. Some say the rounded top, often carved with diagonal grooves,

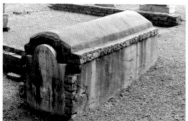

is called a bale because it resembles a bale of wool, while others say that the texture of the grooves is meant to resemble the rumpled cloth of a woolen shroud (in seventeenth-century England, an act was passed

dictating that everyone who died was to be wrapped in a woolen shroud).

Hip Tomb

This tomb takes on the form of a miniature low-slung house. At its simplest, a hip tomb is a rectangular box with a two- or four-sided hip roof applied to the top. Sometimes only the hipped roof is used and the tomb looks like a house with the sides removed. Because of their shape, crosses are often worked into the design.

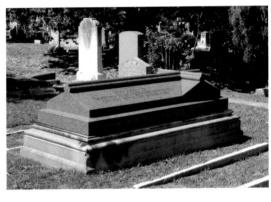

Oakland Cemetery, Atlanta, Georgia

Table Tomb

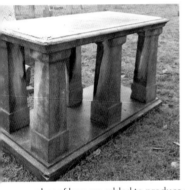

These tombs look like stone tables. It's usually a stone tablet inscribed with the departed's name and is typically supported by six legs. If the stone top is thin, it often becomes bowed, warped, or broken over time. Sometimes a sarcophgus is placed under the table top and a number of legs are added to produce a cage-like effect.

Nashville City Cemetery, Nashville, Tennessee

Pedestal Tomb

To give sarcophagus-like tombs a more imposing look, designers placed them on pedestals. The pedestal tomb also may sport an array of attachments such as urns, draped urns, crosses, and obelisks. Angels and female figures, often depicting one of the virtues, can be found leaning or standing around the tomb.

Elmwood Cemetery, Memphis, Tennessee

Nashville City Cemetery, Nashville, Tennessee

Coffin Tomb

This tomb in the form of a diamond-shaped coffin is rarely seen. Nowadays in America, coffins have been replaced by caskets, which are four-sided rather than six-sided.

Hogback Tomb

Also a low-slung tomb, it looks like a long two-sided roof raised a bit in the center (spine). It is frequently adorned with carvings to resemble ropes or braids.

Mort Safe

A couple of hundred years ago, a new profession—surgery—was emerging, and these new professionals needed something to practice on: bodies. Unfortunately, laws at the time relegated very few bodies to the schools, far less than were needed. Enter another new profession: body snatcher; or as they were known at the time: resurrectionists. These scalawags roamed the cemeteries at night in search of fresh bodies, which they sold to medical students and professors. In fact, the phrase "skeleton in the closet" refers to professors hiding dissected bodies. To ward off the resurrectionists, all manner of devices were employed, from mausoleums to "mort lairs or cages" (devices that looked like a jail cell), to "mort safes" (a series of iron bars placed over the grave), to the "Coffin-Torpedo," patented by one Philip T. Clover of Columbus, Ohio, which fired several lead balls into the would-be thief who made the mistake of tampering with the coffin.

Greyfriars Cemetery, Edinburgh, Scotland

Tablet

The most common type of grave marker is the tablet. They come in all sizes, from a simple stone to elaborately ornamented stele.

Oakwood Cemetery, Tuscumbia, Alabama

Zinc Tombstone

One of the most curious types of grave markers is hollow. The Monumental Bronze Company of Bridgeport, Connecticut, and its subsidiaries manufactured zinc tombstones (which they called white bronze) from the late 1870s until the mid-1930s. The light blue-gray material is very similar to the color of gray granite but,

Maplewood Cemetery, Huntsville, Alabama

unlike granite, is almost impervious to aging. The gravestones were available in a variety of designs and had interchangeable panels. They are fairly easy to spot because of their clean blue-gray look, and rapping on them will show they are hollow.

Cradle Markers

Common in the South, these help define the grave and are a ready receptacle for flowers and plantings.

Mount Holly Cemetery, Little Rock, Arkansas

False Crypt

These tombs are hollow. Sides are thin slabs of stone and frequently become damaged from age, vandals or storms.

Nashville City Cemetery, Nashville, Tennessee

Jonesboro City Cemetery, Jonesboro, Arkansas

Exedrae

Another often-seen cemetery monument is the exedra. These monuments are usually shaped like a curved or rectangular bench, but there are also many examples where the bench is straight.

The ancient Greeks constructed public shelters known as *stoa*. In their simplest form, these structures consisted of a colonnade, walled on one side and roofed. At intervals along these shelters were recesses with seats carved into them. The seating areas were known as *exedrae*, the Greek word for "out of a seat." These structures were frequently used in gymnasiums and public squares. Curved exedrae in public squares were favorite gathering spots for philosophers and teachers, since their students could gather around the conveniently placed seats. In private homes and gardens, exedrae were also used for entertaining and seating guests.

When designing exedrae for American cemeteries, architects used semicircular, rectangular, and straight forms. Typically, a statue or architectural feature with the family name is at the center of the exedra, and bench seats are on either side, although there are some examples that are simply a bench. The heyday of the exedra was from the late nineteenth century until the 1920s. They are still popular today but are usually used in public areas rather than as monuments for individuals or families.

Treestones

Treestones, or tree stumps, are some of the most curious varieties of funerary art. They were derived from the Victorian rustic movement, the most common example of which is cast-iron lawn furniture that looks like it's made of twigs. Any decorative art that was popular outside the cemetery in Victorian times eventually made it inside the cemetery. The heyday of treestone monuments was a quarter-century span from the 1880s to around 1905. Where one treestone is seen, often many will be found, suggesting that their popularity may have been tied to a particularly aggressive monument dealer in the area or a ready local supply of limestone, which was the carving material of choice. Treestones could also be ordered from Sears Roebuck, which may explain why they seem to be more popular in the Midwest where more people read the catalog and became acquainted with the style. Treestones provide a ready canvas for symbols because so much symbolism is closely tied to nature. Treestones are a popular funerary motif for members of the Woodmen of the World (see page 199).

Facing: Elmwood Cemetery Memphis, Tennessee

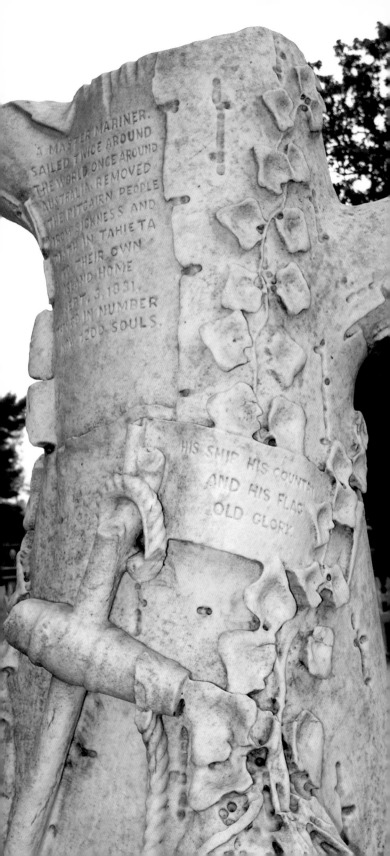

A MASTER MARINER.
SAILED TWICE AROUND
THE WORLD. ONCE AROUND
AUSTRALIA. REMOVED
THE PITCAIRN PEOPLE
FROM SICKNESS S AND
DEATH IN TAHIETA
TO THEIR OWN
ISLAND HOME
SEPT. 3, 1831.
OTHERS IN NUMBER
SOME 1200 SOULS.

HIS SHIP HIS COUNTRY
AND HIS FLAG
OLD GLORY.

SYMBOLISM

Cemeteries are virtual encyclopedias of symbolism. The symbols on a person's tomb may help to tell us something about the life of its inhabitant. Dead men may tell no tales, but their tombstones do. Besides informing us of the person's name and the dates of birth and death, their tombstones often tell us their religion, their ethnicity, what clubs they were members of, what their occupation was, and what their thoughts were on the afterlife.

Before we present our guide to cemetery symbolism, we must issue a small caveat: a person may have requested something on a tombstone simply because they liked the way it looked, and it may have had absolutely nothing to do with their life. This is especially true with flower symbols. But as a rule of thumb, the older the tomb, the more likely the symbolism had something to do with the person's life and their thoughts on the afterlife. An in-depth examination of funerary symbols is found in Douglas Keister's book *Stories in Stone*. The locations of images from Southern cemeteries are identified in this section.

MORTALITY SYMBOLS

It goes without saying that the cemetery is the best place to find mortality symbols. In fact, many of these symbols can only be found in the cemetery. Most folks don't want to be reminded that their time in this realm is fleeting, especially in the modern age when professionals handle the business of death. It was not always so. A couple of hundred years ago when infant mortality rates were very high and most folks died at home, the common person was familiar with the process of dying and death. The dead were laid out in parlors for all to see . . . and to be reminded that death comes to us all. There were even books that explained the proper way to die. A whole genre of books called *ars moriendi* detailed "the good death" in words and pictures (most people were illiterate). The leading character, of course, was the dying person, but the proper behavior was explained for the family, the clergy, and the doctor. Family excursions to the cemetery were much more popular a hundred years ago than they are today. Thus, people were more attuned to their mortality than they are nowadays.

As a rule, the older the tombstone, the more literal is its mortality symbolism. It's unlikely that a cemetery wanderer will find a skull and crossbones on a modern tombstone, but they were commonplace a few hundred years ago. At

*Facing:
Nashville City
Cemetery,
Nashville,
Tennessee*

the time, these graphic mortality symbols were grouped under the heading of Memento Mori, "remember death."

Chair (empty or vacant)

Empty chairs are usually depicted with a small pair of shoes, one of them usually on its side, for the vacant chair symbolizes the death of a child. This is aptly illustrated in a poem that appeared in *Godey's Lady's Book* in January 1850:

"The Vacant Chair"
by Richard Coe Jr.

WHEN *we gather round our hearth,*
Consecrated by the birth
Of our eldest, darling boy,
Only one thing mars our joy:
'Tis the dreary corner, where
Stands, unfilled, the vacant chair!

Little Mary, bright and blest,
Early sought her heavenly rest.
Oft we see her in our dreams—
Then an angel one she seems!
But we oftener see her, where
Stands, unfilled, the vacant chair.

But 'twere sinful to repine;
Much of joy to me and mine
Has the gentle Shepherd given.
Little Mary is in heaven!
Blessed thought! while gazing where
Stands, unfilled, the vacant chair.

Many parents, kind and good,
Lost to them their little brood,
Bless their Maker night and day,
Though he took their all away!
Shall we, therefore, murmur, where
Stands, unfilled, one vacant chair!

Little Mary! angel blest,
From thy blissful place of rest,
Look upon us! angel child,
Fill us with thy spirit mild.
Keep o'er us thy watchful care;
Often fill the vacant chair.

A vacant chair can symbolize the death of young people as well as children. A famous Civil War ballad

eulogizes eighteen-year-old John William "Willie" Grout,
who was killed at Balls Bluff, Virginia, in October 1861:

"The Vacant Chair"
Words by H. S. Washburn
Music by George F. Root (1861)

We shall meet but we shall miss him. / There will be one vacant chair.
We shall linger to caress him / While we breathe our ev'ning prayer.
When one year ago we gathered, / Joy was in his mild blue eye.
Now the golden cord is severed, / And our hopes in ruin lie.

Chorus:
We shall meet, but we shall miss him.
There will be one vacant chair.
We shall linger to caress him
While we breathe our ev'ning prayer.

Oakwood
Cemetery,
Montgomery,
Alabama

Column (broken)

Oakwood Cemetery, Montgomery, Alabama

The broken column is a symbol for the end of life and, more specifically, life cut short. It attained favor in the funerary arts around the middle of the nineteenth century and became one of the most popular mortality symbols because of its visual impact.

Hourglass (usually with wings)

Oakwood Cemetery, Montgomery, Alabama

The symbolism is clear: time is passing rapidly, and every day, everyone comes closer to the hour of their death. A bolder interpretation of the hourglass suggests that since it can be inverted over and over again, it symbolizes the cyclic nature of life and death, heaven and earth.

Skull

It is hard to think of a death symbol quite as vivid as a skull. Other symbols may suggest death; but the skull literally is death, and it reminds us that there is no escape. For those with a literary bent, there are few scenes as evocative as the meditation between Hamlet and the skull of Yorick. It occurs in Act V, Scene i, in the graveyard as the gravedigger hands the skull of the king's jester to Hamlet, who says,

St. John the Baptist Cemetery, New Orleans, Louisiana

Alas, poor Yorick! I knew him, Horatio: a fellow of infinite jest, of most excellent fancy: he hath borne me on his back a thousand times; and now, how abhorred in my imagination it is! my gorge rims at it. Here hung those lips that I have kissed I know not how oft. Where be your gibes now? your gambols? your songs? your flashes of merriment, that were wont to set the table on a roar? Not one now, to mock your own grinning? quite chap-fallen? Now get you to my lady's chamber, and tell her, let her paint an inch thick, to this favour she must come; make her laugh at that.

Death's Heads and Soul Effigies

It's said that a picture is worth a thousand words and, by extension, an image is worth a thousand words. That is certainly true when looking at the evolution of a curious funerary symbol called the death's head. Before the Reformation (early sixteenth century), there were few formal burial grounds for common folk. The rich and powerful were buried inside the church walls and floors, and sometimes in specially constructed tombs. But the most important factor in choosing a final resting place was, as

modern-day realtors like to say, location, location, location. The most desirable spots were the closest to the altar (the better to be inched toward the heavens on the parishioners' prayers). Changing social attitudes (many of which were the result of the Reformation) plus the problem of running out of desirable space inside the church (few new churches were being built at the time) forced the dead out of the church and into newly constructed burial grounds outside the church walls, which came to be known as God's Acres. The good news was that there was much more room for artistic expression out of the confines of the church walls. The bad news (at least for the middle class) was that their chance of making it from this realm to the next was no better than it had been before. But, the opening of these God's Acres did give the middle class a place to at least erect a tombstone so they had a chance of being remembered.

Enter the death's head. At the time, the Puritans had the upper hand when it came to religious thought and practices. Alas, the Puritans were a pretty gloomy lot. They preached that only the elect had much chance of making it to heaven, while the rest of us were doomed to be born, live, die, and then rot. Nowhere is that attitude more aptly illustrated than in the graveyards. In the sixteenth century, those who had the means to have a tombstone carved for their final resting place usually

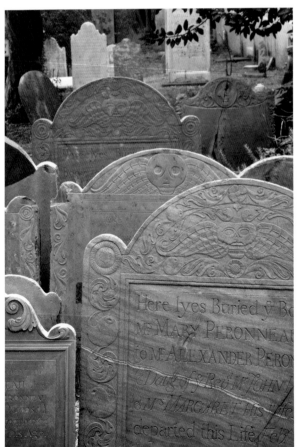

Circular Church Churchyard, Charleston, South Carolina

had their name, birth and death dates, and a skull or a skull and crossbones or a skull gnawing on a femur. Usually the words "Here Lies the Body of" were placed before the name. The image of the skull plus the word "body" pretty much summed up the attitude of the time: "This person lived for a while and now he's dead . . . end of story."

But somewhere in the sixteenth century, the Puritans began to lose their vise-like grip on people's psyche, and ever so slightly, religious attitudes started to change. With that change came the ever-so-small hope that there was a possibility that when they died, they would make it to another realm. What that realm might be (heaven, hell, or purgatory) was unknown, but at least there was hope. We need to go no farther than the cemetery to validate that supposition: almost overnight the skull sprouted wings, a suggestion that there might be something more to this person—something called a soul.

In the next two centuries, the death's head and the inscription continued to change. The degree and speed of change varies by locale, but it can be plumbed with astounding accuracy to coincide with the waning influence of the Puritans. The next major change in the death's heads was swapping the skull for a human face (albeit one with a vacant stare) and subtle changes in the words to phrases like "Here Lies the Mortal Remains of" amplifying the idea of the person having a soul. It wasn't long before a face with very human features and emotions replaced the vacant stare. With the emergence of rural and garden cemeteries in the mid-nineteenth century, the death's head had been replaced by a winged cherub, and any reference to the corruptible body had essentially been eliminated by inscribing the tombstone with flowery phrases such as "Sacred to Memory of" or "Gone But Not Forgotten."

Torch (inverted)

The inverted torch is a purely funerary symbol. It is unlikely that it will be found anywhere but the cemetery. It comes in two forms: the most common is the inverted torch with flame burning that, while symbolizing death, suggests the soul (fire) continues to exist in the next realm; the other version is an upside-down torch without a flame that simply means life extinguished.

Oakland Cemetery, Atlanta, Georgia

Urn (draped)

The draped cinerary urn is probably the most common nineteenth-century funerary symbol. Some nineteenth-century cemeteries appear to be a sea of urns. The drape can be seen as either a reverential accessory or as a symbol of the veil between earth and the heavens. The urn is to ashes as the sarcophagus is to the body, which makes the urn a very curious nineteenth-century funerary devise since cremation was seldom practiced. Nowadays, the word "ashes" has been replaced by "cremated remains" (abbreviated to "cremains" by the death-care industry). But, in the nineteenth century, urns seldom contained ashes. Rather, they were used as decorative devices, perched on top of columns, sarcophagi, and mausoleums, and carved into tombstones, doors, and walls. The urn and the willow tree were two of the first funerary motifs to replace the death's heads and soul effigies when funerary symbolism started to take on a softer air after the Revolutionary War. Word entomologists tell us that the phrase "gone to pot" may have its origin as a reference to a cinerary urn.

Mount Holly Cemetery, Little Rock, Arkansas

Wheel (broken and unbroken)

The wheel is a universal symbol that represents eternity, continuation, and progress. A broken wheel can no longer turn, simply stating that this journey is now over.

Oakwood Cemetery, Montgomery, Alabama

NATURE SYMBOLS

FLOWERS AND PLANTS

Plants, especially flowers, remind us of the beauty and the brevity of life. They have served as symbols of remembrance ever since

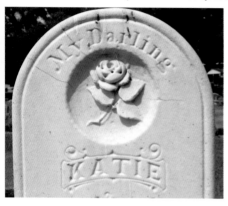

Oakwood Cemetery, Birmingham, Alabama

we began memorializing our dead. The Egyptians were the first culture to use flowers in a widespread way in funerary rites. They believed that the subtle scent of flowers contained a key to divine powers. Indeed, when the Romans under the command of Julius Caesar invaded and conquered Egypt, the scribes who recorded the events described the overwhelming scent of flowers along the banks of the Nile.

As early as the fourth century BC, Greek philosopher Aristotle declared that plants had a soul, albeit a special type of soul since they had no ability to move. The heyday of flower symbolism occurred during Victorian times, which conveniently coincided with the rise of the garden cemetery. The Victorians took great pains to give flowers special attributes, adapting many of the ancient myths to Christian symbolism. Lovers passed flowers to each other to convey a special message, and in the cemetery, specific flowers were assigned proper funerary attributes.

Buds and Seedpods

Oakwood Cemetery, Montgomery, Alabama

Oakwood Cemetery, Montgomery, Alabama

Seedpods and small buds serve to remind us of the fragile beginnings of life, all too often cut tragically short. Buds, especially those that are broken, almost always decorate the grave of a child. The buds can be almost any flower, but rosebuds are the most commonly used.

Calla Lily

With its broad leaves and huge vase-like blooms, the calla lily is one of the most stunning flowers. On tombstones it symbolizes majestic beauty and marriage. The South

African calla lily was introduced in the United States during the second half of the nineteenth century, which coincided with the beginning of the golden age of the American cemetery. Soon after it was imported, it started to appear in mainstream American art as well as funerary art.

Daisies

In the cemetery, daisies and lambs often indicate the graves of children. Because of the unassuming simplicity of the daisy, fifteenth-century artists began using it in scenes of the Adoration to symbolize the innocence of the Christ child. Soon thereafter, wishful lovers started plucking the daisy's petals in the now familiar refrain, "s/he loves me, s/he loves me not."

The daisy is also a symbol of the Virgin Mary; like Mary's love, it can grow almost anywhere. The name "daisy" comes from a corruption of the name the flower was called in England: the e'e of the daie (day's eye). And, lest we forget a popular term to describe the dead: "pushing up daisies."

Fern

Ferns are generally found deep in the forest, and only by those who have honestly searched. They symbolize humility, frankness, and sincerity.

Oakland Cemetery, Atlanta, Georgia

Laurel

In funerary art, laurel (usually in the form of a laurel wreath) can represent victory, eternity, immortality, and chastity. Its association with eternity and immortality comes from its leaves, which do not wilt or fade. Its association with victory comes from ancient contests where the triumphant winner was crowned with a laurel wreath; the crowning with a laurel wreath was supposed to bestow immortality on the recipient. In the Roman world, the laurel wreath was a symbol of military as well as intellectual glory

Oakwood Cemetery, Montgomery, Alabama

and was also thought to cleanse the soul of any guilt it had over the slaying of enemies. Chastity is associated with laurel because the laurel was consecrated to the Vestal Virgins.

Lily of the Valley

All lilies and, in particular, the lily of the valley are found in funerary art. They are symbols of innocence, purity, and virginity. They symbolize the surrender to God's will and grace, as in Matthew 6:28: "Consider the lilies of the field, how they grow; they toil not, neither do they spin . . ."

The lily of the valley has particular significance in funerary art since it is one of the first flowers to bloom in the spring, thus symbolizing renewal and resurrection.

It is native to northern Europe and thus has no direct link to early biblical tales. However, the monks liked the delicate beauty

of the plant and its medicinal properties so much that they named it lily of the valley in reference to the passage in The Song of Solomon 2:1–2: "I am the rose of Sharon, and the lily of the valleys. As the lily among thorns, so is my love among the daughters."

Madonna Lily (Easter Lily)

The Madonna lily is a symbol of purity, but it can also be used as a symbol of chastity. As a symbol of purity, its symbolism can be extended to casting off earthly things and attaining heavenly/spiritual qualities. This may be because the plant has rather plain foliage but strikingly beautiful flowers. As a practical matter, lilies were frequently used for funerals because of their strong scent, which aided in covering up any bothersome odors.

Passionflower

Understandably, this flower symbolizes Christ's Passion, Redemption, and Crucifixion. Spaniards who discovered the flower in the tropical rainforests of South America named it the passionflower. Through an interesting bit of convoluted thinking, the Spaniards saw the passionflower as a divine message that it was okay to massacre the Incas and destroy the Inca culture. The flowers were brought back to Rome in 1568, where they became an extremely popular flower, so much so that a noted botanist and Jesuit of the time, Giovanni Battista Ferrari, described the flower in appropriately flowery prose:

Hollywood Cemetery, Richmond, Virginia

This flower is a miracle for all time, for in it, God's own hand has portrayed the suffering of Christ. The corona ends in thorns reminiscent of Christ's crown of thorns; the Savior's innocence is reflected in the flower's white colour; the ragged nectary is reminiscent of his torn clothes; the styles represent the nails that were driven through his hands and feet; the five stamens represent his five wounds; the tendrils represent the whips.

The passionflower is also known as a maypop, because modern folklore says it pops out in May or its fruits make a popping sound when stepped on. In reality, the word "maypop" is a corruption of the Algonquian word for the flower, *maycock* or *maracock*. Passionflower is also the dominant flavor in the sugary tropical drink Hawaiian Punch.

Rose

The rose has become the queen of flowers because of its fragrance, longevity, and beauty. It has inspired lovers, dreamers, and poets for countless generations. Venus, the goddess of love, claimed the rose as her own. Cleopatra stuffed pillows full of rose petals. Nero arranged for rose petals to rain down upon his guests. But the early Christians were reluctant to use the rose as one of their symbols because of its association with decadence. However, people's love of the rose was strong and long-lived, so the Christians made some tactical adjustments and adopted the rose as one of their own symbols.

In Christian symbolism, the red rose became a symbol of martyrdom, while the white rose symbolized purity. In Christian

mythology, the rose in Paradise did not have thorns, but acquired them on Earth to remind man of his

Oakwood Cemetery, Montgomery, Alabama

fall from grace; however, the rose's fragrance and beauty remained to suggest to him what Paradise is like. Sometimes the Virgin Mary is called the "rose without thorns" because of the belief that she was exempt from original sin.

Sunflower

It's a bit unusual to see a sunflower on a tombstone, and if they are to be found, it's most likely that they will appear in Catholic cemeteries, for they signify devotion to the Catholic Church. In

Hollywood Cemetery, Richmond, Virginia

Catholic iconography, the sun represents the divine light of God and the sunflower represents the devout striving toward God.

The sunflower is a native of North America. It arrived in Spain in 1569, and soon, large expanses of the Spanish countryside were ablaze with the sunflower's dazzling blooms. When a sunflower is young, it exhibits heliotropism (growing toward the sun), but when it matures, the flowers permanently face east. This quality was readily adopted by Christian iconographers since most Christian graves are configured so the deceased faces east toward the rising sun.

Thistle

God says to Adam in Genesis 3:

> 17 *Because thou has hearkened unto the voice of thy wife, and hast eaten of the tree, of which I commanded thee, saying, Thou shalt not eat of it: cursed is the ground for thy sake; in sorrow shalt thou eat of it all the days of thy life;*
> 18 *Thorns also and thistles shall it bring forth to thee; and thou shalt eat the herb of the field; . . .*

Hollywood Cemetery, Richmond, Virginia

This curse associates the thistle with earthly sorrow and is appropriate in funerary use. Since the thistle is a thorny plant, it is also connected with the crown of thorns and the Passion of Christ. When seen in the cemetery, the thistle often marks the grave of a person of Scottish descent since it is their national symbol.

Ivy

Because ivy is eternally green even in harsh conditions, it is associated with immortality and fidelity. Ivy clings to a support, which makes it a symbol of attachment, friendship, and undying affection. Its three-pointed leaves make it a symbol of the Trinity.

Oakwood Cemetery, Montgomery, Alabama

Wheat

A sheaf of wheat on a tombstone is often used to denote someone who has lived a long and fruitful life of more than seventy years. It is one of the most basic foodstuffs and is thought of as a gift from God, particularly because its origins were unknown. It denotes immortality and resurrection because of its use as a harvested grain. This association with immortality may explain why priests in ancient Greece and Rome sprinkled wheat or flour on their victims' heads prior to sacrificing them. A sheaf of wheat is a popular Masonic symbol as well.

Oakland Cemetery, Atlanta, Georgia

TREES

Acorn

Like the egg, the acorn symbolizes prosperity and fruitfulness; thus it's found gracing many coats of arms and column capitals. As a religious symbol, it can be seen at the end of the red cords of a cardinal's hat, representing the power of spiritual growth from a kernel of truth.

Oakwood Cemetery, Montgomery, Alabama

Oak Tree, leaves

Just as the lion is the King of Beasts, the oak is the King of Trees. Oak leaves can symbolize many things, including strength, endurance, eternity, honor, liberty, hospitality, faith, and virtue. All of these elements combined make the oak a symbol of the power of the Christian faith even in times of adversity. The oak, along with the aspen and the holly, is one of the trees that lays claim to being the tree that was made into Christ's cross.

Olive Tree, branch

The olive tree is certainly the most referenced tree in the Bible. In the cemetery, a depiction of a dove with an olive branch in its beak is symbolic of the soul of the deceased that has departed in the peace of God. This is a reference to the peace that God made with man after the great flood, as recounted in Genesis 8:10–11 (see page 162).

The peaceful symbolism of the olive branch was also used by Sienese school painters when they depicted the archangel Gabriel handing an olive branch to the Virgin Mary in scenes of the Annunciation. Most paintings of the Annunciation depict Gabriel with a lily, but the lily was the emblem of Florence, the avowed enemy of Siena.

In addition to its peaceful symbolism, the olive tree also

signifies fruitfulness, purification, strength, and victory. In Islamic tradi-

tion, the olive is the central tree on the world axis and is also associated with light since its oil was used as lamp fuel.

Palm Fronds

Romans used palm fronds as a symbol of victory. Christians adapted them to symbolize a martyr's triumph over death

Elmwood Cemetery, Birmingham, Alabama

and, by extension, any believer's triumph over death.

A staff made out of a palm tree is an attribute of Saint Christopher. In Christian mythology, he carried Christ across the river and then thrust his palm tree staff into the ground, where it grew and bore fruit.

Pine Tree (cone or apple)

The apple of the pine tree, the pinecone, is used as a decoration for homes and in funerary art as a symbol of immortality and incorruptibility. The evergreen tree it comes from represents immortality, and its sticky resin, which resists dilution or removal (just ask any parent who has tried to remove it from their child's hair), represents incorruptibility. Romans associated the pinecone with Venus (Aphrodite in Greek) and fertility.

The kinds of pineapples we eat are symbols of hospitality because they were often presented as gifts from seafarers after they returned from South America. Bronze plaques in the shape of a pineapple are often used on a home's front door.

Oakwood Cemetery, Montgomery, Alabama

Weeping Willow Tree

Although the form of the weeping willow certainly suggests grief and sorrow, in many religions it suggests immortality. In Christianity it is associated with the gospel of Christ because the tree will flourish and remain whole, no matter how many branches are cut off. The willow and urn motif was one of the most popular gravestone decorations of the late eighteenth and early nineteenth century.

FOWLS, INSECTS, REPTILES

Butterfly

The butterfly is one of the more literal funerary symbols. The three stages of its life—caterpillar, chrysalis, and butterfly—are easily recognizable as symbols of life, death, and resurrection. The emergence of the butterfly from the chrysalis is likened to the soul discarding the flesh.

Metairie Cemetery, New Orleans, Louisiana

Dove

The dove is the most frequently seen animal symbol in the cemetery. It is portrayed in a number of poses, but it is mostly seen holding an olive branch, a reference to the dove sent out by Noah to search for land, as explained in Genesis 8:

Oakwood Cemetery, Montgomery, Alabama

10 And he stayed yet other seven days; and again he sent forth the dove out of the ark;
11 And the dove came in to him in the evening; and, lo, in her mouth was an olive leaf pluckt off: so Noah knew that the waters were abated from off the earth.

The dove then became a symbol of purity and peace because God had made peace with man.

Eagle

Without a doubt, the eagle is one of the most powerful bird symbols. It is also the quintessential symbol of America. In funerary art it usually symbolizes the Resurrection and rebirth. It was once thought that, from time to time, the eagle flew toward the sun where its feathers were burned off; then it plunged into water and was rejuvenated. This legend is alluded to in Psalm 103:

4 Who redeemeth thy life from destruction; who crowneth thee with lovingkindness and tender mercies;
5 Who satisfieth thy mouth with good things; so that thy youth is renewed like the eagle's.

Metairie Cemetery, New Orleans, Louisiana

Eagle, Two-Headed, and Masonic Eagle

The eagle has always been associated with power and respect. Eagles with twin heads are intended to amplify the point. The two-headed eagle has had a long history as a symbol. In fact, it is one of humankind's oldest emblematic symbols. Originally, it

was a Hittite symbol, and then it was given a new life in the Middle Ages when the Seljuk Turks adopted it. Europeans embraced it during the Crusades, and, finally, it was incorporated into the coats of arms of imperial Russia and Austria. Somewhere in the middle of all this borrowing, the Freemasons added it to their vast repertoire of symbols. Besides being a symbol of power, the two-headed eagle ultimately represents the dual nature of unity, which is especially appropriate because of its journey from Eastern to Western culture.

Elmwood Cemetery, Birmingham, Alabama

Owl

The owl is another animal that has mixed symbolic messages. In funerary art, it's most likely that an owl symbolizes watchfulness, wisdom, or contemplative solitude. Although owls are not mentioned specifically in the New Testament, the owl has become an attribute of Christ, and depictions of the Crucifixion

often contain an owl, which refers to Christ's ability to guide those who are in darkness. The owl-like powers of Christ are described in Luke 1:79: "To give light to them that sit in darkness and in the shadow of death, to guide our feet into the way of peace."

In another context, the owl symbolizes Satan, the Prince of Darkness, because it was said that the owl fears light and lives and hides in darkness. Like Satan, the owl is also seen as a trickster. Satan deceives mankind while the owl deceives other animals.

Pelican

After the dove, the pelican is the most common bird seen in Christian funerary symbolism. An early observer of pelicans thought they saw pelicans feeding their young from a self-inflicted gash in their flesh. In reality, the pelican was feeding its young from its pouch. Nevertheless, the errant observation became the grist for a legend that says a female pelican either killed her children or they were killed by a serpent, and after three days the pelican opened a gash in her breast and resuscitated her young with her own blood. Thus, the pelican represents self-sacrifice, the greatest love of parents for their children. Christians adopted the pelican's self-sacrificial feeding of its young from its

Metairie Cemetery, New Orleans, Louisiana

own blood as a symbol of Christ's sacrifice on the cross because of his love for humankind. In a cemetery, look for sculptures and carvings of pelicans as well as pelicans perched on top of crosses.

Snake or Ouroboros

In the cemetery, a snake biting or eating its tail is a symbol of immortality, rejuvenation, and eternity. It is seldom used in funerary art nowadays, but it was a very popular symbol in nineteenth-century cemeteries. Images of the Ouroboros (also Uroborus) can be found in the art of ancient Egypt, where it symbolized the daily cycle of the sun; China, where it was among the myriad yin and yang symbols; the Roman Empire, where it was associated with Saturn, the god of time; as well as in European and American funerary art.

Beyond symbolizing immortality, the ouroboros suggests that for every ending there is a new beginning. In alchemy, the ouroboros symbolizes a closed cyclical process (heating/evaporation/cooling/condensation), which refines or purifies substances.

Mount Holly Cemetery, Little Rock, Arkansas

WORLDLY SYMBOLS

Anchor

The anchor is a symbol of hope. The reason for this symbolic meaning comes from the passage in the Epistle to the Hebrews 6:

*19 Which hope we have as an anchor of the soul, both sure and stedfast, and which entereth into that within the veil;
20 Whither the forerunner is for us entered, even Jesus, made an high priest for ever after the order of Melchisedec.*

Oakland Cemetery, Atlanta, Georgia

Another type of anchor is the *crux dissimulata*. This anchor is actually a cross in disguise (the bottom open curve represents receptivity to spiritual matters). When Christians first started practicing their religion, they had to do it under a veil of secrecy lest they be persecuted for their beliefs. The anchor cross was one way Christians could broadcast their religion to other followers without being discovered. It is, understandably, a more popular symbol in cemeteries in coastal cities, but it has no direct link to the seafaring life.

Anvil

The anvil symbolizes the primordial forging of the universe. It is an attribute of the storm and thunder gods Vulcan (Roman) and Thor (Norse). In Christian symbolism, the anvil is an attribute of Saint Eligius (Eloy), the patron saint of blacksmiths. The story goes that around the year 610, Saint Eligius brought a horse to his forge to be shod. The horse kicked furiously, causing everyone to flee except Saint Eligius, who calmly cut off the horse's leg, put the foot on his anvil, affixed a new shoe, and rejoined the severed limb to the horse.

Oakland Cemetery, Atlanta, Georgia

Metairie Cemetery, New Orleans, Louisiana

Balls

Stone balls in the cemetery are almost always purely decorative.

Boat

Virtually all civilizations use an image of a boat with the body of the deceased to represent a voyage or the crossing over to the "other world." The boat also suggests a return to the cradle or the womb. A pilot-less boat implies that God guides the soul's journey. Saint Ambrose equates the ship as the Church and the mast as the cross.

Book (closed)

In the cemetery, a closed book usually represents a completed life; the last chapter in this realm ends in the cemetery. It may also represent virginity, secrecy, and mystery.

Presbyterian Churchyard, Greensboro, North Carolina

Book (open)

An open book is a favorite device for registering the name of the deceased. In its purest form, an open book can be compared to the human heart, its thoughts and feelings open to the world and to God.

Oakwood Cemetery, Montgomery, Alabama

Book (with crown)

This is a symbol of
God and the Bible.

Crooks (Crosier)

In the cemetery,
shepherds' crooks (or
crosiers) are often asso-
ciated with fallen Odd
Fellows. The end of the
crook, which is shaped
like a semicircular
hook, symbolizes the
opening of the earth

to the powers of heaven. The crook was an ancient emblem of
rulership in Egypt, Assyria, and Babylonia, and was an attribute

of the Egyptian god Osiris. In Christian
symbolism, the crook is an emblem
of the Apostles and is associated with
Christ in his role as the Good Shepherd.

*Oakwood
Cemetery,
Montgomery,
Alabama*

Cross (with crown)

The cross with a crown is a Christian
symbol of the sovereignty of the Lord.
When the crown is combined with a

*Oakwood
Cemetery,
Montgomery,
Alabama*

cross, the crown means
victory and the cross
means Christianity. The
cross with a crown also
denotes a member of
the York Rite Masons.
As with all types of

crowns used by the Masons, it symbolizes
the power and authority to lead or command.
(See also Knights Templar on page 204.)

Curtain (Veil)

The veil, which in funerary art usually looks more like a curtain,
is a symbol of the passage from one type of existence to another.
Veils are meant to protect as well as conceal. The veil that

covered the Ark of
the Covenant was
meant to protect
mere mortals
from its radiance.
Christians had a
new interpretation
of the Ark of the
Covenant, which

they called the Glory of the New Covenant. It is explained in 2 Corinthians 3:

12 *Seeing then that we have such hope, we use great plainness of speech:*
13 *And not as Moses, which put a vail over his face, that the children of Israel could not stedfastly look to the end of that which is abolished:*
14 *But their minds were blinded: for until this day remaineth the same vail untaken away in the reading of the old testament; which vail is done away in Christ.*
15 *But even unto this day, when Moses is read, the vail is upon their heart.*
16 *Nevertheless when it shall turn to the Lord, the vail shall be taken away.*
17 *Now the Lord is that Spirit: and where the Spirit of the Lord is, there is liberty.*
18 *But we all, with open face beholding as in a glass the glory of the Lord, are changed into the same image from glory to glory, even as by the Spirit of the Lord.*

Metairie Cemetery, New Orleans, Louisiana

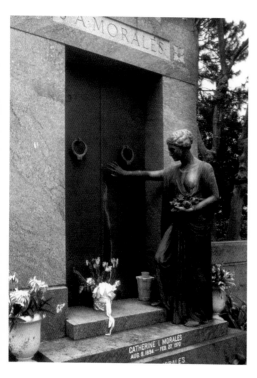

Door

The door is an obvious partition symbolizing the transition from one realm to the next. Unlike gates that, because of their porous nature, provide us with a ready view into the world beyond, there is always a certain amount of mystery attached to the partially opened door. The mysterious aspect aside, doors are ultimately viewed as a sign of hope and opportunity in all cultures. Cathedrals often have three doors symbolizing Faith, Hope, and Charity. In Christian teachings, Christ is often referred to as the "door to heaven."

Gate

In Christian funerary symbolism, gates represent the passage from one realm to the next. In scenes of the Last Judgment, gates are always central in the picture. Christ is often

Oakland Cemetery, Atlanta, Georgia

seen breaking through these dividing barriers
between the damned and the righteous.

Ladder

The most interesting aspect of the ladder as a transport
mechanism between Heaven and Earth is that the ladder is
comprised of rungs, and each rung must be negotiated before
another one is attempted. Ladders are used in many different
religions, including Buddhism, Islam, Polynesian, Native
American, and in ancient mythology. Oftentimes, these ladders
have seven rungs, which correspond to the Seven Heavens.

Oakland Cemetery, Atlanta, Georgia

Harp and Lyre

The ethereal tones of the harp
have long been associated
with heavenly aspirations.
Harps are mentioned
frequently in the Bible as a
musical entertainment and
as a source of Divine music.
David's prowess with the harp
is mentioned in 1 Samuel 16:

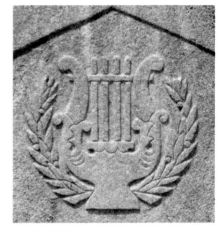

*22 And Saul sent to Jesse, saying, Let
David, I pray thee, stand before me;
for he hath found favour in my sight.
23 And it came to pass, when the
evil spirit from God was upon Saul,
that David took an harp, and played with his hand: so Saul was
refreshed, and was well, and the evil spirit departed from him.*

The Divine aspect of the harp is described in Revelation 5:

*7 And he came and took the book out of the right hand of him that sat
upon the throne.
8 And when he had taken the book, the four beasts and four and twenty
elders fell down before the Lamb, having every one of them harps,
and golden vials full of odours, which are the prayers of saints.*

City Mansions

In the King James Version of the Bible is
the oft-quoted phrase in John 14:2: "In
my Father's house are many mansions:
if it were not so, I would have told
you. I go to prepare a place for you."

In that quote, "house" really means
"city," and the quote is the source for
depictions of cities with glorious mansions
in Christian art as well as tombstones.
Interestingly, in subsequent versions

of the Bible, God's abode has been downsized to a simple house with many rooms. John 14:2 in the Revised Standard Version of the Bible reads, "In my Father's house are many rooms; if it were not so, I would have told you. I am going there to prepare a place for you."

The New American Standard Version changes "rooms" to "dwelling places" and makes the quote a question: "In my Father's house there are many dwelling places. If it were not so, would I have told you that I go to prepare a place for you?"

The New International Version changes the passage even more: "My Father's house has plenty of room; if that were not so, would I have told you that I am going there to prepare a place for you?" Nevertheless, the spirit of the quote is that there is room for everybody, provided they follow the necessary dictates prescribed in the Bible.

Tent

Despite its diminutive size, the tent is jam-packed with symbolism. According to Exodus, Moses was given instructions for a portable tent-like sanctuary that was to be the center of Israel's worship. This sanctuary is called the "Tabernacle" and the "Tent of Meeting." It measured 45 feet long and 15 feet wide, and was divided into two parts. The forecourt contained a lamp stand, an incense altar, and a table with twelve loaves of bread. The inner court housed the Ark of the Covenant, which contained the tablets on which the Ten Commandments were written. The Israelites took the Tent of Meeting with them as they traveled through the wilderness from Mount Sinai to Canaan. After Solomon built the first temple in Jerusalem, a tabernacle was no longer used.

Societies all over the world associate the tent as a place to summon the powers of God. Secret societies frequently use tents or tent-like structures in their initiation rights. The Freemasons put an initiate in a "Chamber of Reflection," which contains a candle that illuminates a human skull, some bones, a piece of bread, a glass of water, an hourglass, and two saucers (one containing salt and the other containing sulphur). On the wall is a scythe, a picture of a rooster, and the initials V. I. T. R. I. O. L., which is the ancient Latin phrase: *visita interiora terrae, rectificando invenies occultam lapidem* ("visit the center of the earth, and by rectifying you shall find the hidden stone"). After a proper time of contemplation, the initiate writes down his thoughts and emerges from the tent, ready to begin his journey in Freemasonry.

RELIGIOUS SYMBOLS

Many symbols in cemeteries have some connection with a religion, such as the cross for Christians and the Star of David for Jews. Until the nineteenth century, most Southerners were Episcopalian or Presbyterian because of their ancestral ties to England and Scotland. From the Civil War onwards, Baptists and Methodists have been the dominant religions. The South is known as the Bible Belt because of a significant presence of evangelical and fundamentalist Protestants, conservative Catholics, as well as Pentecostals and Charismatics. There are significant Catholic populations in most large cities in the South,

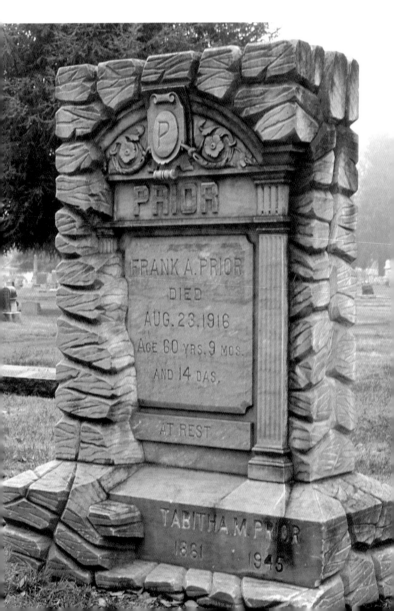

particularly in New Orleans. Interestingly, Atlanta has always had a significant Jewish population. In recent years, because of an influx of emigrants from Southeast Asia, cemetery explorers will see a number of Buddhist and Hindu symbols.

HUMAN SYMBOLS

Eye

The all-seeing eye with rays of light is an ancient symbol for God. Although many cultures have eye symbols, some good and some evil, when seen in a cemetery it usually means that the person was a Mason. This symbol is familiar to us all as one of the mysterious images on the reverse of the dollar bill; its placement there is largely due to America's Founding Fathers, among them George Washington, Benjamin Franklin, Alexander Hamilton, Paul Revere, and John Paul Jones, who were Masons. In fact, one scholar describes Washington's Continental Army as a "Masonic convention."

Hand Coming Down

In early Christian art, it was forbidden to depict the countenance of God. This was largely due to an interpretation of the fourth commandment (Exodus 20:4), "Thou shalt not make unto thee any graven image, or any likeness of any thing that is in heaven above, or that is in the earth beneath, or that is in the water under the earth: ..." But, the Bible is packed with references to

the hand or arm of God, so the presence of God was permitted. Thus, the presence of the Almighty was often depicted as a hand emerging from the clouds, sometimes with three fingers pointing down representing the Trinity, other times holding a flower, and sometimes holding a broken chain.

Hand Pointing Up

A hand pointing up is usually an indication that the soul has risen to the heavens.

Oakwood Cemetery, Montgomery, Alabama

Hands Together

Hands that appear to be shaking are usually a symbol of matrimony. Look carefully at the sleeves. One should appear feminine and the other masculine. If the sleeves appear to be gender neutral, the hands can represent a heavenly welcome or an earthly farewell.

Oakland Cemetery, Atlanta, Georgia

CHRISTIAN SYMBOLS

The Eucharist

The chalice with wafer, grapes, and wheat combined into a single scene are collectively a symbol of the Eucharist. The use of all of these elements together is usually restricted to religious orders. Grapes and wheat together are also a symbol for the Eucharist and are usually found on the graves of common folk.

The Holy Ghost

A dove dive-bombing from the heavens with an olive branch or a cross in its beak is the symbol for the Holy Ghost. This representation of a dove comes from John 1:

32 And John bare record, saying, I saw the Spirit descending from heaven like a dove, and it abode upon him.
33 And I knew him not: but he that sent me to baptize with water, the same said unto me, Upon whom thou shalt see the Spirit descending, and remaining on him, the same is he which baptizeth with the Holy Ghost.
34 And I saw, and bare record that this is the Son of God.

A similar-looking tableau, but with the dove holding the earth in its beak, is a symbol for the fourth, or highest, degree of a Knight of Columbus, a fraternal organization for Catholics.

Lamb

In funerary art, lambs symbolize innocence and usually mark the graves of children and, particularly, infants. The lamb is one of the most frequently used symbols of Christ in all periods of Christian art. Christ is often depicted as a shepherd, but he is also referred to as the Lamb of God, as in John 1:29: "Behold the lamb of God, which taketh away the sin of the world!"

Oakwood Cemetery, Montgomery, Alabama

Agnes Dei—Lamb of God

A lamb with a cross and usually also with a banner and a halo is the symbol for the Lamb of God. Christ is the Lamb of God as referenced in John 1:29: "The next day John seeth Jesus coming unto him, and saith, Behold the Lamb of God, which taketh away the sin of the world." In addition to the cross, banner, and halo, there are a number of other accessories that may be portrayed with the lamb. Among these are shepherds' crooks, Chi-Rho crosses, and alpha/omega symbols. If the lamb is portrayed without any additional items, it is a symbol of innocence and is frequently found on children's graves. Accessorized, the lamb is almost always the Agnes Dei.

Chalice

In the cemetery, the chalice is seen as the human heart's yearning to be filled with the true spirit of the Lord, as symbolized by wine. It is one of the strongest

symbols of Christian faith, and its most vivid
biblical reference is in Mark 14:

23 And he took the cup, and when he had given thanks, he gave it to them:
and they all drank of it.
24 And he said unto them, This is my blood of the new testament, which is
shed for many.
25 Verily I say unto you, I will drink no more of the fruit of the vine, until
that day that I drink it new in the kingdom of God.

Alpha, Omega, Mu

Alpha and Omega are the first and last letters of the Greek
alphabet. In Christian iconography, the Alpha and Omega
emblem relates to three similar passages in the book of
Revelation. The most expansive of the three passages, found in
Revelation 21, reads:

5 And he that sat upon the throne said, Behold, I make all things new. And he
said unto me, Write: for these words are true and faithful.
6 And he said unto me, It is done. I am Alpha and Omega, the beginning
and the end. I will give unto him that is athirst of the fountain of the water of
life freely.
7 He that overcometh shall inherit all things; and I will be his God, and he
shall be my son.

Sometimes the Alpha and Omega will have the letter
M (Mu) inserted, which expands the meaning to the
beginning, the continuation, and the end of all things.

It is quite common to see the Alpha and Omega symbols in all sorts of religious art, especially on books and clothing. As a symbol, the letters are frequently seen dangling from a Latin cross or incorporated in a Chi-Rho emblem.

IHS

This symbol is often seen emblazoned on crosses. Often the letters are overlaid on each other, which, curiously, look a lot like a dollar sign. Popular belief says that IHS (or sometimes IHC) is an abbreviation of the Latin phrase *in hoc signo*, which is a shortened version of a banner with the words *in hoc signo vinces* ("in this sign you will conquer"), seen in a vision by the Emperor Constantine before he went into battle—a good story, but not the origin of IHS. Another puts the origin as an abbreviation of the Latin phrase *Iesus Hominum Salvator* ("Jesus, Savior of Men")—another good story, but also not the origin. In fact, the origin is rather pedestrian. IHS or IHC (derived from the lower-case Greek letters for iota, eta, and sigma) is an abbreviation of Jesus's name in Greek: *Ihsus*, *Ihsoys*, or *Ihcoyc*.

INRI

This symbol is very straightforward. It's the first letters of the Latin words *Iesus Nazarenus Rex Iudaeorum*, meaning "Jesus of Nazareth The King of the Jews." According to John 19:19, after Jesus was crucified, Pilate mockingly wrote these same words on the cross in Hebrew, Greek, and Latin.

RIP

The most common letters seen on tombstones in cartoons are RIP. Even schoolchildren are familiar with this abbreviation, and it may be their first experience with cemeteries. RIP is an abbreviation

for the Latin words *Requiescat In Pace*, which translates nicely to the English words "Rest in Peace."

Greek Cross

Greek-style crosses and other crosses with equidistant arms are more likely to appear as part of a decoration on a tomb rather than as freestanding crosses. The Saint Andrew's cross looks like an X. When Saint Andrew was condemned to be crucified, the story goes that he requested to be nailed to a cross that was unlike the cross on which Jesus was crucified because Saint Andrew thought he was unworthy to be put in the same category as Jesus. Thus, the Saint Andrew's cross has come to signify suffering and humility.

The Maltese cross looks like a + sign with flared ends that are usually indented to form eight points. These eight points represent the Beatitudes, certain declarations of blessedness pronounced by Christ in the Sermon on the Mount. It is often associated with such fraternal orders as the Knights Templar.

Many of the Greek-style crosses are associated with heraldry, and they were worn by many Christian warriors as they marched off to the Crusades. These crosses can often be seen in a cemetery gracing a family crest or as part of an emblem

of a fraternal order. Best known among these are the floré (floriated) cross, which has arms that end in three petal-like projections, and the patté (broadfooted) cross, where the arms look like triangles with the tip of the four triangles pointed at the center. These rather broad arms represent the wings of a bird and symbolize the protective power of the cross.

Latin Cross

The cross most commonly associated with Christianity is the Latin cross. Some of its many variations are the Cross of Calvary, a Latin cross with a three-stepped base representing the Trinity; the Cross of the Resurrection, a simple Latin cross with a spiked end; and the Crucifix, or Rood, with

Christ nailed to it. Cemetery wanderers will also spy many Latin crosses with more than one cross arm. The most common of these is the Cross of Lorraine, which has a shorter arm above the long one. It was applied to the standards of Godfrey of Lorraine, one of the first Crusaders, after he was chosen ruler of Jerusalem. This symbol is familiar to us as the cross that graces Easter Seals. A variation of the style of the Cross of Lorraine is the Russian Orthodox cross, or Eastern Orthodox cross. This cross has an angled crossbar below the main crossbar. Where one is seen, often many are seen, since they generally appear in ethnic cemeteries or in ethnic areas of large cemeteries. Sometimes Latin crosses and Russian Orthodox crosses are seen with angled pieces on top of the cross that look like a little roof. These crosses are known as wayside crosses, which can be seen by roadsides all over Europe. They are usually simple wooden affairs and were erected by the thousands. Unlike American roadside crosses, which usually commemorate victims of automobile accidents, wayside crosses are erected for the convenience of travelers who may be compelled to stop and pray. The more repentant of these travelers may become quite emotional, which gives the wayside crosses their alternate name: weeping crosses. Despite their rather flimsy nature, wayside crosses can often be seen in American ethnic cemeteries.

Rogers-Palfrey-Brewster Cross

Most American cemeteries have an intricate Celtic cross, or two, or three. But few are as elaborate as the Rogers-Palfrey-Brewster Cross in Metairie Cemetery, New Orleans, Louisiana. Many of the elements on the cross bear more than a little resemblance to the Ruskin cross in Cumbria, England, lending one to speculate if the designer may have used the Ruskin cross for inspiration. Famed New Orleans tomb-contractor Albert Weiblen fabricated the stone from an 18-foot 15-ton block of Indiana limestone, chosen because it would weather to look like an ancient stone. Although Weiblen fabricated the monument, Charles L. Lawhon actually designed the monument, based on research and family data. Just like the Ruskin cross, the Rogers-Palfrey-Brewster cross has an almost identical seven-armed candlestick on the east side. And like the Ruskin cross, this one tells a bit of history of the family. On the second panel below the candlestick is the Louisiana pelican seal, embossed with crossed cannons and inscribed with the date 1862 and the letters CSA (Confederate States of America), recognizing the members of the family who fought in the Civil War. Most of the rest of the cross is devoted to traditional religious symbols. At the center of the crossed arms on the east side of the cross is Agnus Dei, the Lamb of God. Surrounding this are depictions of the attributes of the Four Evangelists: The cherub with the scroll is Saint Matthew, portrayed

Metairie Cemetery, New Orleans, Louisiana

as a writer of the Gospel; the winged lion is the attribute of Saint Mark; the winged ox is an attribute of Saint Luke; the eagle is one of the principal attributes of Saint John. (See below for further information on these evangelists.) On the west side of the cross, the arms have the same depictions of the attributes of the evangelists, but in the center is a dove, a symbol of the Holy Ghost.

Of particular interest is the style of writing on the cross. Lawhon specified that the lettering be in a runic script, which is an ancient lettering style of the Nordic tribes. Many names of family members are inscribed in runic at the base of the monument, and there is still ample room for more. Also inscribed in runic on the nimbus are the words "I am the way and the truth and the life" on the east side, and "I know that my redeemer liveth" on the west side.

Shell

Oakwood Cemetery, Montgomery, Alabama

When seen on a tombstone, the cockleshell, or the scallop shell, symbolizes a journey or a pilgrimage. The scallop shell is also a symbol of baptism and, specifically, the baptism of Christ. Even today some baptismal fonts have shells incorporated into their design, and the baptismal water is sometimes sprinkled from a shell.

Cave Hill Cemetery, Louisville, Kentucky

The shell's association with water and the sea is an integral part of many myths, and it is a female/goddess attribute in many cultures. Perhaps the best-known depiction of the shell and a female is Botticelli's famous painting *The Birth of Venus*. Because the shell may also contain a pearl, it is associated with good luck and prosperity in a number of cultures.

Stone

One large stone next to a tomb refers to the Resurrection. This event is detailed in a number of books in the New Testament, including Luke 24:

> 1 *Now upon the first day of the week, very early in the morning, they came unto the sepulchre, bringing the spices which they had prepared, and certain others with them.*
> 2 *And they found the stone rolled away from the sepulchre.*
> 3 *And they entered in, and found not the body of the Lord Jesus.*

The Evangelists

Metairie Cemetery, New Orleans, Louisiana

The four evangelists who wrote the respective Gospels—Matthew, Mark, Luke, and John—all have winged attributes. When you see a depiction of a flying cow or an aeronautical lion in the cemetery, it's not the musings

of a whimsical artist but the symbol of a saint. Usually all four of the fluttering creatures appear together: an angel, a lion, an ox, and an eagle. The angel represents Saint Matthew, the lion Saint Mark, the ox Saint Luke, and the eagle Saint John. The attributes of the Evangelists are referred to in Ezekiel 1:

4 And I looked, and, behold, a whirlwind came out of the north, a great cloud, and a fire infolding itself, and a brightness was about it, and out of the midst thereof as the colour of amber, out of the midst of the fire.
5 Also out of the midst thereof came the likeness of four living creatures. And this was their appearance; they had the likeness of a man.
6 And every one had four faces, and every one had four wings.
7 And their feet were straight feet; and the sole of their feet was like the sole of a calf's foot: and they sparkled like the colour of burnished brass.
8 And they had the hands of a man under their wings on their four sides; and they four had their faces and their wings.
9 Their wings were joined one to another; they turned now when they went; they went everyone straight forward.
10 As for the likeness of their faces, they four had the face of a man, and the face of a lion, on the right side: and they four had the face of an ox on the left side; they four also had the face of an eagle.

They are also referred to in Revelation 4:
6 And before the throne there was a sea of glass like unto crystal: and about the throne, were four beasts full of eyes before and behind.
7 And the first beast was like a lion, and the second beast like a calf, and the third beast had a face as a man, and the fourth beast was like a flying eagle.

This "tetramorph" is, no doubt, influenced by the notion of four guardians supporting the heavens from the four corners of the earth. The four guardians are also said to represent four signs of the zodiac—Aquarius, Scorpio, Taurus, and Leo—in what is known as the fixed cross.

HEBREW SYMBOLS

The Hebrew people have been memorializing their dead for far longer than Christians. Jewish tombstones do not have nearly the vocabulary of symbols as Christian tombstones, but their brevity is deceiving. The father of the deceased person is written on almost all of the Jewish tombstones. This piece of information gives genealogists a step back one generation.

Dates

Dates are written after according to the Jewish calendar, which starts with the Creation of the World. It was calculated by figuring the ages of people and events referred to in the Old Testament. That figure worked out to 3,760 years before the Christian calendar. Thus, the year

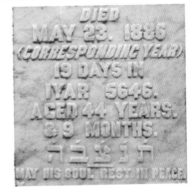

2000 in the Christian calendar would be 5760 (3760 + 2000) in the Hebrew calendar. Occasionally, the first 5,000 years are dropped. Thus, 5760 would be written as 760. It should also be noted that, as a rule, headstones of Jews in Europe contain more symbolism than those in North America. European headstones will often have depictions of the tools of trade of the deceased as well as an array of plants and animals. Since the headstones in Europe are older, the wealth of symbols might point to lower literacy rates.

Here Lies

This sign is found on almost every Jewish tombstone. It is the Hebrew words *po nikbar* or *po nitman* ("here lies").

Here Lies (with crown)

A crown is a commonly used symbol to represent piety. When appearing over Here Lies, it often represents the head of the household.

Menorah

The menorah is a seven-branched candelabra and is usually seen on the tombstone of a "righteous" woman. Its roots go back to the destruction of the Temple of Solomon. The most vivid account of the menorah in the Bible is in Exodus 25, where the Lord explains the furnishings he wants Moses to make for the tabernacle:

31 And thou shalt make a candlestick of pure gold: of beaten work shall the candlestick be made: his shaft, and his branches, his bowls, his knops, and his flowers, shall be of the same.
32 And six branches shall come out of the sides of it; three branches of the candlestick out of the one side, and three branches of the candlestick out of the other side:

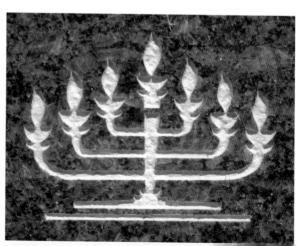

33 *Three bowls made like unto almonds, with a knop and a flower in one branch; and three bowls made like almonds in the other branch, with a knop and a flower: so in the six branches that come out of the candlestick.*
34 *And in the candlesticks shall be four bowls made like unto almonds, with their knops and their flowers.*
35 *And there shall be a knop under two branches of the same, and a knop under two branches of the same, and a knop under two branches of the same, according to the six branches that proceed out of the candlestick.*
36 *Their knops and their branches shall be of the same: all it shall be one beaten work of pure gold.*
37 *And thou shalt make the seven lamps thereof: and they shall light the lamps thereof, that they may give light over against it.*
38 *And the tongs thereof, and the snuffdishes thereof, shall be of pure gold.*
39 *Of a talent of pure gold shall he make it, with all these vessels.*
40 *And look that thou make them after their pattern, which was shewed thee in the mount.*

Interestingly, the seven-branched menorah is rarely seen on European headstones (usually three or five branches are seen) because the seven-branched menorah was a symbol of the Temple and its use was prohibited as a headstone symbol.

Star of David

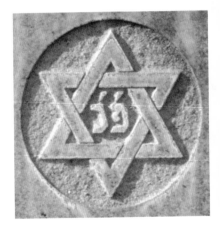

The Star of David, a symbol of divine protection, is probably the most well known Jewish symbol, although it didn't become a major symbol until the late 1880s, when it was used by Zionists to identify themselves. Ironically, the Star of David symbol became a permanent identifier of Jews when Hitler ordered Jews to wear the symbol on their arms. When Israel put the star on its flag, the transition from minor symbol to the universal Jewish symbol was complete.

Yahrzeit

The yahrzeit (also spelled yahrtzeit) is an oil-filled basin with a floating wick. Nowadays a yahrzeit can also be a candle or a lamp. It can also refer to an event as well as an object. Thus, during Yahrzeit, a yahrzeit candle is burned to commemorate the dead. The yahrzeit is also called a Ner Neshamah, a "Lamp of

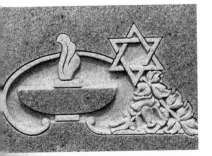

the Soul," based on the verse in Proverbs 20:27—"The spirit of man is the candle of the Lord, searching all the inward parts of the belly."

Ewer

A pitcher signifies a Levite who, according to scripture, was responsible for cleaning the hands of the Temple priest (the Cohanim) prior to a religious service. Aside from these cleansing duties, Levites were also musicians, singers in choirs, and gatekeepers. In today's world, the Levites are the ones called on second (after the Cohanim) in the reading of the Torah.

Shofar Horn

The ram's horn appears in Exodus 19:13: ". . . when the trumpet soundeth long, they shall come up to the mount." The Shofar emblem is derived from the biblical story that tells of the sacrifice of a ram instead of Isaac. It is also a messianic symbol of resurrection associated with the prophet Elijah and the belief that it will sound prior to the arrival of the Messiah.

The Mosaic Decalogue

Thanks to Charlton Heston and Cecil B. DeMille, almost everyone knows these tablets as the Ten Commandments. In the cemetery, the two tablets are always joined. Sometimes they are seen with the Hebrew figures (five on each side) for the numbers 1–10, while other times the commandments are written out in an abbreviated form. Christians liked the idea of the tablets so much that they modified it with Roman numerals, and it has become a popular Christian symbol. Modern-day tombstones generally

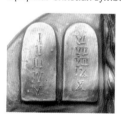

depict five numerals on the left and five on the right, but on older tombstones, Roman Catholics and Lutherans tend to like three numerals on the left and seven on the right, while Calvinists and the Greek Church tend to like four numerals on the left and six on the right.

Cohanim (Kohanim) Hands

These hands with thumbs, and sometimes forefingers, joined are a symbol of the members of the ancient priestly tribe of Aaron, who was a Levite. Nowadays, at certain services, the Cohanim raise their hands in the air to form an opening, which directs the radiance of God to stream down on the congregation. The Cohanim hands usually mark the graves of fallen Cohns, Cohens, Cahns, Cowens, and their families.

Pebbles

All cultures have ways of continuing to memorialize their dead by leaving something at the grave site. Some of the more popular items include flowers (real and artificial), immortelles (ceramic flowers), food, pictures, toys, and notes. One of the most curious memorial practices is the Jewish custom of leaving pebbles on and around the tombstone. The custom has become so well established that some Jews will bring pebbles and small stones from their travels to place on the tombstone. And, if pebbles are not available in the cemetery, coins and bits of glass are sometimes substituted. Nevertheless, the message is clear: at its most basic level, pebbles say that someone still cares and remembers. But why use stones? Like many folk customs, scholars say the origin of the practice is somewhat shadowy. What is clear is that using stones to memorialize a person or mark a place has gone on for thousands of years. In fact, because of the ready supply of durable materials, building rock cairns was one of the earliest methods man employed to mark important places.

Ultimately, the use of rocks and pebbles on graves is a practical matter. Graves in a rocky or sandy environment couldn't be dug very deep. Rocky ground is hard to excavate, and sand collapses before it can be dug very deep. Thus, graves were often quite shallow, and rocks and pebbles needed to be placed over the grave to prevent the remains from being disturbed by animals. These rock mounds became grave markers by default because of the nature of their form.

It should be noted that the Jews were a nomadic people and, as such, traveled from place to place. When they passed the grave site of a member of their tribe, it was entirely reasonable that they would do a bit of maintenance to that site, which, in an arid environment, would mean maintaining and perhaps adding to the stones. By extension, a nomadic tribe wouldn't leave fragile plants or flowers on a grave since these people would soon be moving on and unable to care for them. Flowers, food, and other remembrances that are part of memorial practices of other cultures were never part of early Jewish burial practices. Adding more rocks simply served the same purpose.

JOHN M. GRANVILLE

SECRET SOCIETIES AND CLUBS

We are a nation of joiners. Sociologists say that we humans are herd animals; if enough of us are thrown together for any length of time, eventually we'll form a club or start a competition and appoint leaders. We do this for companionship as well as protection and security. In the years before formal health and life insurance, "benevolent societies" were founded to provide their members with companionship, medical care, and death care. Immigrant groups originated many of these societies as a way to preserve and honor the ways of the old country. Conversely, people who wanted to distance themselves from the new arrivals formed their own organizations. Understandably, the greatest popularity of these clubs and societies were during the years of the heaviest immigration and, in the South, the economically tough times after the Civil War. The membership of most organizations took a pronounced nosedive in the 1930s after the enactment of the New Deal, which provided a number of the same benefits as the benevolent societies did.

Many societies provided a death benefit as a part of their membership. This benefit could range from a tombstone, to a plot in the organization's cemetery, to a space in a community mausoleum. For the finest examples of tombs of benevolent societies, explore the cemeteries of New Orleans, which boast row after row of society tombs, like the Cristoforo Colombo Society tomb in Metairie Cemetery (see page 23), the Screwmen's Benevolent Association tomb in Saint Roch Cemetery, and the Italian Benevolent Society tomb in Saint Louis Cemetery No. 1. As membership in these societies waned, many of the tombs have fallen into disrepair.

Of course, not all organizations provided death benefits, and some were more for fun and drinking than anything else. Alas, groups like the Exalted Order of Big Dogs, an organization of musicians that held their meetings in Kennels, and the Order of Bugs, which met in Bughouses presided over by the Supreme Exalted Bugaboo, no longer exist. Others, like the Ancient and Honorable Order of the Blue Goose (AHOBG)—which was founded in 1906 as a society for fire insurance men and whose officers consist of a Most Loyal Gander (president), Wielder of the Goose Quill (secretary), and Keeper of the Golden Goose Egg (treasurer)—have fallen into obscurity. But organizations like the Freemasons, Woodmen of the World, Elks, Eagles, and Moose continue to prosper.

In the cemetery, by far the most represented society is the Freemasons. But even in small cemeteries, tombstones with the symbols of the Odd Fellows, Woodmen of the World, and their female equivalents can be found. A little sleuthing will also reveal that many tombstones have the symbols of more

than one society. This is particularly true of the Freemasons and the Odd Fellows, who not only shared members but also shared a number of symbols. Less common but still fairly easy to find are the symbols of many of the "animal societies," like the Elks, Eagles, and Moose. Not so easy to find are the symbols of some of the less popular animal societies, like the Buffalo, Beavers, Bears, Camels, and Owls.

Although most of the societies did not specifically state that they were for whites only, because of the secret voting that took place when a new member applied, defacto segregation was the rule. However, a number of African American secret societies were formed that were essentially the same as their white counterparts, such as the Freemasons (the black equivalent was the Prince Hall Freemasons), the black Odd Fellows, the Colored Knights of Pythias, and the Black Elks.

In the Southern states, some of the most popular societies are ones that continue to honor and celebrate the unpleasantness of the 1860s. Chief among these are the United Daughters of the Confederacy and the Sons of Confederate Veterans. These two groups continue to be very active despite the decades that have passed since there was a Confederacy.

STONE SENTINELS
United Daughters of the Confederacy (UDC)
The United Daughters of the Confederacy, which was originally named the National Association of the Daughters of the Confederacy, was organized in September 1894 by Caroline Meriwether Goodlett and Anna Davenport Raines. The name was changed to United Daughters of the Confederacy in 1895. The organization was officially incorporated in Washington, D.C., on July 18, 1919. The organization traces its roots to two other associations: the Daughters of the Confederacy (DOC) in Missouri; and the Ladies Auxiliary of the Confederate Soldiers Home in Tennessee that came into existence in the early 1890s.

According to the UDC, "Membership is open to women no less than sixteen years of age who are blood descendants, lineal or collateral, of men and women who served honorably in the Army, Navy or Civil Service of the Confederate States of America, or gave Material Aid to the Cause." The insignia most often seen in the cemetery consists of the Confederate flag surrounded by a laurel wreath bearing the letters "UDC" and tied with

a ribbon with the dates 1861–1865. Seen less often is the emblem and motto, which is a cotton boll on a five-pointed star. At the tips of the points are the words of the motto: Love, Live, Pray, Think, Dare.

The organization has a number of social and historic objectives, chief among them "To collect and preserve the material necessary for a truthful history of the War Between the States and to protect, preserve, and mark the places made historic by Confederate valor." Besides preserving the memory of the "War Between the States" the UDC has been a large supporter of nursing organizations and the Red Cross. Now and then, the UDC has found itself embroiled in controversy, usually involving accusations that it is associated with neo-Confederate movements and has a thinly veiled agenda of white supremacy.

Other organizations associated and supported by the UDC include the Children of the Confederacy, the Granddaughters Club, the Great Granddaughters Club, and the Great-Great Granddaughters Club.

Sons of Confederate Veterans (SCV)
United Confederate
Veterans (UCV)

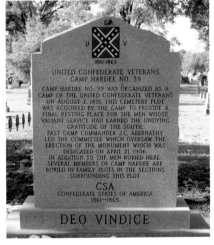

Like the Daughters of the Confederacy, the Sons of Confederate Veterans' main purpose is "dedicated to insuring that a true history of the 1861–1865 period is preserved." The SCV is an outgrowth of the United Confederate Veterans (UCV), which was founded in 1889. The UCV was modeled on the Grand Army of the Republic (GAR), an organization for Union veterans. Unfortunately, both the UCV and the GAR were self-extinguishing organizations since membership was limited to veterans of the Civil War. Sons of Confederate Veterans, however, include male descendents of soldiers who served the Confederate States of America. Members must be at least twelve years old. There is a Cadet organization for boys younger than twelve.

For decades the Sons of Confederate Veterans' main tasks involved maintaining Confederate gravestones and monuments, erecting and maintaining monuments, and researching and preserving history. Starting in the 1990s, schisms have developed in the organization as certain members have pressed the organization to be more politically involved. Among the more politically motivated goals has been the push to have images of the Confederate flag and various insignias more prominently displayed. Different

factions clashed, and in 2002, a dissident organization, Save the Sons of Confederate Veterans (SSCV), was formed.

The organization's authorized grave marker is most often seen in the cemetery. It consists of a stylized Southern Cross encased in an octagon with the Southern Cross version of the Confederate flag in the center. At the compass points of the markers are these words: Sons of, Confederate, Veterans, 1896.

Confederate States of America (CSA)
Confederate States Army (CSA)
Confederate States Navy (CSN)

Thousands of these markers have been placed in Southern cemeteries, mainly by the Sons of Confederate Veterans and the United Daughters of the Confederacy. The cast-iron markers are patterned on the Southern Cross of Honor Medal. On one side is the Southern Cross battle flag pattern surrounded by a laurel wreath (honor and victory) and the CSA acronym. The other side has the dates of the war, 1861–1865, and the Latin phrase *Deo Vindici* ("God is our vindicator or God will Vindicate") surrounded by a laurel wreath.

Daughters of the American Revolution (DAR)

The Daughters of the American Revolution was founded on October 11, 1890, by a group of women who wanted to acknowledge their patriotism but had a hard time doing it because they weren't allowed into male-only patriotic organizations. Since its founding over a century ago, it has expanded to all fifty states and a number of foreign countries. Although the DAR's publicly stated eligibility requirements state that "Membership in DAR is open to women at least eighteen years of age who can prove lineal bloodline descent from an ancestor who aided in achieving United States independence," and include Revolutionary War veterans, local militias, French and Spanish soldiers and sailors, participants in the Boston Tea Party and other patriots, the organization had a thinly veiled segregationist policy. The organization finally amended its constitution to bar discrimination on the basis of race and creed after a highly publicized 1984 incident when Lena Lorraine Santos Ferguson was denied membership in the Washington, D.C., chapter because she was black. Ferguson eventually became a very active member of the Washington, D.C., chapter.

The organization is very active in genealogy and children's education, offering a number of scholarships. The DAR houses an

extensive genealogy archive in its one-
square-block building in Washington, D.C.,
which also contains a theater, offices, a
library, and a museum. As of 2008, the
organization has about 170,000 members.

The DAR utilizes a seal, an emblem,
and a ribbon as symbols of the organiza-
tion. The insignia is most commonly used
to mark the graves of DAR members.
The primary part of the insignia consists
of a spinning wheel mounted over a
distaff—homage to Abigail Adams, who
told her husband, John Adams, that the
best way for her to help the revolutionary
cause was to work with wool and flax.
On the wheel's edge is the society's
name, Daughters of the American Revolution, surrounded by
thirteen starts representing the thirteen original colonies.

Sons of the American Revolution (SAR)

The Sons of the American Revolution has almost identical
membership requirements as the Daughters of the American
Revolution except, of course, that members are males. The

organization traces
its roots to 1876 in
San Francisco, where
a group of men who
were descendents of
Revolutionary War
veterans wanted to
celebrate the country's
centennial. The group
called itself the Sons
of Revolutionary
Sires, which sounded
more like a radical
horse-breeding club
than a patriotic
organization. The
name was changed to
the Sons of the American Revolution in 1889.

Although the majority of U.S. presidents have been
members (Theodore Roosevelt signed the formal incorpora-
tion papers in 1906), it has never attained anything close to
the membership figures of the Daughters of the American
Revolution (26,000 members vs. 170,000 members).

In the cemetery, SAR graves are usually marked with a
variation of the obverse side of the SAR badge. The marker
consists of a laurel wreath topped by a Maltese Cross with
eight points, the acronym SAR, and a minuteman at the center.
The SAR badge and grave marker are loosely based on the

Military Order of Saint Louis (founded by Louis XIV in 1693) and the Legion of Honor (founded by Napoleon in 1803).

The Grand Army of the Republic (GAR)

The GAR was an organization with built-in extinction, since membership was limited to honorably discharged veterans of the Union Army, Navy, Marine Corps, or Revenue Cutter Service who had served between April 12, 1861, and April 9, 1865. Benjamin F. Stephenson founded it in Decatur, Illinois, on April 6, 1866. Many of the ceremonies and rituals of the GAR were based on Masonic principles, including the infamous "black ball" method of voting, except the GAR required more than one black ball to be denied membership.

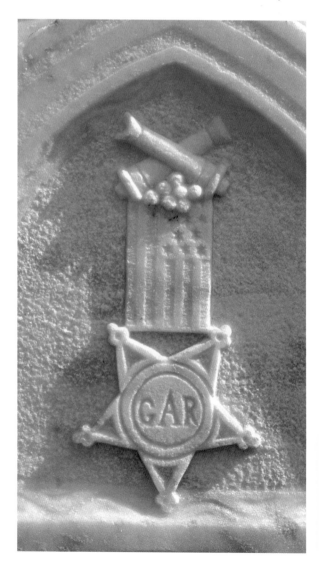

The main activities of the GAR were to provide companionship through organized Encampments and, more importantly, to establish soldiers' homes and to lobby for soldiers' pensions. The organization grew to 409,000 members by 1890 and was a political force to be reckoned with. Five U.S. presidents were GAR members, and any Republican candidate who had any hope of becoming president needed an endorsement of the GAR. This organization was also instrumental in establishing Memorial Day, May 30, as a national holiday and day of remembrance.

Alas, the GAR is no more. The final Encampment of the Grand Army of the Republic was held in Indianapolis, Indiana, in 1949, and the last member, Albert Woolson, died in 1956 at the age of 109 years.

In 1881, the GAR formed the Sons of Veterans of the United States (SV), better known as the Sons of Union Veterans of the Civil War (SUVCW). There is also a women's auxiliary, the Daughters of Union Veterans of the Civil War (DUV or DUVCW). Both organizations are still active today.

Order of the Owls (OOO)

The Order of the Owls (not to be confused with the Independent International Order of Owls, a Masonic group) was founded by John W. Talbot and some associates in South Bend, Indiana, in 1904. The Owls was primarily a social and benevolent club with no apparent ties to insurance companies or a religion. Like other social clubs of the time, it provided its members a forum to discuss business and employment opportunities, and assisted the widows and orphans of fallen Owls. The Owls had four degrees and the usual assortment secret rituals, passwords, oaths, and handshakes. At its peak in the early 1920s, the Order of the Owls had about 600,000 members who met in 2,148 lodges that they called nests. Although there is evidence that small groups of Owls continue to meet, the membership numbers are now in the dozens rather then hundreds of thousands. This

decline in membership may or may not be attributed to the founder of the order being sentenced to five years in Leavenworth prison in 1921 for morals charges involving a nurse at an Owls hospital.

Eagles (FOE)
Ladies Auxiliary of the Eagles

The Fraternal Order of Eagles, originally named "The Order of Good Things," was founded in Seattle, Washington, in 1898 by a group of theater owners. According to the Eagles, their first organizational meetings revolved around a keg of beer, and before long, the wishy-washy name, the Order of Good Things, was changed to the more authoritarian Fraternal Order of Eagles. A constitution and bylaws were drawn up, and the name "Aerie" was adopted as the designation for their meeting places and

groups. The Eagles were originally composed of people working in the theater business (actors, stagehands, playwrights, etc.), and word of the organization spread rapidly because of the mobile nature of its members. Although the organization was like many others of the time in pro-viding brotherhood, health benefits, and a funeral

benefit ("no Eagle was ever buried in a Potter's Field"), the Eagles went farther by providing an "Aerie physician." The order also had its own stirring Eagle-appropriate script for a funeral service.

The Eagles still thrive. Much of their work revolves around lobbying for improving workman's compensation and social security, and sponsoring a number of health-related charities.

Knights of Pythias (KP)
Colored Knights of Pythias (CKP)

If you see a heraldic shield coupled with a suit of armor on a tombstone, chances are it marks the spot of a fallen Knight of Pythias. Usually the letters F, C, and B, which stand for Friendship, Charity, and Benevolence, accompany the shield. It has been said that the Pythians have used upwards of 20,000 different symbols, so it's not unusual to find an array of symbols on one of their tombstones.

The Knights of Pythias was officially founded in 1864 as a secret society for government clerks. The name Pythias is a misspelling of the Greek name Phintias, a Pythagorean philosopher from Syracuse whose story dates to the fifth century BC. Evidently, the infamous tyrant Dionysius was about to put Phintias to death for questioning his rule. Phintias's friend Damon requested that he be held as a hostage so Phintias could go out and say goodbye to his friends and put his house in order

before he died. At the appointed time of execution, Phintias was nowhere to be found, so Damon offered himself in Phintias's stead. But Phintias arrived at the last minute, prepared to accept his fate. Dionysius was so impressed with the trust and loyalty of these two men that he stayed the execution and asked both of the men to join him in friendship.

One Justus H. Rathbone was so favorably influenced by the tale, which he had seen as a play, that he formed a fraternal society (albeit misspelled) based on the traits of friendship, benevolence, and charity. It took a while for the Knights of Pythias to get started, including the expulsion (on two occasions) of Rathbone. At its peak, in 1923, the society boasted over 900,000 members, but the Great Depression took its toll, and by the end of the twentieth century, membership had dropped to less than 10,000. In 1869, a group of blacks in Philadelphia petitioned the Supreme Lodge to be admitted to the society, but they were rejected a number of times and formed their own order, the Colored Knights of Pythias (CKP), in 1875. The CKP was a popular society among Southern blacks. In 1920 in Georgia, it had over 30,000 members.

Pythian Sisters (PS)

The female auxiliary of the Knights of Pythias is the Pythian Sisters. Their symbol is a Maltese cross embossed with the letters P (Purity), L (Love), E (Equality), and F (Fidelity).

Elks (BPOE)
Black Elks (IBPOEW)

Tombstones of Elks are easy to identify. They have an emblem with an elk in the center surrounded by a clock with Roman numerals and the letters BPOE (Benevolent Protective Order of Elks). The clock's hands are frozen at eleven o'clock, a sacred time to all Elks. At eleven o'clock at any Elks ritual, the following toast is read:

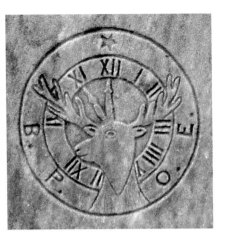

My Brother, you have heard the tolling of the eleven strokes. This is to impress upon you that the hour of eleven has a tender significance. Wherever an Elk may roam, whatever his lot in life may be, when this hour falls upon the dial of night, the great heart of Elkdom swells and throbs. It is the golden hour of recollection, the homecoming of those who wander, the mystic roll call of those who will come no more. Living or dead, an Elk is never forgotten, never forsaken. Morning and noon may pass him by, the light of day sink heedlessly in the West, but ere the shadows of midnight shall fall, the chimes of memory will be pealing forth the friendly message, "to our absent Brothers."

The Elks were an offshoot of a drinking club, the Jolly Corks (JC), that was formed by actors in 1866. The purpose of the club was to avoid a New York law that prohibited the sale of spirits on Sundays. Gatherings of the Corks became very popular, and it was deemed necessary to formalize the club. The name Jolly Corks must have seemed a bit too explicit, so a search was conducted to find a more suitable name. It's said the name Elks came from a stuffed head one of the members saw on display at the P. T. Barnum Museum (some say it was actually a moose head; but after all, it was a drinking club and mistakes do happen). The Elks became much more than a drinking club, and with over 1,500,000 members, it is now one the largest of the "animal clubs." The Elks are very strong on patriotism, public service, and caring for Elks who have fallen onto hard times.

In early 1898, two African Americans, B. F. Howard and Arthur J. Riggs tried to join the all-white organization. After being denied membership, they formed the Improved Benevolent Protective Order of the Elks of the World on November 17, 1898. The IBPOEW found out the Elks ritual had not been copyrighted, so they adopted it and secured their own copyright on the ritual. The IBPOEW currently claims a membership of approximately 500,000.

American Legion (AL)

The American Legion was founded in Paris, France, in 1919. It is primarily an association for ex-servicemen and works especially hard for veterans' rights for the wounded, infirm, and elderly. Because of its substantial membership, it also exercises quite a bit of political clout. The American Legion has gone to great lengths to explain the symbolism of their emblem. Here is the official explanation:

The Rays of the Sun form the background of our proud Emblem, and suggest that the Legion's principles will dispel the darkness of violence and evil.

The Wreath forms the center, in loving memory of those brave comrades who gave their lives in the service of the United States, that liberty might endure.

The Star, victory symbol of World War I, signalizes as well honor, glory and constancy. The letters U.S. leave no doubt as to the brightest star in the Legion's star.

Two Large Rings, the outer one stands for the rehabilitation of our sick and disabled buddies. The inner one denotes the welfare of America's children.

Two Small Rings set upon the star, the outer pledges loyalty and Americanism; the inner is for service to our communities, our states and the Nation.

The words American Legion tie the whole together for truth, remembrance, constancy, honor, service, veteran's affairs and rehabilitation, children and youth, loyalty, and Americanism.

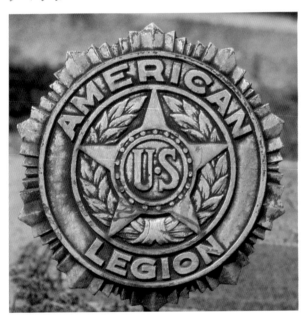

Boy Scouts of America (BSA)

The Boy Scouts were founded in 1910 by W. D. Boyce, who modeled the Scouts on a similar organization founded in England in 1907 by Robert Baden-Powell. At the beginning of the twenty-first century, there were more than 3.3 million youth members and 1.2 million adult members of the Boy Scouts.

The fleur-de-lis on the Boy Scout emblem was adapted from the north point of a mariner's compass; the three points are reminders of the three parts of the scout's oath. The two stars

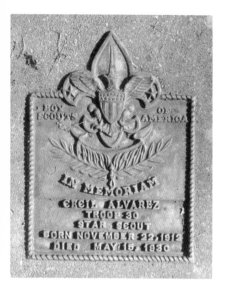

symbolize the outdoors as well as the attributes of truth and knowledge. At the bottom of the emblem is the well-known Boy Scout motto, "Be Prepared." According to official Boy Scout literature, the upward swoop of the banner "hints that a Scout smiles as he does his duty." This particular example is the Americanized version that was adopted in 1911 by the addition of the eagle and shield, which stands for "freedom and readiness to defend that freedom." Most Boy Scout emblems also have a small knot at the bottom, which is a reminder to "Do a Good Turn Daily."

Moose (LOOM)
Women of the Moose (WOM) (WOTM)

Dr. John Henry Wilson founded the Loyal Order of the Moose (now known as Moose International) in 1888 in Louisville, Kentucky, apparently on little more than a whim. Wilson's plan was to establish a fraternal organization loosely based on other animal fraternities. Membership in the Loyal Order of the Moose didn't exactly skyrocket, but in a few years, there were about 1,000 members who met in lodges called "watering places," a reference, no doubt, to the alcoholic beverages that were consumed. Wilson's initial enthusiasm must have waned, because in a few more years, there were only several hundred loyal members.

Enter one James J. Davis, who was a government clerk from Elwood, Indiana. In 1906, he attended a rather grim Moose convention (at this point, there were only 246 active members) and was sworn in as member 247. Davis, who in today's world would have been labeled a "self-starter," saw hidden potential in the Moose world and, in short order, talked the struggling society into bestowing him with the title of Supreme Organizer. Davis came up with the idea of providing a "safety net" for working-class families as the benefit of Moose membership. For $5 to $10 a year, a member could buy protection for his wife and children if he died or became disabled. For the next twenty years, Davis toured the country, extolling the virtues of membership in the Loyal Order of the Moose. His proselytizing paid off: there were more than 650,000 members by 1928.

Today, membership hovers around 1.8 million. Two of Moosedom's proudest achievements are Mooseheart (a campus-like environment that provides care for the families of fallen Moose) and Moosehaven (a retirement community in Florida). The Moose emblem usually contains the letters P.A.P. (Purity, Aid, Progress). The female auxiliary, the Women of the Moose, was established in 1913. Its emblem is essentially the same but contains the letters H.F.C., which stand for Hope, Faith, Charity.

Woodmen of the World (WOW)

Treestones, also known as "tree-stump tombstones," often mark the resting place of a Woodman of the World. Joseph Cullen Root, a native of Lyons, Iowa, founded Woodmen of the World in Omaha, Nebraska, on June 6, 1890. Root was an inveterate joiner and, at various times, had been a member of the Odd Fellows, Freemasons, Knights of Pythias, and others. Root's organization was originally open to white males aged eighteen to forty-five from the twelve healthiest states, and it specifically

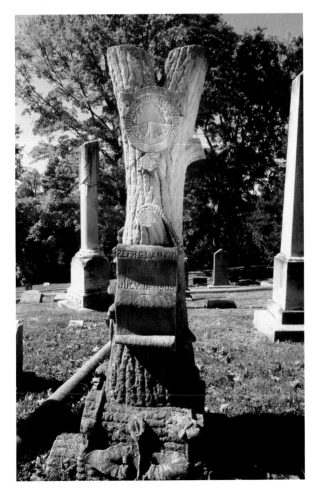

excluded men in hazardous vocations like train brakemen, gunpowder factory employees, bartenders, and even professional baseball players. Today, Woodmen of the World has relaxed most of its restrictions and totals more than 800,000 members. It is now known as the Woodmen of the World Life Insurance Society/Omaha Woodmen Life Insurance Society.

Although its membership is modest compared to other insurance-like organizations, it is one of the best-represented organizations in the cemetery, since membership in the Woodmen of the World provided each member with a tombstone carved with the society's name. Even today, the insurance company claims "no Woodmen shall rest in an unmarked grave." At first, the Woodmen of the World supplied the tombstone designs directly to local manufacturers but soon found that it was best to have local suppliers handle the design, manufacturer, and setting of the tombstones. Rustic treestones were already a popular style of tombstone and, with their woodsy name, the Woodmen of the World popularized treestones even more.

Although Woodmen of the World was primarily an insurance company, Root established a variety of ceremonies and rituals, and adopted a number of symbols because of his history with other fraternal organizations. Many of the symbols were formalized at the Woodmen Sovereign Camp in 1899, when the tree stump was officially adopted to symbolize equality and commonwealth. On tombstones there are usually the Latin words *Dum Tacet Clamet*, roughly translated as "Though Silent, He Speaks," or in popular language as "Gone but Not Forgotten." Usually embossed on the tombstone are a dove with an olive branch (peace) and an axe, beetle, and wedge that, according to Root, symbolize workmanship and progress of culture.

Like many organizations, the Woodmen had internal problems, and a number of schisms and splinter groups developed. Some of them are Neighbors of Woodcraft (NOW), Woodmen Circle (WC), Royal Neighbors (RN), Supreme Forest Woodmen Circle (SFWC), Modern Woodmen of the World (MWW), and Woodmen Rangers and Rangerettes (WRR).

Women of Woodcraft

The Women of Woodcraft was a female auxiliary organization to the Woodmen of the World. Organized in 1897, they covered nine western states, and for a time their headquarters were in Leadville, Colorado. Their officers had titles such as "Guardian Neighbor," "Captain of the Guards," "Inner Sentinel," "Outer

Sentinel," and "Magician." Unfortunately, it is not known what the duties of the Magician entailed. In 1917, the Women of Woodcraft changed their name to Neighbors of Woodcraft. From a distance, the emblem looks identical to the Woodmen of the World, but close inspection reveals that besides the different name, the motto *Dum Tacet Clamet* has been replaced with "Courage, Hope, Remembrance," and the tree stump is often broken, symbolizing the end of life.

Modern Woodmen of America (MWA)

The Modern Woodmen of America was the original name of the Woodmen of the World. It is still an active organization and,

with more than 750,000 members in 2003, it claims to be the country's fifth-largest fraternal life insurance company. Although most of the symbolism has been abandoned or toned down, until the 1950s, members could purchase various items like cuff links and rings to identify them as Modern Woodmen of America. This jewelry featured the axe, wedge, and beetle (industry, power, and progress); the log and maple leaf (shield of protection and brotherhood); and a palm, five stars, and a shield (peace, light, and safety). Modern Woodmen used the color red to signify life and action, white to signify innocence and purity of intention, and green to signify immortality. Employing a Victorian funerary tradition, some necklaces and watch fobs used braided human hair.

Neighbors of Woodcraft (NOW)

The Women of Woodcraft, also known as the "Pacific Circle, Women of Woodcraft" (it covered the states of Colorado, Montana, Wyoming, Utah, Idaho, Nevada, Washington, Oregon, and California) moved to Portland, Oregon, in 1906, where articles

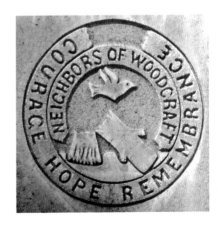

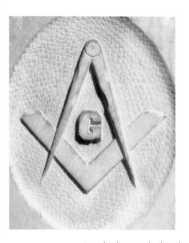

of incorporation were filed with the state of Oregon. In 1917, the Women of Woodcraft changed its name to Neighbors of Woodcraft to reflect the organization's acceptance of both men and women for membership. On July 1, 2001, the 7,000 Neighbors of Woodcraft merged with the Woodmen of the World.

Freemasons
(many acronyms; see Masonic Keystone, page 203)
Prince Hall Freemasons (PHF)
Black Society

The primary symbol of the Freemasons is the square and compass. Often, inside the symbol is the letter "G," which some say stands for geometry while others say it stands for God. Sometimes the symbol also contains clasped hands. The square and compass represent the interaction between mind and matter, and refer to the progression from the material to the intellectual to the spiritual. The Freemasons have a gift for clouding the origins of their organization, but historians say the roots of Freemasonry were among the stonemasons who built the great cathedrals in Europe. Since they went from job to job and were essentially self-employed, they were free masons. When they worked on a large job, they banded together to form lodges. The Masons have grown to become the largest fraternal organization in the world. They are noted for their wide use of symbols and secret handshakes. A free black named Prince Hall started the black equivalent of the Freemasons in 1775.

Besides the square and compass, also be on the lookout for other Masonic symbols such as the all-seeing eye, often with rays of light, which is an ancient symbol for God. Although many cultures have eye symbols, some good and some evil, when seen in a cemetery it usually means that the person was a Mason. This symbol is familiar to us as one of

the mysterious images on the reverse of the dollar bill. Its placement on the dollar bill is largely the result of America's Founding Fathers, among them George Washington, Benjamin Franklin, Alexander Hamilton, Paul Revere, and John Paul Jones, who were Masons. In fact, one scholar describes Washington's Continental Army as a "Masonic convention."

Shriners (Mystic) (AAONMS)

The Imperial Council of the Ancient Arabic Order of the Nobles of the Mystic Shrine, better known as the Shriners, was founded in 1872 by Freemasons Walter M. Fleming (an M.D.) and William J. Florence (an actor), who apparently weren't having enough fun at Freemason functions. The Shriners were only open to 32nd-degree Master Masons and Knights Templar. They adopted many of the symbols of Islam, but in a parody form, which, understandably, has irritated followers of that religion. They routinely wear amusing garments, including fezzes; give themselves titles, like Most Illustrious Grand Potentate; engage in questionable antics; and have rather boisterous conventions. At one time, the Freemasons considered banning any member who was also a member of the Shriners. When the letters of the Ancient Arabic Order of the Nobles of the Mystic Shrine are rearranged, they spell, "A MASON."

The emblem of the Shriners contains a scimitar, from which hangs a crescent, "the Jewel of the Order." In the center is the head of a sphinx (not always seen in simple emblems) and a five-pointed star. On elaborate renditions of the emblem, the crescent contains the motto *Robur et Furor* ("Strength and Fury").

The Shriners have redeemed themselves by giving large sums of money to hospitals that care for badly burned and crippled children and to a number of other causes. They still engage in their antics, most notably driving miniature cars and scooters in parades. Famous Shriners include Harry Truman, Barry Goldwater, J. Edgar Hoover, Chief Justice Earl Warren, and Red Skelton.

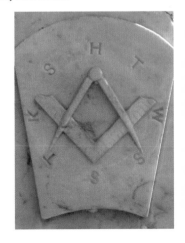

Masonic Keystone (HTWSSTKS)

The letters HTWSSTKS, arranged in a circle and usually within a keystone, are known as the Masonic Mark of an Ancient Grand Master. The letters are an abbreviation for "Hiram The Widow's Son Sent To King Solomon." Sometimes the center of the keystone contains a sheaf of wheat.

The Freemasons are not only big on symbols, but they also have a multitude of degrees and attributes that they abbreviate on tombstones. Some of the most often seen include the following:

AASR	Ancient and Accepted Scottish Rite
AF&AM	Ancient Free and Accepted Masons
AFG	Ancient Free Gardeners
F&AM	Free and Accepted Masons
GA	Grand Architect

For more Masonic symbols, see the double-headed eagle, cross with crown, tent, and shepherds' crooks.

Knights Templar (KT)
Social Order of the Beauceant (SOOB)

In cemetery symbolism, the Knights Templar is part of the convoluted Freemasons structure. The Knights claim to have been founded in 1118 by a group of warrior monks whose job was to keep the roads safe for pilgrims traveling to Jerusalem. They eventually grew very wealthy but were overthrown in 1307 by King Phillipe le Bel of France, who desired their income. Many of them escaped to England, Portugal, and Scotland, where they are said to have formed the Freemasons in the late 1700s. So many of their affairs have been shrouded in secrecy that it is impossible to put together an accurate history, except to say that in the cemetery, the Knights Templar emblem is almost always seen in its Masonic form, which is the symbol for York Rite Templarism: a cross with a crown enclosed in a Maltese cross, often containing the phrase In Hoc Signo Vinces ("in this sign conquer"), mistakenly thought to be the origin of the Christian monogram IHS.

The female auxiliary of the Knights Templar is the Social Order of the Beauceant. The organization, which was founded in 1890, was originally named "Some of Our Business Society," a reference to the help the ladies were going to provide at the Knights Templar Grand Encampment in 1892. The organization grew to more than 15,000 members, a set of rituals was established, and a more flowery name, the Social Order of the Beauceant, was adopted in 1913. The emblem of the SOOB, a cross and a crown, is the same as the Knights Templar.

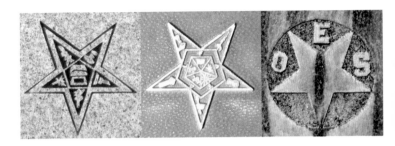

Eastern Star (OES) (ES)
Prince Hall Eastern Star (PHES)
Black Women's Organization
Prince Hall Grand Chapter (of the) Eastern Star
(PHGCES) Black Women

The Order of the Eastern Star has a convoluted history, but simply put, it is the female counterpart to Freemasonry. Three organizations use the name Eastern Star: the General Grand Chapter, Order of the Eastern Star; the Prince Hall–affiliated Eastern Stars; and the Federation of Eastern Stars. The original group, the General Grand Chapter, Order of the Eastern Star, was formed in 1876. It has been in decline in recent years, no doubt because of its powerful patriarchal rules. All degrees must be administered by a Master Mason (male).

A five-pointed star with the tip pointing down marks the grave of a member of the Eastern Star. Each symbol within the star points represents a heroine: Adah, Ruth, Esther, Martha, and Electa. They also symbolize the tenets of the Eastern Star: fidelity, constancy, loyalty, faith, and love. On tombstones, sometimes between the points of the star and other times in the center of the star, are the letters F.A.T.A.L. This refers to a double meaning of an oath taken by a member of the Eastern Star when a degree is bestowed on her. The first meaning is simply the word "FATAL," which means that it would be fatal to the character of a lady if she disclosed any of the secrets of the order. The other meaning of FATAL is an acronym meaning "Fairest Among Ten-thousand Altogether Lovely."

Eastern Star Past Matron

The emblem of an Eastern Star Past Matron has the Eastern Star symbol with a gavel suspended on a link of chain (or sometimes a gavel mysteriously levitating on a link of chain). Occasionally, a laurel wreath circles the star and a gavel is attached to the wreath by a chain.

International Order of the
Rainbow for Girls (IORG)

The meaning of the letters BFCL stands for Bible, Flag, Constitution and Linen (or List of Masonic leaders). When positioned over an R with a pot of gold, it becomes the symbol for the International Order of the Rainbow for Girls (DeMolay is

for boys). A clergyman, William Mark Sexson, founded the club in 1922 as a fraternal and social club for girls aged eleven to twenty who are related to members of the Freemasons or Eastern Star. Although all of the Masonic organizations profess to be nonsectarian, the Rainbow for Girls was originally associated with the Bible and Christian beliefs. Rainbow Girls teach seven lessons tied to the colors of the rainbow: 1) red–love 2) orange–religion 3) yellow–nature 4) green–immortality 5) blue–fidelity 6) indigo–patriotism 7) violet–service.

It is relatively rare to find this symbol in the cemetery because of the narrow age group of its members and the relatively low mortality rate of teenage girls.

Knights of the Maccabees (KOTM)

The Knights of the Maccabees was one of the more successful mutual assessment fraternal societies that sprang up after the Civil War. Although they took on many of the trappings of other societies, such as the establishment of lodges, which they called Subordinate Camps (a Supreme Tent was the highest level), the KOTM was basically a pass-the-hat organization. When a member of the society died, each member was assessed ten cents, which was given to the widow. The name of the organization was changed to the Maccabees in 1914, and it became more like a regular insurance company, although some of its older members

insisted that its rituals and ceremonies remain. At its peak, the Maccabees boasted more than 300,000 members. But the Great Depression took its toll and there are few members today.

The name Knights of the Maccabees refers to a Jewish tribe of the second-century BC that revolted against Antiochus IV of Syria in the name of religion. The tribe was led by Judas Maccabeau, who eventually secured a Jewish state, Judea. The founders of the Maccabees were impressed by Maccabeau's feats, especially his instruction to his soldiers that they reserve a portion of their spoils for the widows and orphans of their fellow comrades in arms. At the center of the Maccabees emblem are often three small tents containing the letters O T and M, which refer to the Old Testament wisdom the organization embodies.

Ladies of the Maccabees of the World (LOTM)

There was also a female counter-part to the Maccabees known as the Ladies of the Maccabees of the World. It became a national auxiliary in 1892 known as the Supreme Hive of the Ladies of the Maccabees of the World and is said to be the first fraternal benefit group run by women. This particular tombstone is inscribed with the Latin phrase *ad astra per asperi* ("toward the stars [heavens] through adversity").

Knights of Columbus (KC) (K of C)

The Knights of Columbus, founded in 1882, has often been described as the "Catholic Masons" because Catholics were forbidden by a Papal edict from joining the Freemasons. The purpose of the fraternal organization, which was originally open to Catholic men over the age of eighteen, was to provide assistance to widows and orphans of the parish. It had close to 1.5 million members in 1994. Although it has many similarities to the Freemasons, including degrees and rituals, it is mainly an insurance company. In recent years, it has become more active in community affairs and politics.

The emblem of the Knights of Columbus was designed by Supreme Knight James T. Mullen and officially adopted on May 12, 1883. The emblem incorporates a medieval knight's shield

mounted on a formée cross. The formée cross is an artistic representation of the cross of Christ. Mounted on the shield are three objects: 1) a fasces, an ancient Roman symbol of authority composed of a bundle of rods bound together around an axe; 2) an anchor, which is the mariner's symbol for Columbus; and 3) a short sword, which is the weapon of the knight when engaged in an "errand of mercy."

Independent Order of Odd Fellows (IOOF)
Grand United Order of the Odd Fellows (GUOOF) Black Society

The primary symbol of the Independent Order of Odd Fellows is three links of a chain. They share this symbol and a number of other symbols, such as the all-seeing eye, with the Freemasons, but the Odd Fellows use it as their dominant sign. Indeed, sometimes the Odd Fellows are known as the "poor man's Freemasonry." The Odd Fellows are also known as the "Three Link Fraternity." The links represent Friendship, Love, and Truth.

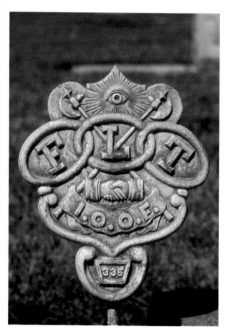

On tombstones, the letters F, L, and T are often enclosed within the links of the chain.

The IOOF is an offshoot of the Odd Fellows, which was formed in England in the 1700s as a working-class social and benevolent association. The United States branch was founded in Baltimore, Maryland, on April 26, 1819, when Thomas Wildey and four members of the Order from England instituted Washington Lodge No. 1. By the Civil War, it had more than 200,000 members, and by 1915, there were 3,400,000 members. The Great Depression and lack of interest in fraternal orders took their toll, and by the 1970s, there were fewer than 250,000 members. But the society claims that there has been a resurgence of interest and states that now it has close to 500,000 members. Death care, including funerals, was one of the major benefits of Odd Fellows membership. One of the first orders of business, after establishing a lodge in a new town, was to purchase plots in an existing cemetery or to establish a new cemetery where plots were sold to members at a modest fee. The Grand United Order of the Odd Fellows was the largest and wealthiest black fraternal order in Georgia by 1916, boasting over 1,100 lodges with 33,000 members.

Daughters of Rebekah (DR)

The Daughters of Rebekah were formed in 1851 as a female auxiliary of the Odd Fellows. Like other women's auxiliaries of fraternal organizations, they were subservient to the male organization and, understandably, their numbers have fallen off in modern times.

In the cemetery, look for a circular emblem with a half moon sometimes containing seven stars on the right, which, according to the Rebekahs, represents "the value of regularity in all our work." The emblem also consists of a dove (peace), a white lily (purity), and the intertwined letters D and R. Sometimes the emblem also contains a small beehive, which symbolizes "associated industry and the result of united effort."

International Order of Twelve, Knights and Daughters of Tabor

The Knights of Liberty was a secret African American organization organized by Moses Dickson and eleven black men in St. Louis, Missouri, in August 1846. Their goal was the destruction of slavery. The Knights claimed a peak membership of nearly 50,000, and they estimated that over a ten-year period, they helped some 70,000 slaves escape from slavery via the Underground Railroad.

Moses Dickson was also the author of the book *International 777 Order of Twelve 333 of Knights and Daughters of Tabor*. The International Order of Twelve, Knights and Daughters of Tabor is the successor to the Knights of Liberty. The Knights took the name Tabor from the Bible. Tabor is a mountain in northern Israel where an army of Israelites won a decisive victory over their enemies, the Canaanites. The 777 is the biblical prophecy number of perfection; the 333 is the biblical prophecy number for the Trinity and the Resurrection.

Companions of the Forest of America (CFA)

This is the emblem of the Companions of the Forest of America, a women's auxiliary of the Ancient Order of Foresters (AOF). In addition to the letters C of F of A on the emblem, there are the letters S, S, and C, which stand for Sociability, Sincerity, and Constancy.

The Improved Order of Red Men (IORM)
The Degree of Pocahontas (DOP)

In the cemetery, the initials T.O.T.E. (Totem of the Eagle) indicates a member of the Red Men, which traces its origin (although no direct evidence can be found) to certain secret patriotic societies founded before the American Revolution, such as the Sons of Liberty (SL). In 1813, the Society of Red Men was officially founded but was dissolved shortly thereafter, apparently because of its reputation for drunkenness. It was reformed as the Improved Order of Red Men, and its stated aim is "to perpetuate the

beautiful legends and traditions of a vanishing race and keep alive its customs, ceremonies, and philosophies." Interestingly, until recently, American Indians were banned from admission. The female auxiliary of the Red Men is the Degree of Pocahontas, which was organized in 1885.

Salvation Army

The Salvation Army is best known nowadays as a place for the downtrodden and disadvantaged to get help. It is well known for its drug and alcohol rehabilitation centers, its thrift stores, and, of course, its yuletide bell-ringing Santas. The Christian quasi-military organization (its leader is addressed as General, employees are known as Officers, and volunteers are known as Soldiers) was founded in 1865 by Englishman William Booth. It was officially named the Salvation Army in 1878.

Salvationists wore metal shields as badges in the early 1880s. The 1886 Orders and Regulations for Field Officers implored every Soldier to wear a uniform, "even if it be but the wearing of a shield," so that they could be identified as Salvationists. The first shields were white with red lettering, but this was soon changed to red with white lettering, and that shield is the one most recognized today.

A more complex formal shield with abundant symbolism is sometimes seen. According to the Salvation Army, the symbolism is thus:

(a) The round figure "the sun" represents the light and fire of the Holy Spirit.
(b) The cross in the center represents the cross of our Lord Jesus Christ.
(c) The letter "S" stands for salvation.
(d) The swords represent the warfare of salvation.
(e) The shots represent the truths of the gospel.
(f) The crown represents the crown of glory, which God will give to all his soldiers who are faithful to the end.

Fraternal Brotherhood (FB)

Alas, no one seems to know what has become of the Fraternal Brotherhood. What is known is that they were a secret beneficial society with all the usual passwords and symbols, they were organized in 1896, and they had a substantial building in Los Angeles that was featured

on ca. 1910 postcards that stated they accepted both
sexes. Why they no longer exist remains a mystery.

B'nai B'rith (IOBB)

The Independent Order of
B'nai B'rith (Children of the
Covenant) is one of the few
Jewish fraternal organizations.
It was formed in New York in
1843, partly because Jews were
denied membership in the more
mainstream fraternal organiza-
tions like the Freemasons.
Eventually, Jews were admitted
into organizations like the Freemasons and the Odd Fellows,
and those organizations are surprisingly well represented in
Jewish cemeteries. B'nai B'rith has evolved into a huge charitable
organization (it gives out and receives significant donations).
Today, the B'nai B'rith is most well known through its Anti-
Defamation League, which serves to combat anti-Semitism.

Rotary International

Rotary International,
unlike many other
organizations that were
founded in the early
twentieth century, was
not a quasi-insurance
company. Founded
in 1905, Rotary was
one of the first pure
service organizations.
It is comprised primarily of business owners and city officials.
Its members participate in community service at both local
and international levels. The organization claims 1.2 million
members in 170 countries. The name Rotary was derived from
rotating meetings between its various members' offices.

ACRONYMS

There are literally hundreds of secret societies, clubs, and
organizations. Many no longer exist while others remain
strong. *The Cyclopaedia of Fraternities* (also known as Cyclopaedia of
fraternities; a compilation of existing authentic information and
the results of original investigation as to more than six hundred
secret societies in the United States, compiled and edited by
Albert C. Stevens, assisted by more than one hundred members
of living secret societies), published in 1899 and 1907, has over
600 listings. When you see an emblem with an acronym that you
aren't familiar with or if you simply find an acronym without an
emblem, enter the name you find into an Internet search engine.
A list of acronyms also appears on the back of the fold-out map.

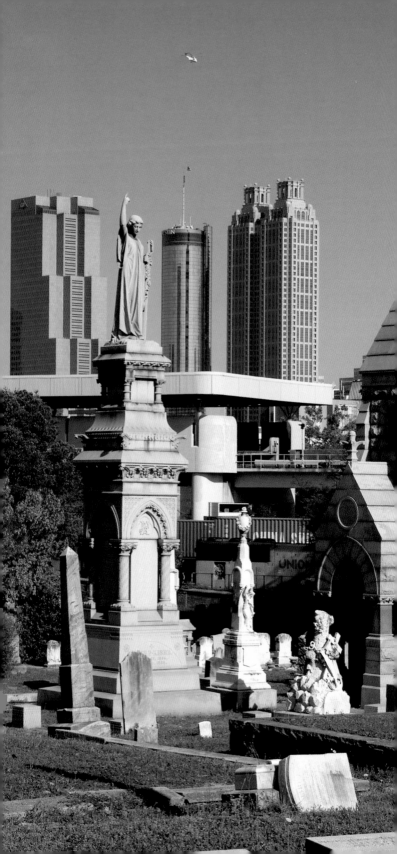

SOUTHERNERS FOREVER

Noted Civil War historian Shelby Foote stated, "Southerners put family above all else, we are what anthropologists call Ancestor Worshipers." He wasn't referring to some dark cult that sacrifices animals to appease their ancestors; he was noting that Southerners have a long history of keeping the memory of past generations alive. Indeed, even the tiniest Southern community will have a statue or two of some fallen hero, most likely one who fought during the unpleasantness that occurred between 1861 and 1865. Southerners, it seems, have a long tradition of keeping the family together—in life and in death. Mississippi-born writer Willie Morris told an interviewer, ". . . if there is anything that makes southerners distinctive from the main body of Americans, it is a certain burden of memory and a burden of history. . . . I think sensitive southerners have this in their bones, this profound awareness of the past."

In the rest of the country, cremation is fast becoming the preferred (and most convenient) way of disposing of a body. Scattering a loved ones ashes to the wind or dumping them in the sea may seem like the environmentally right thing to do, but it doesn't give future generations much of a touchstone of someone's life. In the South, however, ground burial is still the preferred choice. And ground burial, understandably, needs to take place in a cemetery. Despite advances in technology, old-fashioned cemeteries are still the best places to remember the dead.

In the following pages, you'll find a sampling of permanent Southerners who aren't in the dozen cemeteries profiled elsewhere in this book. There are children, racecar drivers, musicians, eccentrics, social reformers, and just plain folks. It's been said that you only have one chance to make a first impression. Conversely, you only have one chance to make a last impression. What follows are some modest, some grand, and some just-plain-odd last impressions.

Facing: Oakland Cemetery, Atlanta, Georgia

DAVEY ALLISON
February 25, 1961-July 13, 1996
Highland Memorial Gardens
Bessemer, Alabama
33 25 29 N 86 57 31 W (cemetery)
33 25 38 N 86 57 29 W (grave)
Inhabitants of the Southern states are known for their religious devotion. On Sunday mornings, houses of worship are often full to bursting. On other

days (or on Sundays after church) throngs of Southerners pack another type of church—the racetrack. If fans can be equated with parishioners, then racecar drivers are the priests. A few truly noble ones become saints. Davey Allison (born David Carl Allison) is one of the saints. Davey was born into a racing family on February 25, 1961, in Hollywood, Florida. His father was NASCAR series champion Bobby Allison. Davey was the nephew of NASCAR driver Donny Allison and older brother of Clifford Allison, who died in a crash in 1992 while taking practice laps on the Michigan International Speedway.

Davey, who won nineteen races in 191 starts, died from injuries sustained on the famous Talladega Superspeedway in Alabama. Ironically, his injuries were not the result of a fiery car crash but rather from a helicopter crash. On July 12, 1993, Allison and legendary NASCAR driver Red Farmer were landing a helicopter on the speedway (Allison had purchased the helicopter earlier that year). Something went wrong and the helicopter spun out of control and crashed to the ground. Farmer sustained a few broken bones, but Allison suffered massive head injuries; he died the next day. In 1998, Allison was inducted into the International Motorsports Hall of Fame. He's buried in Highland Memorial Gardens in Bessemer, Alabama. There is a memorial bench with a checkered-flag motif situated directly on one of the cemetery's roads. About 50 feet behind the bench is a large flat grave marker with Allison's likeness. It is often adorned with flowers and coins as well as cans of oil and other automobile-related items. Nearby is the grave of his brother Clifford and the future burial site reserved for his parents, Judith and Robert (Bobby) Allison.

SUSAN HAYWARD
June 30, 1917–March 14, 1975
Our Lady of Perpetual Help Catholic Church Cemetery &c: Carrollton, Georgia
33 39 49 N 85 02 58 W (cemetery) &c: 33 39 46 N 85 03 00 W (grave)
Although Susan Hayward (born Edythe Marrenner) was born in Brooklyn and died in Hollywood, her heart was in the South. Her show business career began when she worked as a photographer's model as a teenager. Like hundreds of other young

women, she journeyed to Hollywood in 1937 with the hope of securing the role of Scarlett O'Hara in the epic movie *Gone with the Wind*. Although she didn't land the role, she soon got a number of bit parts, and by 1939, she was cast opposite Gary Cooper in *Beau Geste*. Throughout the 1940s, she landed a number of leading lady roles. By the end of the 1940s, she started taking on grittier roles, starting with her Academy Award–nominated role of an alcoholic nightclub singer in *Smash Up, The Story of a Woman* (1947). Then she portrayed another alcoholic in *I'll Cry Tomorrow* (1955). She finally won her only Oscar (she was nominated five times) for her portrayal of killer Barbara Graham in *I Want to Live!*

She continued to act on television and movies throughout the 1960s until she was diagnosed with cancer in 1972. Hayward may have been exposed to excessive amounts of radiation in the summer of 1955 while she was working on the movie *The Conqueror* in St. George, Utah. St. George is downwind from the Nevada nuclear test range where two nuclear explosions were set off during the thirteen weeks of filming. As of the 1990s, ninety-one of the 220 people who worked on the location had contracted cancer, including actors Susan Hayward, John Wayne, Agnes Moorehead, and director Dick Powell. The statistical norm for cancer occurrence in a group of 220 people is about thirty cases. Hayward's cancer could also be attributed to the two packs of cigarettes she smoked daily and her heavy alcohol consumption.

Hayward married twice. The first union, from 1944 to 1954, with actor Jess Barker produced two children. In 1957, she married Southern businessman and rancher Floyd Eaton Chalkey. The two remained happily married until Chalkey's death in 1966. The couple donated heavily to Our Lady of Perpetual Help Catholic Church in Carrollton, Georgia, and were rewarded with a prominent grave site. Passersby will hardly notice that Susan Hayward is buried there, since her original grave was marked "Mrs. F. E. Chalkey 1917–1975." Some years later, a small plaque with the name Susan Hayward was added.

RAMSEY GRAVE SITES

JonBenét Patricia Ramsey ◊◊ August 6, 1990–December 25, 1996
Patricia Paugh Ramsey ◊◊ December 29, 1956–June 24, 2006
Saint James Episcopal Cemetery ◊◊ Marietta, Georgia
33 57 19 N 84 33 21 W (cemetery) ◊◊ 33 57 15 N 84 33 22 W (grave)

Most people think of JonBenét Ramsey as a Coloradoan, and while she may have lived more of her six years in Colorado than anywhere else, her family's roots are definitely East Coast, particularly West Virginia and Georgia. JonBenét is the subject

of one of the most puzzling unsolved murder cases of all time. She was born in Atlanta, Georgia, to wealthy businessman John Bennett Ramsey and beauty queen Patricia Ann "Patsy" Ramsey (née Paugh). After the family moved to Colorado when JonBenét was nine months old, her mother entered her in a number of child beauty pageants in different states. Among those she won were America's Royal Miss; Colorado State All-Star Kids Cover Girl; Little Miss Charlevoix, Michigan; Little Miss Merry Christmas; Little Miss Sunburst; and National Tiny Miss Beauty.

JonBenét was found strangled in the basement of her parents' Boulder, Colorado, home on December 26, 1996. Her parents became suspects almost immediately, but no significant evidence has ever been found to prove their guilt. Part of the reason that the unsolved case has been in the public eye for so long is the odd relationship between JonBenét and her parents. The world of child beauty contests has become a hot discussion topic, often circling around parents depriving their children of a normal childhood so the parents can cash in (directly and indirectly) on their child's celebrity status. From time to time, new evidence and theories have emerged, but none have led authorities to the murderer.

JonBenét's mother, Patsy, was a beauty queen whose most notable title was Miss West Virginia (1977), a title she won after winning the Miss Parkersville Area contest. She went on to the Miss America Pageant and won a nonfinalist special talent scholarship. Patsy married John Ramsey in 1980, gave birth to a son Burke in 1987, and welcomed JonBenét in 1990. In 1993, Patsy was diagnosed with ovarian cancer; with treatment, however, it went into remission. She suffered a relapse of the cancer in 2003 and ultimately died of the disease on June 24, 2006. She is buried in front of JonBenét and beside a number of other family members.

NADINE EARLES
April 3, 1929–December 18, 1933
Oakwood Cemetery &c Lanett, Alabama
32 52 20 N 85 12 07 W (main cemetery entrance)
32 52 05 N 85 12 09 W (grave and rear cemetery entrance)

No offense to the 8,500 citizens of Lanett, Alabama, but there isn't a lot of reason to visit this tidy little town. Well, except for one thing: it has one of the most interesting tombs in America. The tomb of Nadine Earles, which would be technically called a mausoleum, doesn't exactly look like a traditional mausoleum. It looks more like a child's playhouse, because that's exactly what it is. The only deviation from a real playhouse is that little Nadine is buried beneath it, and it is located in Oakwood Cemetery.

Nadine Earles was the oldest daughter of Julian and Alma Earles. Poor little Nadine was born with a cleft lip (also known as a harelip) and spent much of her young life in doctors' offices and in speech therapy. In November 1929, just before she was scheduled to have her second surgery, she came down with diphtheria, a highly contagious upper-respiratory disease.

Because of the contagious and deadly nature of the disease, the entire block where the Earles family lived was roped off, and the Earles' house was placed under quarantine. Shortly before Nadine became ill, her father had purchased the materials to build her a playhouse, and now that the family was forced to stay home, her father had time to build the playhouse. Unfortunately, all the hammering and sawing noise bothered the feverish Nadine, so her father halted construction. As Christmas neared, Nadine was given some of her presents early, but mostly she wanted the playhouse. Alas, Nadine succumbed to the disease on December 18.

Immediately after Nadine's death, her grief-stricken father tore down the playhouse and began rebuilding it on her grave site in Oakwood Cemetery. However, Nadine's new playhouse needed to be built with more permanent materials, and it took going through a couple of contractors before an adequate structure could be built. On April 3, 1934, on what would have been Nadine's 5th birthday, a group of twenty-five children dressed in their best party clothes showed up at Nadine's playhouse to enjoy games and a traditional birthday cake with ice cream. A photograph of that ceebration is mounted in an oval frame and propped up against a widow inside the playhouse.

As the years have progressed, Nadine's playhouse has been meticulously maintained by the family. Gifts are often left on the steps. A number of Nadine's dolls and others sent by visitors decorate the playhouse's interior. Nadine's father, Julian, died in 1976 and her mother Alma died in 1981. Their graves are located directly in front of the playhouse

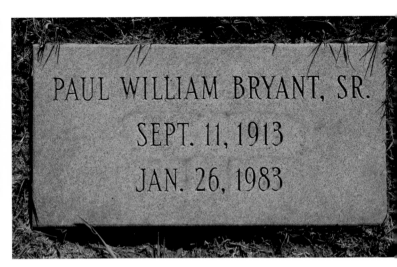

PAUL WILLIAM "BEAR" BRYANT
September 11, 1913-January 26, 1983
Elmwood Cemetery ❧ Birmingham Alabama
33 29 24 N 86 50 24 W (cemetery entrance) ❧ 33 29 06 N 86 50 38 W (grave)
There are three major religions in the South: the various
Protestant denominations; NASCAR racing; and football.
Of the latter, the highest-ranking Saint is "Bear" Bryant.
Paul William Bryant was the eleventh of twelve children
born to William Monroe Bryant and Ida Kilgore Bryant.
Paul got the nickname "Bear" as a youth when he went to
a local theater in Fordyce, Arkansas, and agreed to wrestle
a bear for one dollar. He wrestled the bear, and though he
was never paid for his feat, he acquired a nickname.

　　Bryant, it seems, had a natural talent for football. In 1930,
as a senior he led the Fordyce Red Bugs to a perfect season
and state championship. In 1931, a representative from the
University of Alabama came to Fordyce to recruit a couple of
players. He was unsuccessful in getting the players he wanted,
but he took Bryant as a consolation. During Bryant's three
years playing for the Alabama Crimson Tide, the team went
23-3-2. After graduation, Bryant turned to coaching, and from
1936 to 1957 (except for a stint in the Army from 1942–44), he
coached for a string of colleges, including assistant coach at
Union College (Tennessee), Alabama, and Vanderbilt, and head
coach at North Carolina Pre-Flight (a Navy school), Maryland,
Kentucky, and Texas A&M. In 1957, he was lured back to his
alma mater Alabama, and from the fall of 1958 to his final game
(a 21–15 victory over Illinois in the Liberty Bowl on December
29, 1982), he coached the Crimson Tide, compiling a record of
232-46-9. Including his years at the four other schools, Bear
Bryant compiled a lifetime record of 323-85-17. During his career,
he coached such greats as Joe Namath and Kenny Stabler.

Bryant announced his retirement prior to the Liberty Bowl game with Illinois. When one reporter asked him what he would do after retiring, Bryant joked that he'd "probably croak within a week." On the night of January 25, 1983, four weeks after the Liberty Bowl victory, he checked into the Druid City hospital in Tuscaloosa, Alabama, complaining of chest pains; he died the next day. Immediately after the announcement of Bryant's death, the flag at the state capitol in Montgomery was lowered to half-mast. After his funeral on January 28, thousands of fans crowded the overpasses of Interstate 59 as the funeral procession wound its way to Elmwood Cemetery in Birmingham. Paul William "Bear" Bryant is buried beneath a simple bronze marker. There is no mention of his association with the University of Alabama, his coaching record, or his nickname "Bear." Despite his modest grave, it's easy to find— just follow the red (or more properly, crimson) line painted on the road that starts at the cemetery entrance. Visitors will likely spy offerings of bags of Golden Flake Potato Chips and Coca-Cola on his grave; they were two of his sponsors. At the time of his death, he was the winningest major college coach of all time.

JULIETTE "DAISY" MAGILL KINZIE GORDON LOW

October 31, 1860–January 17, 1927
North Laurel Grove Cemetery &c· Savannah, Georgia
32 03 52 N 81 06 23 W &c· 32 03 57 N 81 06 35 W

Juliette Low, founder of the Girl Scouts, was born with a happy optimistic disposition, a quality that would get her through some unpleasant times. Born into a well-to-do Savannah family, she acquired the nickname "Daisy" (a name she kept for her entire life) when her uncle saw her as a baby and exclaimed, "I'll bet she'll be a daisy." Sometimes she also used the nickname "Little Ship"—a shortened version of "Little-Ship-Under-Full-Sail," a name given to her great-grandmother by the Seneca Indians after they captured her. Apparently her great-grandmother's equally sunny disposition confounded her captors and they eventually let her go.

Young Daisy developed an interest in the arts, wrote poems, sketched, and sculpted. As was common in wealthy families, she went to private boarding school and finishing school. When she was twenty-five, she developed an ear infection, which a doctor treated with silver nitrate. That treatment left her with partial deafness. At age twenty-six, she married a wealthy Englishman, William Mackey Low, reportedly against her parent's wishes. Unfortunately, the union was not a happy one, but it did allow Daisy

to travel extensively in Europe and America. Adding to Juliette's woes was a pesky grain of rice that had lodged in her good ear during the traditional rice throwing at the end of her wedding. The ear became infected and eventually she lost almost all of her hearing. Sometime later, William Low took a mistress and Juliette made plans to divorce him, but he died in 1905 before she could file for divorce. In his will, he granted most of his estate to his mistress and gave little more than a widow's pension to Juliette.

The contents of the will were a real slap in the face to Juliette, and she spent a few years without much of a sense of direction. However, she regained her buoyant spirit in 1911 when she met Sir Robert Baden-Powell, the founder of the Boy Scouts and Girl Guides. Charged with newfound enthusiasm, she phoned a friend in Savannah one day in late winter 1912 and announced, "I've got something for the girls of Savannah, and all America, and all the world, and we're going to start it tonight." On March 12, 1912, Juliette gathered eighteen girls together and formed the American Girl Guides; the name was changed to the Girl Scouts in 1913. From 1912 until her death from breast cancer in 1927, she was a tireless promoter of the Girl Scouts. Juliette "Daisy" Low's mission was to get girls of all backgrounds into the out-of-doors and learn about nature while developing self-reliance and resourcefulness. She also actively recruited disabled girls, a subject she was sensitive to because of her own deafness. The epitaph on her grave in North Laurel Grove Cemetery in Savannah says that she was the wife of William M. Low, but her two-timing husband is buried elsewhere.

EDDIE JAMES KENDRICK

December 17, 1939–October 5, 1992
Elmwood Cemetery &c Birmingham Alabama
33 29 24 N 86 50 24 W (cemetery entrance) &c 33 29 15 N 86 50 50 W (grave)

Eddie Kendricks, born Eddie James Kendrick, was an original member and co-founder of the famous Motown group, The Temptations. Kendrick was born to Johnnie and Lee Bell Kendrick in Union Springs, Alabama. After the family moved to Birmingham, he met his lifelong friend Paul Williams in a church choir. The duo formed a doo-wop group with friends Kel Osbourne and Willie Waller, and called themselves The Cavaliers. They traveled around the area; then, on the advice of their

manager, Milton Jenkins, they moved to Detroit and changed their name to The Primes. The group did well in the Detroit area, so well that a namesake female group, The Primettes,

was formed. The Primettes changed their name to The Supremes. In 1961, The Primes disbanded, and Kendricks and Williams joined forces with another group and renamed themselves The Temptations.

The Temptations' first job was singing background for Mary Wells; then they branched out on their own. They quickly rolled out a string of hits, often featuring Kendricks' falsetto voice in the lead, including "The Way You Do the Things You Do," "Get Ready," and "Just My Imagination." As with many groups, friction developed between the members. Kendricks left the group in 1971 to pursue a solo career. As a parting jab at Kendricks, the Temptations recorded the hit song "Superstar (Remember How You Got Where You Are)."

Kendricks had some fits and starts getting his solo career on track but scored big in 1973 with his only number one solo hit, "Keep on Truckin'." Kendricks decided to leave Motown in 1978 and move to Arista Records but had to give up his Motown royalties to do so. In the 1980s, he went back to using his birth name Kendrick and briefly toured with a reunited Temptations. In 1989, Kendrick and his original Temptations band mates were inducted into the Rock and Roll Hall of Fame. Shortly after being inducted into the Hall of Fame Kendrick got together with other bandmates and made plans for a group to be called Ruffin/Kendrick/Edwards, Former Leads of The Temptations. Unfortunately, Ruffin died of a drug overdose, and then Kendrick was diagnosed with lung cancer (he was a chain-smoker). Eddie James Kendrick died on October 5, 1992, in Birmingham, Alabama, at the age of fifty-two. His grave is somewhat difficult to find. From the road, look for an upright marker carved with the name Simpson (Kendrick is on the other side). Eddie Kendrick is buried beneath a flat stone marker. The original marker had a porcelain portrait inset in the stone, but when someone attempted to steal it, the portrait shattered and only fragments remain.

GEORGE CORLEY WALLACE JR.

August 25, 1919–September 13, 1998
Greenwood Cemetery &❧ Montgomery, Alabama
32 22 21 N 86 15 55 W (cemetery entrance) &❧ 32 22 20 N 86 15 45 W (grave)

George Wallace's life is testament that it's never too late to ask for forgiveness. He was born in Clio, Alabama, to George Corley Wallace and Mozell Smith. In high school, he became a regionally successful boxer, which may account for his lifelong feistiness, or boxing was certainly an outlet for his feistiness. After high school, he went to law school at the University of Alabama and emerged with a law degree in 1942. After law school, he served in the army but was discharged after a bout with spinal meningitis left him with partial deafness and nerve damage.

In late 1945, he entered into a lifelong career in politics and public service when he was appointed assistant attorney general of Alabama. Then, in May 1946, he was elected to the Alabama house of representatives. In Wallace's early political career, he was considered a moderate on racial issues. But

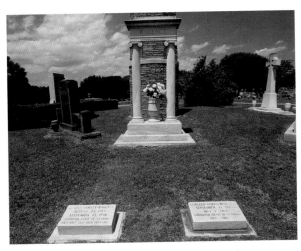

in order to attain more political clout, he started to become a more hard-line segregationist. The determining moment that cemented his segregationist policies came in the 1958 Democratic gubernatorial primary (which was essentially a general election at the time because the Republicans had little power). His opponent had the support of the Ku Klux Klan while Wallace had the support of the NAACP. Wallace lost the election.

After his defeat he became a rabid segregationist, and in 1962, he achieved a landslide victory on a pro-segregationist, pro-states' rights platform. During his inaugural speech, he uttered what has now become the quote most associated with him: "In the name of the greatest people that have ever trod this earth, I draw the line in the dust and toss the gauntlet before the feet of tyranny, and I say segregation now, segregation tomorrow, segregation forever." Even though Wallace claimed that the words were written by a speechwriter and that he did not preview the speech, he never retracted them.

On June 11, 1963, Wallace stood in front of Foster Auditorium at the University of Alabama in an attempt to block desegregation of the university by trying to stop the enrollment of two black students, Vivian Malone and James Hood. This incident became known as the "Stand in the Schoolhouse Door." Wallace stood aside only after being confronted by federal marshals, Deputy Attorney General Nicholas Katzenbach, and the Alabama National Guard. However, there is evidence that the entire encounter was partially or wholly coordinated with the Kennedy administration to allow Wallace to save face with Alabama voters.

Wallace was elected governor of Alabama for three terms. He essentially served four terms when, in a clever political move, his wife Lurleen ran for governor (and won) after his first term expired. Lurleen died in 1968 while serving as governor. While campaigning for president as a Democrat in 1972, Wallace was shot by would-be assassin Arthur Bremer. Interestingly, Bremer wasn't politically motivated; he just wanted to be famous. The shooting left Wallace paralyzed, but he continued

his life in public office, serving as governor from 1971 to1979 and again from 1983 to1987. In later years, his position on segregation and racial relations softened, so much so that in 1979, Wallace placed a call to civil rights leader John Lewis to ask his forgiveness for his actions of the past. Lewis, as well as many other African Americans who Wallace contacted, accepted his repentance. Then in 1996, Vivian Malone Jones, one of the black students Wallace tried to stop from enrolling at the University of Alabama in 1963, received an award honoring her courage from a foundation bearing Wallace's name.

Wallace married and divorced two more times after Lurleen's death in 1968. His health steadily declined in the last years of his life. He died of septic shock from a bacterial infection in Jackson Hospital in Montgomery, Alabama, on September 13, 1998. He had also suffered from Parkinson's disease and respiratory problems in addition to complications due to his spinal injury. He is buried next to his first wife, Lurleen.

DR. MARTIN LUTHER KING JR.
January 15, 1929–April 4, 1968
Martin Luther King Jr. Center ❦ Atlanta, Georgia
33 45 18 N 82 22 24 W

Dr. Martin Luther King Jr. was one of the most important social reformers of the twentieth century. He was the son of minister and civil rights activist Reverend Martin Luther King Sr., known as Daddy King, and schoolteacher Alberta Williams King. King's father and his maternal grandfather, Reverend Adam Daniel Williams, served as pastors of Atlanta's Ebenezer Baptist Church. By the time King was five, he was performing gospel songs at church affairs, accompanied on the piano by his mother. At age fifteen, he entered Morehouse College where he became an admirer of its president, Dr. Benjamin E. Mays. Under Mays' influence, King entered the ministry. He graduated from Morehouse College in 1948, went on to receive a divinity degree from Crozer Theological Seminary in Chester, Pennsylvania, and then went to Boston University where he received his PhD in theology in 1955. During his time at divinity school, King met his future wife, Coretta Scott. They married in 1953. While pastoring at the Dexter Avenue Baptist Church in Montgomery, Alabama, from 1954 to 1957, King became active in the civil rights movement. His first involvement was a boycott of Montgomery's segregated bus system in 1955. The boycott's success won King national fame and identified him as a symbol of Southern blacks' new efforts to fight racial injustice. Along with friend Reverend Ralph D. Abernathy and others, he, founded the Southern Christian Leadership Conference (SCLC) in New Orleans in 1957. The organization's goal was to expand the nonviolent struggle against racism and discrimination.

Throughout the 1960s, King and other civil rights leaders demonstrated to protest discrimination. Media coverage of both the nonviolent and the violent demonstrations produced a national outcry against segregation. King's nonviolent demon-

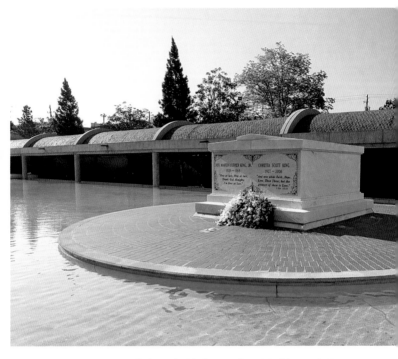

strations culminated with the March on Washington in August 1963. The march brought more than 200,000 white and black citizens to the nation's capital to demand the passage of civil rights legislation by Congress. The climax of the march was King's famous "I Have A Dream" speech, which he delivered on the steps of the Lincoln Memorial. In 1964, Congress passed the civil rights bill that was spearheaded by President John F. Kennedy and his successor, President Lyndon B. Johnson. King received the Nobel Peace Prize in Oslo, Norway, in December 1964.

Continued violence against civil rights workers, especially in the Southern states, fueled a more violence-oriented segment of the civil rights movement that used black power slogans. King repeated his commitment to nonviolence, but disputes among civil rights groups over black power continued to fragment the movement. Increased concerns about the relationship between racism and the unfair distribution of wealth in the economy propelled King to plan to organize a "Poor People's Campaign" in early 1968 to unite all disadvantaged people to combat economic oppression. In early 1968, King accepted an invitation to join demonstrations in support of striking black sanitation workers in Memphis, Tennessee. He was assassinated on the balcony of a hotel in Memphis on the evening of April 4, 1968, by gunman James Earl Ray (whether Ray acted alone is still debated). Later that evening, King was pronounced dead at St. Joseph Hospital. King's body was flown to Atlanta, where it lay in state at Sisters Chapel of Spelman College.

On April 9, 1968, Ralph Abernathy, who had been with King since the Montgomery bus boycott days, conducted his funeral service at Ebenezer Baptist Church. Prominent civil rights leaders, black entertainers, and professional athletes, as well as the four leading presidential contenders—Senator Eugene McCarthy, Senator Robert Kennedy, Vice President Hubert Humphrey, and Richard Nixon—attended the service. A crowd exceeding 60,000 listened to the service over loudspeakers outside, and as many as 50,000 joined in the funeral cortege from Ebenezer to the campus of Morehouse College. King's casket was borne on a farm cart drawn by two mules, symbolic of the Poor People's Campaign. At Morehouse, college president emeritus Benjamin Mays gave a brief eulogy before King was buried next to his grandparents at Atlanta's South View Cemetery.

Martin Luther King Jr.'s remains were moved to the King Center (founded by Coretta Scott King) in 1971. King's marble sarcophagus-style tomb was constructed in 1976, and the surrounding King Center complex was completed in 1981. The sarcophagus is sited on a circular island in a pool, which is part of a memorial plaza that incorporates cascading pools, a fountain, and the Freedom Walk, a barrel-vaulted arcade. The narrow end of the sarcophagus, which faces Auburn Avenue and the Ebenezer Baptist Church, is inscribed, "REV. MARTIN LUTHER KING, JR. 1929–1968 Free at Last, Free at Last, Thank God Almighty, I'm Free at Last." After Coretta Scott King's death in 2006, the sarcophagus was modified into a double sarcophagus. Her inscription reads, "Coretta Scott King 1927–2006 "And now abide Faith, Hope, Love, These Three; but the greatest of these is Love.' 1 Cor. 13:13."

O. HENRY (WILLIAM SYDNEY PORTER)

September 11, 1862–June 5, 1910
Riverside Cemetery ✣ Asheville, North Carolina
35 36 09 N 82 33 58 W (cemetery)
35 36 00 N 82 34 12 W (grave–approximate)

There is a simple grave in Asheville's Riverside Cemetery carved with the name William Sydney Porter. He was born in Greensboro, North Carolina. His mother died when he was three and much of his early education came from his aunt,

who ran an elementary school. He was an avid reader and, by all accounts, enjoyed school immensely. At age nineteen, he became a licensed pharmacist. He moved to Texas in 1882, hoping a change of climate would cure a nagging cough he couldn't shake. Porter worked on a ranch doing odd jobs but, after moving to Austin, secured a job as a pharmacist and then got a good-paying job as a draftsman. While he was in Austin, he met and married Athol Estes, and the couple became involved in various art and theater groups.

During the couple's time in Austin, Porter, with encouragement from his wife, began to write. It seems he had a natural gift for storytelling. Soon his stories started appearing in magazines and newspapers. He also used his time in Austin to develop ideas for stories that would appear in the future, such as "Buried Treasure" (1908) and "Georgia's Ruling" (1900). In 1894, Porter got a job as a teller and bookkeeper at the First National Bank of Austin. Later that year, he was accused of embezzlement by the bank but was never indicted. No longer able to get a job in the banking industry, he moved his family to Houston, where he secured a job as a writer for the *Houston Post*, earning a paltry $25 a month. When he was working at the paper, Federal auditors arrived at his old job in Austin and after finding some discrepancies in the books, got a federal indictment against him. His father-in-law bailed him out, but days before the trial, Porter jumped bail and fled to Honduras via New Orleans. During his time in Honduras, he coined the term *Banana Republic* to described dictatorships in tropical countries.

While in Honduras, Porter sent for his Athol and their child, Margaret, but Athol felt she was too ill to travel. When Athol became even sicker, Porter returned to the United States, where he surrendered himself to authorities. Athol Estes Porter died on July 25, 1897. Porter went on trial in March 1898 and was convicted and sent to prison in April. Luckily, because of his skills as a pharmacist, he never had to spend time in a cell and was allowed to have a room of his own. During his time in the Ohio Federal Penitentiary, he resumed his writing, using a variety of pseudonyms. His most popular pseudonym was O. Henry. While he was in prison, fourteen of his stories were published; among the most popular was "Whistling Dick's Christmas Stocking," which appeared in the December 1899 issue of *McClure's Magazine*. On July 24, 1901, William Sydney Porter, aka O. Henry, was released from prison early because of good behavior.

After he was released, Porter was reunited with his twelve-year-old daughter, Margaret (she had been told that he was away on business). They moved to New York so he could be nearer his publishers. He married again in 1907, this time to his high school sweetheart, Sarah Lindsey Coleman. The couple separated in 1908. From his arrival in New York in 1902 until his death in 1910 from cirrhosis of the liver (he was a heavy drinker and probably an alcoholic), 381 of his stories were published under his O. Henry pseudonym. Although he rarely received acclaim from the critics, he was loved by the

public, especially the common man. His stories were often playful and optimistic, and frequently had surprise endings. Among his most famous short stories are "The Gift of the Magi," "The Ransom of Red Chief," and "The Cop and the Anthem."

Porter never explained how he came up with the name O. Henry as a pseudonym, but there are a few popular theories:

1. The Harrells, with whom Porter stayed in Austin, had a cat named Henry that Porter played with. The cat came running when Porter would shout, "Oh, Henry!"

2. He took the name from the place he was imprisoned, the Ohio Penitentiary.

3. He acquired the pseudonym from a warden named Orrin Henry.

4. It is an abbreviation of the name of a French pharmacist, Etienne Ossian Henry, who is referred to in the U.S. Dispensatory, a reference work Porter used when he was in the prison pharmacy.

5. In New Orleans, before he left for Honduras, Porter would often call to the bartender of his favorite saloon, "Oh Henry, set 'em up again!"

PORTER HEADSTONES

Dr. Algernon Sidney Porter ⊗⊗ August 22, 1825–September 20, 1889
Mary Swaim Porter ⊗⊗ February 12, 1825– September 26, 1865
First Presbyterian Church Cemetery ⊗⊗ Greensboro, North Carolina
Guide book available in gift shop adjoining cemetery
36 04 31 N 79 47 16 W

Dr. Algernon Sidney Porter and his wife, Mary, were the parents of legendary writer O. Henry. Mary died when her son was only three years old, but O. Henry always said that his mother had a profound influence on his writing. Algernon Porter was a man of many talents. He was a pharmacist, doctor, teacher,

and inventor. Among his inventions was a train car coupler that made what was a very dangerous operation much safer. He was also known as an altruistic man and often provided his medical services for little or no charge to poor families.

VOODOO QUEEN TOMB
St. Louis Cemetery No. 1 ❧ New Orleans, Louisiana
29 57 33 N 90 04 17 W

This is the reputed burial place of one of New Orleans' most notorious voodoo queens, Marie Laveau. The mystic cult of voodooism has its origins in Africa, although it was brought to New Orleans by way of the Caribbean island of Santo Domingo. Voodoo developed quite a following in the nineteenth century and still exists today. There are always offerings of some sort in front of the tomb. The exterior of the tomb is awash in the letter X, a voodoo sign of good luck. Guidebooks describe this tomb as Greek Revival, but at best, it is a rather stripped-down version of the style.

These brick and plaster "house tombs" often contain the remains of generations of families. They are usually designed with two vaults (one above the other) and a pit (or caveau) below. When room is needed for another body, the tomb is opened and the bones of the previous occupant are removed and placed in the caveau. If the casket hadn't completely disintegrated, it was used for firewood.

ELVIS AARON PRESLEY
January 8, 1935–August 16, 1977
Graceland Estate ❧ Memphis, Tennessee
35 02 47 N 90 01 29 W

Without a doubt, the most visited grave in the South is the last resting place of Elvis Aaron Presley. Elvis, aka The King, was born in Tupelo, Mississippi, to Vernon and Gladys Presley. He had a stillborn twin brother, Jessie Garon Presley. His father, Vernon Elvis Presley, a bit of a ne'er-do-well, was employed at a variety of jobs and spent time in jail for check forgery. It was Elvis's mother, Gladys Love Smith Presley, who was largely responsible for the young boy's upbringing. In Priscilla Presley's autobiography *Elvis and Me*, she describes Gladys as a "surreptitious drinker and alcoholic." Elvis was known as a momma's boy because he spent so much time with his mother. To combat his shyness, Elvis sang in the church choir. In 1946,

he purchased a guitar with money his mother had given him as a birthday present. That guitar changed everything.

Young Elvis took his guitar everywhere he went, singing and playing at hardware stores and in local singing contests. In 1948, the family moved to Memphis, and he played in a band in the public housing project where the family lived. For the next few years, Elvis immersed himself in the world of music, listening to hillbilly music, gospel, boogie-woogie, blues, and soul. By incorporating elements of those different musical styles, he invented his own signature style of music. On July 18, 1953, he made his first record, paying the Memphis Recording Service (later known as Sun Studios) $3.98 to record a two-sided acetate of "My Happiness" and "That's When Your

Photo courtesy of Tim Giusta.

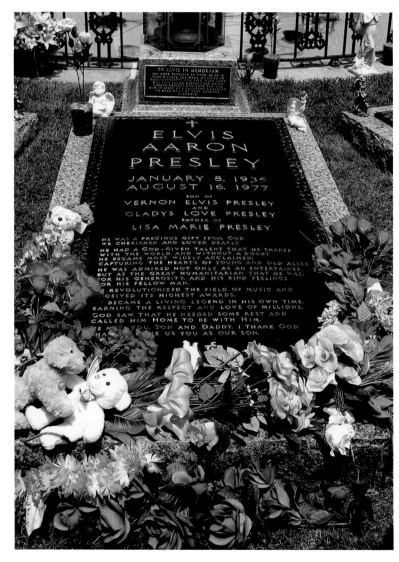

Heartaches Begin." He presented the recording to his mother for her birthday. He made more recordings in the next few months, and record producers began to take notice. The more notice he received, the more he let his own style emerge.

A large part of Elvis's style didn't have to do with the lyrics, the rhythm, or the instruments; it had to do with his body. He gyrated all over and mostly from the hips down. In 1956, when he was asked to explain his gyrations after appearing on a New York City television program, he stated, "Rock and roll music, if you like it, and you feel it, you can't help but move to it. That's what happens to me. I have to move around. I can't stand still. I've tried it, and I can't do it." The defining moment in his gyrating career came in a September 1956 appearance on the Ed Sullivan Show, when the straight-laced Sullivan felt compelled to show Elvis only from the waist up. By that time, Elvis Aaron Presley was already a phenomenon. Girls swooned for him, white racists attacked him for mingling black music and white music, and some blacks accused him of stealing their music. Never mind, Elvis was selling millions of records and making himself (and his manager, Colonel Tom Parker) buckets of money.

From the mid-1950s into the early '60s, Elvis was the King. It seemed that nothing could stop him—not an Army-interrupted career, court orders that banned him from gyrating, a series of less-than-inspired movies, nor the sudden death of his mother—nothing. Nothing except hippies. By the mid-1960s, Elvis had become passé. The next generation was into turning on, tuning in, and dropping out with music and drugs. Only middle-aged people listened to Elvis; he just wasn't cool anymore. He may have been down, but he wasn't out. He essentially admitted he had become passé by staging a comeback tour in December 1968.

Much of Elvis's comeback was focused on his flamboyant costumes and theatrics. He increasingly performed before audiences in Las Vegas, where middle-aged and blue-haired patrons didn't mind spending a little extra to see a bona fide American icon. Although Elvis became pudgy and overweight, and turned increasingly to prescription drugs, he never really lost his appeal. On August 17, 1977, he was found on his bathroom floor by his fiancée Ginger Allen. The official cause of death was congestive heart failure. Presley was buried at Forest Hill Cemetery, Memphis, next to his mother. After an attempt to steal his body, Elvis's remains were reburied at his Memphis home, Graceland, in what is now called the Meditation Gardens. Also buried there are his mother, Gladys Love Smith Presley (1912–1958); his paternal grandmother, Minnie Mae (Hood) Presley (1890–1980); and his father, Vernon Elvis Presley (1916–1979). There is also a memorial marker to his stillborn twin brother, Jessie Garon Presley, marked January 8, 1935. In 2005, the last of Elvis's horses, Ebony's Double, died at age thirty-two and was buried on the estate.

MISS BAKER

1957–November 29, 1984
Huntsville Space Center ❦ Huntsville Alabama
34 42 43 N 86 39 14 W

Records and firsts often come with an asterisk. Did George Washington really chop down that cherry tree? Does Barry Bonds deserve the home run record if some of those homers were

pharmaceutically assisted? Did Columbus really discover America? And is the epitaph on Miss Baker's tombstone, "First U.S. animal to fly in space and return alive" true? Miss Baker was a squirrel monkey and one of America's first astronauts. On May 28, 1959, she and Miss Able, a rhesus monkey, made history when they were strapped into a capsule atop a Jupiter rocket, fired 300 miles into space, and returned safely to the earth.

Miss Able didn't enjoy her fame for long; she died the next day during surgery to remove her electrodes. Miss Baker, however, lived long and well, retiring to the Redstone Arsenal in Huntsville and later to the U.S. Space & Rocket Center. She died there, age twenty-seven, in 1984. Miss Baker is buried under a granite pillar in a grove of trees next to the Space & Rocket Center parking lot. The pillar singles out her accomplishment. She was a famous monkey, yes, but her post mortem claim to fame properly belongs to poor Miss Able as well. Offerings of bananas are placed on Miss Baker's tombstone on an almost daily basis.

And if we're splitting hairs, it should be noted that in 1958, a monkey named Gordo was catapulted 300 miles into space from Cape Canaveral and then landed alive (according to the monitors) 1,500 miles away, only to drown after the flotation device failed to properly deploy.

JOHN LUTHER "CASEY" JONES

March 14, 1863-April 30, 1900
Mount Calvary Cemetery ❦ Jackson, Tennessee
Note: gravestone has wrong birth date
35 37 57 N 88 48 22 W (cemetery entrance)
35 37 57 N 88 48 24 W (grave)

Casey Jones is without a doubt America's most famous railroad engineer. Born John Luther Jones in southeast Missouri, he

got his nickname "Casey" from one of the places he lived, Cayce, Kentucky. Jones was a strapping lad at 6 feet 4 1/2 inches tall, and his size and strength made him especially suited for strenuous railroad work. He worked his way up the ladder of the Illinois Central from telegrapher to brakeman to fireman and, eventually, to engineer. As an engineer, he developed a distinctive whistle and people would remark, "There goes Casey Jones" as he sped by. He liked speed and was known as a chance taker. During his career, he racked up nine infractions, which resulted in his suspension for 145 days.

On the night of April 29, 1900, Casey Jones filled in for a sick engineer on the New Orleans Express (later known as the City of New Orleans). Jones could have waited until the next morning but decided to go that night and to try to make the 188-mile run from Memphis to Canton, Mississippi, in record time. Casey and his fireman, Sim Webb, poured on the steam. The pair made great time but took risks, especially on some of the curvy sections of tracks. About fifteen miles north of the town of Vaughn, Mississippi, a disabled train was blocking the tracks. Unaware of the problem, Casey was barreling in their direction at about 75 miles an hour. The engineer of the disabled train had laid down warning flares, but it was too late; Casey Jones was going too fast to stop. Jones yelled to Sim Webb to jump as Jones applied the brakes and pulled hard on the whistle. The New Orleans Special plowed into the other train's caboose and Jones was killed. (His watch was stopped at 3:52 am.) Miraculously, none of the passengers on Jones' train were seriously hurt. An investigation followed that put the blame on Jones. The whole episode would have become a mere asterisk in the history of American railroading had it not been for the song "The Ballad of Casey Jones."

The story goes that black engine wiper Wallace Sanders composed and sang songs while he worked in the railroad shop in Canton. After the train wreck, Sanders, who knew and admired Casey, composed a ballad about the wreck to the tune of "Jimmie Jones," a popular song at the time. The catchy tune and timely lyrics were an immediate hit among the trainmen working on the Illinois Central. Since the words were never formalized, the song had many versions. William Leighton, an engineer on the Illinois Central told his brothers, Frank and Bert, about it. Frank and Bert Leighton were vaudeville performers, and soon they were singing their version of the song all over the country. Other performers picked up the song, and with each performance, the legend of Casey Jones grew. The song was finally published in 1902 with words by Eddie Newton and music by T. Lawrence Seibert. Neither Wallace Sanders nor Casey's wife, Janie, ever received any royalties for the song. There have been over forty different renditions of the song. What follows is the version Casey's widow, Janie Jones, considered to be the most accurate representation of Wallace's original.

The Ballad of Casey Jones

Come all you rounders if you want to hear
A story 'bout a brave engineer,
Casey Jones was the rounder's name
'Twas on the Illinois Central that he won his fame.

Casey Jones, he loved a locomotive.
Casey Jones, a mighty man was he.
Casey Jones run his final locomotive
With the Cannonball Special on the old I.C.

Casey pulled into Memphis on Number Four,
The engine foreman met him at the roundhouse door;
Said, "Joe Lewis won't be able to make his run
So you'll have to double out on Number One."

If I can have Sim Webb, my fireman, my engine 382,
Although I'm tired and weary, I'll take her through.
Put on my whistle that come in today
'Cause I mean to keep her wailing as we ride and pray.

Casey Jones, mounted the cabin,
Casey Jones, with the orders in his hand.
Casey Jones, he mounted the cabin,
Started on his farewell Journey to the promised land.

They pulled out of Memphis nearly two hours late,
Soon they were speeding at a terrible rate.
And the people knew by the whistle's moan.
That the man at the throttle was Casey Jones.

Need more coal there, fireman Sim,
Open that door and heave it in.
Give that shovel all you got
And we'll reach Canton on the dot.

On April 30, 1900, that rainy morn,
Down in Mississippi near the town of Vaughan,
Sped the Cannonball Special only two minutes late
Traveling 70 miles an hour when they saw a freight.

The caboose number 83 was on the main line,
Casey's last words were "Jump, Sim, while you have the time."
At 3:52 that morning came the fateful end,
Casey took his farewell trip to the promised land.

Casey Jones, he died at the throttle,
With the whistle in his hand.
Casey Jones, he died at the throttle,
But we'll all see Casey in the promised land.

His wife and three children were left to mourn
The tragic death of Casey on that April morn.
May God through His goodness keep them by His grace
Till they all meet together in that heavenly place.

Casey's body lies buried in Jackson, Tennessee,
Close beside the tracks of the old I.C.
May his spirit live forever throughout the land
As the greatest of all heroes of a railroad man.

Casey Jones, he died at the throttle,
Casey Jones, with the whistle in his hand.
Casey Jones, he died at the throttle,
But we'll all see Casey in the promised land.

HENRY WOOLDRIDGE

January 29, 1822-May 30, 1899
Maplewood Cemetery ❦ Mayfield, Kentucky
36 44 55 N 88 38 11 W (cemetery entrance) ❦ 36 44 57 N 88 38 10 W (grave)
Henry Wooldridge, who never married (his first and only love
died in a riding accident), may be the only one buried here, but
he is surrounded by friends. This incredible monument was com-
missioned by Wooldridge in the late 1890s, a few years before
his death. Understandably, a monument as unique as his has
been the subject of many stories and folklore. How Wooldridge
came up with the idea is not known, but what is known is the
identification of all eighteen statues. The elevated figure is
Henry Wooldridge, as is the figure in foxhunting garb astride his
horse Fop. Also depicted are his mother, Keziah; his brothers,
Alfred, W. F., John, and Josiah; his sisters, Susan Neely, Narcissa
Berryman, Minerva Nichols; plus his two nieces, Maud Reeds
and Minnie Neely. Along for the stroll are his two dogs, Towhead

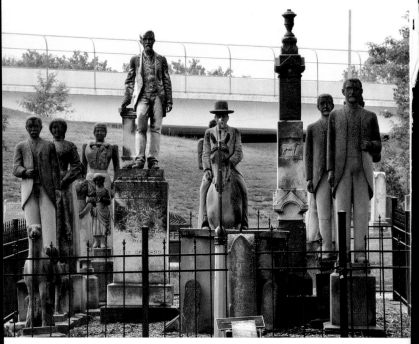

and Bob, and a fox who remains nameless. Interestingly, there is
no depiction or mention of Colonel Wooldridge's father, Josiah.

The monuments were crafted by the Paducah
Marble Works and the Pryor & Radford Monument
Works in Paducah, Kentucky. They were placed on
the National Register of Historic Places in 1980.

THELMA E. HOLFORD
1906-1989
Jonesboro Memorial Park &c Jonesboro, Arkansas
35 47 46 N 90 41 22 W (cemetery entrance) &c 35 47 51 N 90 41 17 W (grave)

It's often been said that you only have one chance to make a first
impression. Thelma Holford decided to turn the tables on that
old saw and made a unique last impression at the Jonesboro
Memorial Park by erecting a one-of-a-kind monument featuring

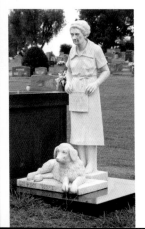

her and her dog, Bunnie. Thelma was known
as the town eccentric in Jonesboro. She was an
astute businesswoman who managed a success-
ful awning business. She was also a great lover
of dogs and treated them like the children she
never had. After her death, a pet cemetery was
started in her honor. According to the cemetery
sexton, she had been married but was divorced
for many years and never remarried. That fact
may partially account for the message on the
sign she holds, "Don't be afraid to stand alone."
The monument was crafted in Italy, and the first

rendering apparently was not to Thelma's liking. She sent it back, saying that it made her dog look like a horse.

TAMMY WYNETTE

May 5, 1942-April 6, 1998
Woodlawn Memorial Park Cemetery &c Nashville Tennessee
36 06 42 N 85 45 40 W (cemetery entrance)
36 06 58 N 85 45 36 W (community mausoleum, 4th floor)

Country music fans know Tammy Wynette as the "First Lady of Country Music" because of her numerous hit country songs. To more pedestrian souls she is known as the singer of "Stand by Your Man," judged by Country Music Television as the greatest country music song of all time. Ironically, standing by her man was never particularly easy for Wynette; at least not for very long. She was married five times.

Virginia Wynette Pugh was born near Tremont, Mississippi, on May 5, 1942, the daughter of farmer William Hollice Pugh and Mildred Russell. Unfortunately, Hollice was dying of a brain tumor and passed away in February 1943. The care of Wynette (she was always called Wynette or Nettie rather than Virginia) was entrusted to her maternal grandparents, Thomas Chester and Flora A. Russell in Alabama. Wynette grew up listening to Hank Williams, Patsy Cline, and George Jones, and learned how

to play piano and guitar from her grandmother. In 1959, shortly before graduating from high school, she married the first of her five husbands, Euple Byrd. Although she went to and graduated from beauty school, she dreamed of being a star, a dream that was not supported by Byrd. Over the next few years, she worked a variety of jobs and had three children but continued to pursue

her dream by singing at night and auditioning when she could. In 1966, she divorced Byrd and, shortly thereafter, married husband number two, Don Chapel, a marriage that was annulled in 1968.

Wynette got her big break in 1966 when she met record producer Billy Sherrill. He encouraged her to change her name to Tammy Wynette because he thought she looked a bit like the character Debbie Reynolds played in the movie *Tammy and the Bachelor*. Her first single, "Apartment #9," was released in late 1966 and reached the top forty on the U.S. country charts. In 1967, she had hits with "Your Good Girl's Gonna Go Bad," "My Elusive Dreams" and "I Don't Wanna Play House," all of which reached the country top ten. Wynette had three number one hits in 1968: "Take Me to Your World," "D-I-V-O-R-C-E," and her best known song, "Stand by Your Man" (which she said she wrote in fifteen minutes). In 1969, she had two additional number one hits, "Singing My Song" and "The Ways to Love a Man." That same year, Wynette earned a gold record (awarded for albums selling in excess of one million copies) for *Tammy Wynette's Greatest Hits*; she was the first female country artist to do so. During her marriage to Don Chapel, she began an affair with legendary country music star George Jones. The couple married in 1969 and divorced in 1975. They recorded a number of hit records together even after their divorce.

Wynette began to experience health problems during her marriage to Jones, problems that would lead to dozens of operations and a dependency on pain-relieving narcotics. In 1976, she embarked on marriage number four to real estate tycoon Michael Tomlin. That union, Wynette's shortest, lasted a mere forty-four days before being annulled. In late 1977, Tammy began dating Nashville record producer and songwriter George Richey. Within a few months, he became her musical arranger, conductor, manager, and husband number five. The two were married on July 6, 1978. Tammy often said of him, "I made a lot of mistakes in my love life, but thank God I finally got it right." The couple remained married until her death in 1998.

Her drug dependency would eventually lead her to the Betty Ford Clinic in 1986. The treatment didn't take, and she continued to use drugs while her health deteriorated. By the time of her death, some reports said she weighed less than eighty-four pounds. Her death was ruled a cardiac arrhythmia, but it was no doubt brought on by large doses of pain medication.

WILLIE MORRIS AND THE "WITCH OF YAZOO CITY"

Willie Morris ❧ November 29, 1934-August 2, 1999
Glenwood Cemetery ❧ Yazoo City, Mississippi
32 51 25 N 90 23 54 W

In the middle of the Glenwood Cemetery in Yazoo City, Mississippi, is a grave surrounded by chain links known as "The Witch's Grave." The legend of the "Witch of Yazoo" was wonderfully illuminated in Willie Morris's 1971 book, *Good Old Boy*.

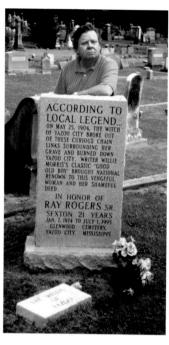

William Weaks "Willie" Morris has been called Mississippi's writer of the millennium by his fans. Morris was born in Jackson, Mississippi, but his family moved to Yazoo City when he was six months old. He grew up in a family of storytellers, and that, combined with his experiences growing up in a small town in Mississippi, became fodder for and colored much of his writing. After he graduated from high school in 1952, he enrolled at the University of Texas in Austin. He excelled in his studies, and in his senior year, he became the editor of the student newspaper, the *Daily Texan*. Student newspapers have long been known to rankle university officials, but Morris took it to a new level with blistering editorials attacking segregation, government corruption, and censorship. Although he eventually earned the respect of many of the university's higher-ups, they no doubt breathed a sign of relief when he graduated in 1956 and went on to be a Rhodes Scholar at Oxford.

The seminal moment in Morris's life came in 1967 when his book *North Towards Home*, which the *London Times* called "The finest evocation of American boyhood since Mark Twain," was published AND he became *Harper's Magazine*'s youngest editor-in-chief at age thirty-two. To the joy of some and the disdain of others, Morris set out to revamp the stodgy magazine, stating, "A lot of distinguished magazines have folded over the years. They were venerable institutions but they did not move with the times. . . . The idea is to be relevant, and we fully intend to be that." Although Morris is credited with launching and enhancing the careers of notable writers such as David Halberstam, Norman Mailer, and William Styron, his

Photos courtesy of Jack Bales, author of Willie Morris: An Exhaustive Annotated Bibliography *and a Biography, and JoAnne Prichard Morris.*

liberal editorial leanings displeased many of the mainstream advertisers, which of course affected the publisher's bottom line. With more than a little nudging from the publisher, Morris resigned in 1971. His resignation and a painful divorce sent him into a tailspin. He left the fast life in Manhattan and, according to biographer Larry L. King, "He moved out to Long Island and settled onto a barstool at Bobby Van's."

Tiring of life on a barstool, Morris started to write again, penning his classic books, *Good Old Boy* (1971) and *The Last of the Southern Girls* (1973). In 1980, he returned to Mississippi as writer-in-residence at the University of Mississippi. He continued to write and coach young writers, most memorably a young John Grisham. In 1990, he married childhood friend and University of Mississippi Press editor JoAnne Prichard. With Prichard's encouragement, he wrote at an almost frantic pace and also became a consultant to movies that were based on his novels. His widely reviewed best seller, *My Dog Skip* (1995), was made into a successful movie in 1999. A few days after seeing a preview of the movie in New York, Willie Morris returned home and died of a heart attack. He became the first writer in Mississippi history and only the third person in the twentieth century to lie in state in the rotunda of the old capitol in Jackson. His tombstone's unique design is amplified by the epitaph carved into its base: "Even across the divide of death, friendship remains an echo forever in the heart. Willie Morris."

Morris's grave is just thirteen paces from the grave of the Witch of Yazoo, a legendary character immortalized in *Good Old Boy*, where he writes about an ugly old witch the police were chasing after they found out she killed a number of men:

The old woman had been trapped in a patch of quicksand, and they caught up with her just seconds before her ghastly, pockmarked head was about to go under. But she had time to shout these words at her pursuers: I shall return. Everybody always hated me here. I will break out of my grave and burn down the whole town on the morning of May 25, 1904! Then, as Joe Bob also described it later, with a gurgle and a retch the woman sank from sight to her just desserts.

The story goes on to say that the woman's body was retrieved from the quicksand and buried in Glenwood Cemetery. Yazoo City had a disastrous fire on May 25, 1905. All the facts except for the fire are quite fictitious. But it makes for great storytelling, a skill that Willie Morris was very good at.

CASH-CARTER MONUMENT

Johnny Cash ⊗ February 26, 1932–September 12, 2003
June Carter Cash ⊗ June 23, 1929–May 15, 2003
Hendersonville Memory Gardens ⊗ Hendersonville, Tennessee
36 18 46 N 86 35 36 W (cemetery entrance)

It seems fitting that the monument to the Man in Black and his wife June Carter Cash is a black granite, bench-like grave marker. Johnny Cash was born near Kingsland, Arkansas. He

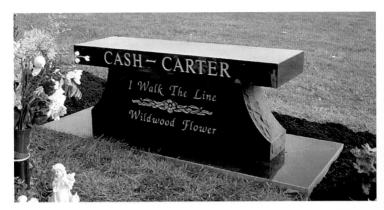

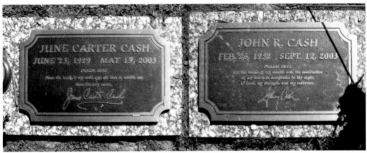

Photos courtesy of Robert Boraski.

was one of seven children born to Ray and Reba Cash, who were a poverty-stricken family by all accounts. The family moved to Dyess, Arkansas, when Johnny was three years old, and it was there that he listened to radio at night and then started composing songs at age twelve. In 1950, he enlisted in the air force, and while stationed in Germany, he started to put music to his lyrics. One of his first completed songs was "Folsom Prison Blues." After being discharged from the air force in 1954, he married his high school sweetheart, Vivian Liberto.

Almost as soon as Cash got out of the military, he teamed up with Luther Perkins and Marshall Grant, and signed on with Sun Records in Memphis as Johnny Cash and the Tennessee Two. The group's first major hit was "I Walk the Line" in 1956, which was written by Cash. The group continued to have a number of hits, including "Ballad of a Teenage Queen" and "Guess Things Happen That Way." In 1958, the group (now the Tennessee Three, with the addition of drummer W. S. Holland) switched to Columbia Records and recorded the hits "Don't Take Your Guns to Town" and "Ring of Fire." Around that time, major changes occurred in his life: he met June Carter, his friend Johnny Horton died, his marriage collapsed, and he started taking amphetamines and tranquilizers.

Despite his troubles (but buoyed by his relationship with Carter), he recorded the smash hit "Ballad of Ira Hayes" followed by Cash and Carter's rendition of the Bob Dylan hit "It Ain't Me Babe." Cash's health deteriorated, but he still

recorded modest hits. He and Carter were married in June 1968. His album *Johnny Cash at Folsom Prison* revitalized his career, and he had other hits like "A Boy Named Sue" and, with June Carter Cash, "If I Were a Carpenter." Cash turned more toward gospel-oriented songs later in his career and also had a television program, *The Johnny Cash Show*.

Johnny Cash and June Carter Cash often performed together in the 1970s and '80s, and he also appeared with a number of other performers such as Waylon Jennings, Kris Kristofferson, and Willie Nelson. His health problems continued (he had heart bypass surgery in 1988), and he ultimately succumbed to diabetes on September 12, 2003. He was inducted into the Songwriters, the Country Music, and the Rock and Roll Halls of Fame, the first to be inducted into all three Halls of Fame.

Country singer, producer, author, and actress June Carter Cash was born in Maces Springs, Virginia, as Valerie June Carter. Her family, performing as The Carter Family, began recording country music in 1927 and continued until 1978, when "Mother" Maybelle Carter died. June Carter performed with the family and also studied acting in New York. In 1961, she turned down an offer to work on a variety show and instead agreed to tour with Johnny Cash. At the time, she was married to country singer Carl Smith. Although June Carter Cash may be best remembered for her singing with the Carter Family and her collaborations with Johnny Cash, she had a long career in movies and television in particular. She appeared in dozens of programs such as *Gunsmoke*, *Little House on the Prairie*, and *Dr. Quinn Medicine Woman*. After being admitted to the Baptist Hospital in Nashville with heart problems on May 7, 2003, she passed away a week later with her husband and family at her side.

MORRIS THE CAT
May 1973–October 1994
Crescent Hotel ❧ Eureka Springs, Arkansas
Note: marked grave is in the flowerbed just behind the hotel
36 24 30 N 93 44 15 W

Morris the Cat, spokes-cat for 9Lives–brand cat food, is without a doubt the most famous cat in America. Like other animal stars such as Lassie, Morris has been portrayed by a number of cats over the years. The original Morris was a 14-pound orange tabby who was rescued from a Chicago animal shelter in 1968 by Bob Martwick, a professional animal trainer. Since the dawn of the original Morris, owners of temperamental felines have been tempted to name their cat Morris. Such is the case of Morris the cat who is spending eternity in the flowerbed of the 1886 Crescent Hotel and Spa in Eureka Springs, Arkansas. The Eureka Springs Morris was every bit as finicky as the television Morris and just as popular (or so say the hotel's owners). Morris lorded over the hotel for twenty-one years and, when he died at the ripe

In loving memory of Morris

old age of twenty-one in 1994, his funeral was attended by over 200 people. A large photo of Morris prominently hangs in the hotel's lobby. By contrast, when Morris of television fame died in 1975, he was unceremoniously buried in his owner's backyard.

Photo courtesy of Bill Ott.

SUGGESTED READING

Axelrod, Alan. *The International Encyclopedia of Secret Societies and Fraternal Orders*. New York, New York: Facts On File, Inc., 1997.

Benson, George Willard. *The Cross: Its History and Symbolism*. Buffalo, New York: Hacker Art Books, 1983.

Bliss, Harry A. *Memorial Art Ancient and Modern*. Buffalo, New York: Harry A. Bliss, 1912.

Bucy, Carole Stanford, and Carol Farrar Kaplan. *The Nashville City Cemetery: History Carved In Stone*. Nashville, Tennessee: The Nashville City Cemetery Association Inc., 2000.

Carmack, Sharon DeBartolo. *Your Guide to Cemetery Research*. Cincinnati, Ohio: Betterway Books, 2001.

Colvin, Howard. *Architecture and the Afterlife*. New Haven, Connecticut: Yale University Press, 1991.

Crawford, Sybil F. *Jubilee: The First 150 Years of Mount Holly Cemetery. Little Rock, Arkansas*. Little Rock, Arkansas: August House, Inc., 1993.

Ferguson, George. *Signs and Symbols in Christian Art*. New York, New York: Oxford University Press, 1954.

Gandolfo, Henri A. *Metairie Cemetery: An Historical Memoir (Tales of Its Statesman, Soldiers and Great Families)*. New Orleans, Louisiana: Stewart Enterprises, Inc., 1981.

Guss, John Walker. *Savannah's Laurel Grove Cemetery*. Charleston, South Carolina: Arcadia Publishing, 2004.

Keister, Douglas. *Going Out in Style: The Architecture of Eternity*. New York, New York: Facts On File, Inc., 1997.

Keister, Douglas. *Stories in Stone: A Field Guide to Cemetery Symbolism and Iconography*. Salt Lake City, Utah: Gibbs Smith, 2004.

Magness, Perre. *Elmwood: In the Shadows of the Elms*. Memphis, Tennessee: Elmwood Cemetery, 2004.

Memorial Symbolism, Epitaphs and Design Types. Olean, New York: American Monument Association, Inc., 1947.

Meyer, Richard, ed. *Cemeteries and Graveyards: Voices of American Culture*. Logan: Utah State University Press, 1989.

Meyer, Richard, ed. *Ethnicity and the American Cemetery*. Bowling
Green, Ohio: Bowling Green State University Popular
Press, 1993.

Mitchell, Mary H. *Hollywood Cemetery*. Richmond:
The Library of Virginia, 1999.

Moore, Carol. *Greensboro's First Presbyterian Church Cemetery*.
Charleston, South Carolina: Arcadia Publishing, 2006.

Mould, David R., and Missy Loewe. *Historic Gravestone Art
of Charleston, South Carolina, 1695–1802*. Jefferson, North
Carolina: McFarland & Company, Inc. Publishers, 2006.

The Penguin Dictionary of Symbols. London,
England: Penguin Books, 1996.

Preuss, Arthur. *A Dictionary of Secret and Other Societies*.
St. Louis: B. Herder Book Co., 1924.

Ridlen, Susanne S. *Tree-stump Tombstones*. Kokomo,
Indiana: Old Richardville Publications, 1999.

Taliaferro, Tevi. *Historic Oakland Cemetery*. Charleston,
South Carolina: Arcadia Publishing, 2001.

Thomas, Samuel W. *Cave Hill Cemetery: A Pictorial
Guide and Its History*. Louisville, Kentucky: Pinaire
Lithographing Corporation, 1985.

Willsher, Betty. *Understanding Scottish Graveyards*.
Edinburgh, Scotland: Canongate Books Ltd, 1995.

Wilson, Amie Marie, and Mandi Dale Johnson. *Bonaventure
Cemetery: Photographs from the Collection of the Georgia Historical
Society*. Charleston, South Carolina: Arcadia Publishing, 1998.

On the World Wide Web:

There are hundreds of Web sites that address various aspects
of cemetery symbolism and religious beliefs. As a starting
point, go to the Association for Gravestone Studies (www.
gravestonestudies.org) and Find a Grave (www.findagrave.com).

INDEX

Abernathy, Ralph D., 223, 225
Abu Ghurob, 129
Acorn, 159
Acronyms, 211.
 See also fold-out map
Acuff, Roy, 98
Adams, Abigail, 191
Adams, John, 191
Agnes Dei—Lamb of God, 175, 179
Ahavath Achim Congregation, 93
Ahrens, Babette and Arthur
 Vonderbank, 19
"Albert Sidney Johnston," 28–29
Aldigé Monument, 17
Allen, Ginger, 231.
 See also Presley, Elvis Aaron
Allison, Clifford, 214
Allison, Davey, 213–14
Allison family: Clifford, Donny,
 Judith and Robert, 214
Alpha, Omega, Mu, 176–77
Altar Tomb, 140
American Colonization Society, 60
American Legion (AL), 196–97
Anchor, 165
Ancient and Honorable Order of
 the Blue Goose (AHOBG), 187
Ancient Arabic Order of the Nobles
 of the Mystic Shrine (AAONMS),
 Imperial Council of the, 203
Anderson, Robert, and Mary Read,
 81
Anderson, Samuel Read (wife
 Mary, daughter Mary, son
 Robert), 81
Angel, Henry Love, 88
Anvil, 165
Aristotle, 154
Army of Northern Virginia tumulus,
 15, 58
Army of Tennessee Tumulus, 18,
 26–29
Arnold, Herman Frank, 53
Ars moriendi, 147
Art Deco Architecture, 127, 137
Art Nouveau Architecture, 127, 136
Ashley, Chester, Senator, 73
Atlanta Campaign, 89
Augusta National Golf Club and
 Masters Tournament, 92–93
Austell Mausoleum, Oakland
 Cemetery, Atlanta, Georgia, 133

Baden-Powell, Robert, 197, 220
Baird, John, 44
Baldwin Family Plot, 34
Bale Tomb, 140–41
"Ballad of Casey Jones," 233,
 234–35
Balls, 165
Barker, Jess, 215
Barnum, P. T., 40, 46; Museum, 196
Baroque Architecture, 135
Barrel Tomb, 140
Basham Family Plot, 74, 143

Basham, Martha Parma, and Pearl
 Reed, 74
Bauer (Rachel B. and Adolphus
 Gustavus) Monument, 106–7
Beaux-Arts architecture, 135
Bears, 188
Beavers, 188
Beebe, Roswell, 73
Beauregard, P. G. T., 17–18, 21, 27
Bell House, 74
Bellefontaine Cemetery, St. Louis,
 Missouri, 7
Belvedere, Magnolia Cemetery, 67
Berendt, John, 31, 34
Bible Belt, 128, 171
Bird Girl, 31, 34
Black Elks, 188. See also Elks (BPOE)
Bliss, Gertrude A, 33
B'nai B'rith (IOBB), Independent
 Order of, 211
Boat, 166
Bolton, Wade Hampton, 50
Bonaventure Cemetery, Savannah,
 Georgia, 30–37
Book: closed, 166; open, 166;
 with crown, 167
Booth, William, 210
Boswell (Geogina Rose and
 Melvin) Monument, 51
Bottinelli, Theodore, 25
Bounty survivors, 81
Boy Scouts of America (BSA),
 197–98
Boyce, W. D., 197
Buds and Seedpods, 154
Brady, Matthew, 32
Brady, T. M., 89
Bremer, Arthur, 222
Bright, Barney, 41
Brongniart, A. T., 42
Brookin, Henry, 76–77
Brune, Charles, 21
Brown, Ruth Toof, 52
Brownlee and McMorrin, 75
Bryant, Paul William "Bear," 218–19
Bryant, William Monroe, and Ida
 Kilgore, 218
Brunswig (Lucien) Mausoleum,
 25, 128
Buddhist symbols, 172
Buffalo, 188
Buffalo nickel, 94
Bull Run, First Battle of, 18
Burial, aboveground.
 See Metairie Cemetery
Burton and Bendernagel, 23–24
Butler, Rhett, 104–5.
 See also Upshaw, Berrien Kinnard
Butterfly, 162
Byrd, Euple, 237–38
Byzantine Architecture, 21–22, 131,
 132; influences of, 133

Caesar, Julius, 154
Calhoun, John Caldwell, 114
Calla Lily, 154–55
Cambaceres Mausoleum, Recoleta
 Cemetery, Buenos Aires,
 Argentina, 136

Camels, 188
Carey, Mariah, 41
Carmichael, Hoagy, 32
Carpenter Gothic architecture, 49, 74
Carroll, William, 81
Carter Family, 242
Carter, "Mother" Maybelle, 242
Cash, Johnny, 82, 240–42
Cash, June Carter, 240–42
Cash, Ray and Reba, 241
Casse, Pierre, 20, 27
Cave Hill Cemetery Company, 45
Cave Hill Cemetery, Louisville, Kentucky, 7, 11, 38–46, 134, 180
Chair (empty or vacant), 148
Chalice, 175–76
Chalkey, Floyd Eaton, 215
Chapel, Don, 238
Charleston Churchyards, Charleston, South Carolina, 11, 110–17
Charleston, Siege of, 113
Chest Tomb, 139
Chi-Rho, 176
Children of the Confederacy, 189
Children of the Covenant, 211
Christian Symbols, 25, 154, 155, 156, 157, 158, 159, 160, 161, 162, 163, 171, 173–81
Christianity/Christian architecture, 133
Church of England, 115
Church of the Annunciation, New York City, 61
Churchyards, definition of, 10
Cimitero Monumentale, Milan, Italy, 25
Cimetière du Père-Lachaise, Paris, France, 10, 31, 39, 42, 79, 80
Circular Congregational Church, Charleston, South Carolina, 112, 114–16; Churchyard, 115, 116, 151
City Cemeteries, definition of, 10
City Mansions, 169–70
Civil War, 14–15, 18, 20–21, 26–27, 32, 47, 49, 63, 65, 67, 68, 71, 80, 81, 82, 86, 88, 89, 101, 104, 109, 148, 179, 187, 189, 206, 208, 213
Classical/Revival Architecture, 22, 26, 42–43, 44–45, 90, 127, 130–31, 136
Cline, Patsy, 82, 237
Codner, William, 116
Coe, Richard, Jr., 148
Coffin Tomb, 142
Cohanim (Kohanim) Hands, 184
Collins, Harry Leon, 47
Colored Knights of Pythias (CKP), 188, 194–95.
 See also Knights of Pythias
Columbus, Christopher, 23, 207
Column (broken), 150
Condon, James, Mayor, 79
Companions of the Forest of America (CFA), 209
Confederate Army/troops/soldiers/ prisoners, 18, 26, 27, 51, 57, 64,

67, 68, 80, 83, 89, 109
Confederate Cemetery, Raleigh, North Carolina, 103.
 See also Oakwood Cemetery
Confederate Obelisk, Oakland Cemetery, 89
Confederate Relief and Historical Association (CRHA), 51
Confederate Rest Monument, 51
Confederate Section, Magnolia Cemetery, 67–68
Confederate Section, Oakland Cemetery, 88–89
Confederate Section, Oakwood Cemetery, 100, 109; and House of Memory, 109
Confederate Soldiers Monument, Hollywood Cemetery, 63
Confederate States Army (CSA), 190
Confederate States Navy (CSN), 190
Confederate States of America/ Confederacy, 15, 57, 58, 64, 69, 70, 179, 188, 189, 190
Contessa Entellina Association Tomb, 22
Coon dogs/hounds, 118–25
Cottage, The, 49–50
Cradle Markers, 143
Crawford Howard Family Foundation, 50
Cremation/cremains, 153
Crescent Hotel, Eureka Springs, Arkansas, 242–43
Cristoforo Colombo Society Mausoleum, 23, 134, 187
Crooks (crosier), 167
Cross: St. Andrew's, 41; with crown, 167; floré, 178; Latin, 177, 178; Greek, 178; Maltese, 178, 204; patté, 178; of Lorraine, 179; Ruskin, 179; Russian Orthodox (Eastern), 179; Rogers-Palfrey-Brewster, 179–80
Crosby, Bob and Bing, 47
Crouch, C. C., 94
Crusades, 163, 178
Cunnington, William, 67
Curry, J. L. M. (Jabez Lamar Monroe), 63–64
Curtain (Veil), 167–68
Cyrrus, Andronicus, 25
Cyrus the Great, 26

Daisies, 155
Dates, 181–82
Daughters of Rebekah (DR), 208
Daughters of the American Revolution (DAR), 190–91
Daughters of the Confederacy (DOC), 101, 188
Daughters of Union Veterans of the Civil War (DUV/DUVCS), 193
Davis Circle, Hollywood Cemetery, 58, 59
Davis, James J., 198
Davis family: Samuel Emory, 57; Jane Cook, 57; Sarah Knox Taylor, 58; Jefferson, Jr., 59;

Varina Howell, 58, 59; Varina
 Anne, 59; Margaret Howell Davis
 Hayes, 59
Davis, Jefferson Finis, 15, 18, 53,
 57–59, 62, 63, 64, 71
Death's Heads and Soul Effigies,
 150–52
DeMille, Cecil B., 184
DeMolay, 205–6
Dempsey, Patrick, 120
DeSylva, Buddy, 33
Devaney, Uearl, 125
Dexter, Andrew, 97
Dickens, Charles, 46
Dickens, Samuel and Josephine, 50
Dickens, Thomas, 50
Dickson, Moses, 209
Dignitaries Circle, Hollywood
 Cemetery, 60–61, 62
Dimitry, John, 27, 28–29
Dimmock, Charles H. 63
"Dixie," 7–8, 53
Domingueaux, 22
Door, 168
Dove, 162
Dowson, Ernest, 87
Doyle, Alexander, 27
Drach, Max, 41
Dreux, Charles Didier, 27
Driver, William, 81–82
Dylan, Bob, 241

Eagle, 162
Eagle, Two-Headed, and Masonic
 Eagle, 162–63
Eagles (FOE), Fraternal Order of,
 187, 194
Earles, Julian and Alma, 216–17
Earles, Nadine, 216–17
Easter Lily (Madonna Lily), 156
Eastern Star (OES) (ES), 205, 206.
 See also Prince Hall Eastern Star
Eastern Star Past Matron, 205
Eastwood, Clint, 31
Edwards, John and Elizabeth, 108
Edwards, Wade, 108
Egan, Henry, 20; and Yelverton, 21
Egan Tomb, 20–21
Egypt/Egyptians, 51, 128–29, 154,
 157, 164
Egyptian/Revival Architecture, 25,
 36, 69, 70, 90, 93, 127, 128–30;
 symbols of, 128–29
Elks (BPOE), Benevolent Protective
 Order of, 23, 187, 195–96.
 See also Black Elks
Elks of the World (IBPOEW),
 Improved Benevolent Protective
 Order of the, 196.
 See also Black Elks; Elks (BPOE)
Elks Tumulus, Greenwood
 Cemetery, New Orleans,
 Louisiana, 128
Ellington, Duke, 32
Elmwood Cemetery, Birmingham,
 Alabama, 161, 163, 218–19,
 220–21
Elmwood Cemetery, Memphis,
 Tennessee, 48–55, 141, 144–45

Emi Records, 33
Emmett, Daniel, 7
"Empty Chair, The," 148
End of the Trail, 94
Erskine Mausoleum, Maplewood
 Cemetery, Huntsville, Alabama,
 130
Eternal Rest Jewish Cemetery,
 Oakwood Cemetery Complex, 97
Eucharist, 173
Evangelists, Four, 179–80, 181
Evergreen Cemetery Company, 31
Evergreen Cemetery of Bonaventure,
 Savannah, Georgia, 31
Ewer, 184
Exalted Order of Big Dogs, 187
Exedrae, 64, 144
Eye, 172

False Crypt, 143
Farmer, Red, 214
Federal architecture, 68–69
Ferguson, Lena Lorraine Santos,
 190
Fern, 155
Fields, W. C., 40
Fire-Eaters, 70
First Baptist Church, Charleston,
 South Carolina, 112
First Presbyterian Church
 Cemetery, Greensboro, North
 Carolina, 228
First (Scots) Presbyterian,
 Charleston, South Carolina, 112
Fleming, Walter M., 203
Florence, William J., 203
Flowers and Plants, 154–61
"Folly," 136
Foote, Shelby, 213
Forest Hill Cemetery, Memphis,
 Tennessee, 231
Forest Lawn Memorial Park,
 Glendale, California, 105
Forest Lawn Memory Gardens,
 Savannah, Georgia, 32
Foresters (AOF), Ancient Order
 of, 209
Formwalt, Moses, 91
Founding Fathers, 172, 203
Fountain (Out in the Rain), Oakland
 Cemetery, 91
Fowls, Insects, Reptiles, 162–64
Franklin, Benjamin, 172, 203
Fraser, James Earle, 94
Fraternal Brotherhood (FB), 210
Freemasons, 11, 51, 63, 101, 187,
 188, 199, 202–3, 204, 205, 206.
 See also Prince Hall Freemasons;
 Masonic Keystone; Masons
Freer, Debra, 88
French, Daniel Chester, 89
French, H. Q., 89
French Huguenot (Protestant)
 Church, Charleston, South
 Carolina, 112
French Renaissance architecture,
 134
Funerary Architecture, 126–45:
 Mausoleums and Monuments,

127–38; Sarcophagi, Tombs, and
 Memorials, 138–45.
 See also individual entries
Funston, William L., 74

Gallagher, William, 51
Garden Cemeteries, definition of,
 10, 127
Gate, 168–69
General George Izard Chapter,
 United States Daughters of
 1812, 76
German Renaissance architecture,
 134
Gettysburg, Battle at, 67
Gheens (Charles W.) Mausoleum,
 43
Gilchrist (William) Monument, 75
Gilmer Sarcophagus, 139
Gindrat, John, 101
Girl Scouts, 219–20
Glenn, John, 27
Glenwood Cemetery, Yazoo City,
 Mississippi, 238, 240
Global Positioning System (GPS), 8
Glover, Lillie Mae, 52
Goldwater, Barry, 203
God's Acre(s), 10, 151
Gone with the Wind, 86, 87–88, 215
Goodlett, Caroline Meriwether, 188
Gothic Architecture, 27, 89, 127,
 132–33
Gothic Revival Architecture, 24, 109
Gouverneur family, 60, 61
Graceland Estate, Memphis,
 Tennessee, 52, 229–31
Grand Army of the Republic (GAR),
 189–90, 192–93
Grand Army of the Republic
 Section, Oakwood Cemetery,
 100–101
Grand Ole Opry, 98
Grand Union Order of Odd Fellows
 (GUOOF), 92
Granddaughters Club, 189
Grant, John T., 91
Grant, John W., 91
Grant, Marshall, 241
Grant Mausoleum, 90–91
Grant, Ulysses S., 58
Grant, William D., 91
Graves (Antoine and Catherine)
 Mausoleum, 92
Graves, Antoine, Jr., 92
Graves, Lena Louise, 92
Graveyards, definition of, 10
Great Depression, 47, 206, 208
Great Granddaughters Club, 189
Great-Great Granddaughters Club,
 189
Greek symbolism, 159, 161, 176
Green, Anna Leroy Pope, 76
Green, Benjamin W., 76
Green Hill, Magnolia Cemetery, 67
Green-Wood Cemetery, Brooklyn,
 New York, 75
Greenwood Cemetery,
 Montgomery, Alabama, 221
Greenwood Cemetery, New

Orleans, Louisiana, 128
Greffulhe family mausoleum, 42
Greyfriars Cemetery, Edinburgh,
 Scotland, 142
Griffin, Rex, 98
Grisham, John, 240
Grottoes, 128. *See also* Tumulus
Gunter, John Frank, 51

Habersham, John, 31
Hagia Sophia, 131
Halberstam, David, 239
Hamilton, Alexander, 172, 203
Hampton, Lionel, 32
Hand(s): Coming Down, 172–73;
 Pointing Up, 173; Together, 173
Haney, Cara Peyton, 76
Haney, John and Mary, 76
"Happy Birthday," 46
Harp and Lyre, 169
Harper Mausoleum, 136
Harrington, Bertha, 20
Harrington (Joseph V. "Never
 Smile") Mausoleum, 19–20
Harrison, William, 61–62
Harrod, Benjamin F., 14, 21
Harvie, John, 57
Hayes, Margaret Howell Davis, 59
Hayward, Bartlett and Company,
 64
Hayward, Susan, 214–15
Hebrew Symbols, 171, 181–85
Helms (Jesse and Dorothy Jane
 Coble) Plot, 109
Heloise and Abelard, 79
Hendersonville Memory Gardens,
 Hendersonville, Tennessee,
 240–41
Henry, Clifford, 86
Here Lies, 182; with crown, 182
Heston, Charlton, 184
Highland Memorial Gardens,
 Bessemer, Alabama, 213–14
Hill, Luther, 99
Hill (Mary and children)
 Monument, 99–100
Hill Sisters (Patty Smith and
 Mildred Jane), 46
Hindu symbols, 172
Hip Tomb, 141
Historic Oakland Foundation, 85
Hittite symbolism, 162–63
Hogback Tomb, 142
Holford, Thelma E., 236–37
Holiday, Billie, 32
Holland, W. S., 241
Hollywood Cemetery Company,
 57, 61
Hollywood Cemetery, Richmond,
 Virginia, 15, 56–65, 137, 157, 158
Hollywood Memorial Association,
 63
Holy Ghost, 173–75, 180
Hood, James, 222
Hood (Ouida Estelle Emery) Prikryl
 (Franklin Stanley) Monument,
 105–6
Hood, Wallace, 105–6
Hoover, J. Edgar, 203

Horne, Lena, 92
Horton, Johnny, 241
Hourglass, 150
Howard, B. F., 196
Howard, Harlan Perry, 82
Human Symbols, 172–73
Humphrey, Hubert, 225
Hunley Crews, The, 67, 68
Huntsville Space Center,
 Huntsville, Alabama, 232
Hurricane Hugo, 67, 69

IHS (IHC), 177
Indian Removal Act of 1830, 76
INRI, 177
Insects, Reptiles, Fowls, 162–64
International Order of Twelve,
 Knights and Daughters of Tabor,
 209
International Style architecture,
 137
Irvin, Florence McHarry, 42
Irvin (James F.) Mausoleum, 42
Islamic Architecture, 44–45, 131
Islamic tradition, 160–61
Italian Benevolent Society, 187
Italian Renaissance Architecture,
 134–35
Ivy, 159

Jackson, Andrew, 81
Jackson, Stonewall, 50
James River, Richmond, Virginia,
 57, 64
Jarvis, Anna, 104
Jarvis, Anna Reese, 104
Jefferson, Thomas, 60
Jenkins, Milton, 220
Jennings, Waylon, 242
Jett, Bobby, 98
Jewish Section, Oakland Cemetery,
 93
Jewish Symbols. *See* Hebrew
 Symbols
Johnson, Lyndon B., 224
Johnston, Albert Sidney, 26, 27
Johnston, Joseph E., 89
Jolly Corks (JC), 196
Jones, Edward C., 67
Jones, George, 237, 238
Jones, Janie, 234
Jones, John Luther "Casey," 232–35
Jones, John Paul, 172, 203
Jones Mausoleum, 137
Jones, Robert Tyre "Bobby," 92–93
Jones, Vivian Malone, 223
Jonesboro City Cemetery,
 Jonesboro, Arkansas, 144
Jonesboro Memorial Park,
 Jonesboro, Arkansas, 236
Judson, Sylvia Shaw, 34

Kadish Society, 93
Kahal Kadosh Beth Elohim
 Temple, Charleston, South
 Carolina, 112
Katzenbach, Nicholas, 222
Keller, Helen, 120

Kendrick, Eddie James, 220–21
Kendrick, Johnnie, and Lee Bell,
 220
Kennedy, John F., 224
Kennedy, Robert, 225
Kenner, Duncan, 14
Kentucky Fried Chicken (KFC),
 38–46
Key Underwood Coon Dog
 Memorial Graveyard, 11, 118–25
King, Coretta Scott, 223, 225
King, Larry L., 240
King, Martin Luther, Jr., 223–25. *See
 also* Martin Luther King Jr. Center
King, Martin Luther, Sr., and
 Alberta Williams, 223
King's Circle, Magnolia Cemetery,
 68
Kingsley, Alpha, 80
Kirk, Pamelia A., 82
Knights of Columbus (KC) (K of C),
 175, 207
Knights of Liberty, 209
Knights of Pythias (KP), 11, 194–95,
 199. *See also* Colored Knights of
 Pythias
Knights of the Maccabees (KOTM),
 206
Knights Templar (KT), 178, 203, 204
Kohanim Hands, 184
Kollock, Phineas Miller, 33
Kontz (Christian) Monument, 93,
 129
Kristofferson, Kris, 242
Ku Klux Klan, 222

La Fontaine, 79
Lacosst (Eugene) Monument
 23–24
Ladder, 169
Ladies Auxiliary of the Confederate
 Soldiers, 188
Ladies Auxiliary of the Eagles, 194
Ladies Confederate Memorial
 Association (LCMA), 51
Ladies Memorial Association
 (LMA), 67
Ladies of the Maccabees of the
 World (LOTM), 207
Laffoon, Ruby, 40
Lake Lawn Metairie Cemetery,
 16, 20
Lake Lawn Park Cemetery, 16
Lamb, 175
Lamb of God—Agnes Dei, 175, 179
Land of Peace Jewish Cemetery,
 Oakwood Cemetery Complex, 97
Langles, Angele Marie, 16–17
Langles, Pauline Costa, 16–17
Larendon (Laure Beauregard)
 Mausoleum, 21, 131
Latham, Harold, 87
Laukhuff (Ralph Lewis and Mickey)
 Monument, 54
Launitz, Robert Eberhard, 75
Laurel, 155–56
Laurel Grove Cemetery, Savannah,
 Georgia, 33, 35
Lawhon, Charles, 179, 180

Lawn-Park Cemeteries, definition of, 11
Lawton Family Plot: Corinne, Alexander Robert, Sarah Hillhouse Alexander, 35
Lee, Edmund Francis, 39
Lee, Robert E., 65, 69
Lefebvre Mausoleum, 26
Legare, Hugh Swinton, 71
Leigh, Jack, 31, 34
Leighton brothers: Bert, Frank, William, 234
Lewis, John, 223
Liberia, 60
Lily of the Valley, 156
Lincoln, Abraham, 70, 89
Louisiana Division, Army of Northern Virginia tomb, 58
Low, Juliette "Daisy" Magill Kinzie Gordon, 219–20
Low, William Mackey, 219–20
Lucas, Josh, 120
Lyre and Harp, 169

Maccabeau, Judas, 206
Mackay, Charles, 32
Madonna Lily (Easter Lily), 156
Magnolia Cemetery, Charleston, South Carolina, 66–71, 127–28
Mailer, Norman, 239
Malone, Vivian, 222
Manassas, First Battle of, 18
Maplewood Cemetery, Huntsville, Alabama, 130, 143
Maplewood Cemetery, Mayfield, Kentucky, 235–36
Marble Cemetery, New York City, 60
Marlin, Dan, 82–83
Marsh, John Robert, 86, 87, 104
Marsh, Margaret Munnerlyn Mitchell, 86–88.
 See also Mitchell, Margaret
Marshall, John, 59
Martin, James E., 43
Martin Luther King Jr. Center, Atlanta, Georgia, 139, 223–25
Martwick, Bob, 242
Masons, 23, 63, 75, 202–3, 205.
 See also Freemasons; Prince Hall Freemasons
Masonic Eagle, 162–63
Masonic Keystone (HTWSSTKS), 202, 203–4
Masonic symbols, 159, 172
Mausoleums and Monuments, 127–38
Maypop, 157
Mays, Benjamin E., 223
McCan (David) Mausoleum, 24–25
McCarthy, Eugene, 225
McHarry, Frank, 42
McMillan, Thomas H., 33
McNairy (John) Family Vault, 83
McNeil, Alice, 98
McNeil, J. C., 98
Memento Mori, 148
Memorial Parks, definition of, 11
Memorials. See Sarcophagi, Tombs, and Memorials

Menorah, 182–83
Mercer, George Anderson, Jr., 32
Mercer, Ginger Meehan, 32
Mercer, John Herndon "Johnny," 32–33
Metairie Cemetery Company, 14
Metairie Cemetery, New Orleans, Louisiana, 12–29, 58–59, 131, 134, 135, 162, 164, 165, 168, 179, 180, 187
Mexican-American War, 17, 64, 81
Midnight in the Garden of Good and Evil, 31, 34
Minerva Association Society Tomb, 22
Mique, Richard, 42
Miro, Esteban, 13
Miss Baker, 232
Missouri Compromise, 60
Mitchell, Eugene Muse, 86
Mitchell, Margaret, 85, 86–88, 103–4
Mitchell, Mary Isabelle "Maybelle" Stephens, 86
Mitchell, Stephens, 86
Modern Architecture, 137–38
Modern Classicism Architecture, 136
Mohammed, 131
Mongin-Stoddard Tomb, 36
Monroe Doctrine, 60
Monroe, Elizabeth Kortright, 60, 61
Monroe, James, 57, 59–61, 64
Monroe Gouverneur, Maria, 60, 61
Montgomery, Henry A., 52
Moore, Bartholomew F., 107
Moore, Ruth Brown, 52
Moose International, 198
Moose (LOOM), Loyal Order of the, 187, 198–99
Mordecai, Henry, 103
Morris, John A., 15–16
Morris, JoAnne Prichard, 239, 240
Morris the Cat, 242–43
Morris, Willie, 213, 238–40
Morrison, Jim, 31
Morse Tomb, 139
Mort Safe, 142
Mortality Symbols, 147–53
Mosaic Decalogue, The, 184
Mother's Day, 104
Mott (J. L.) Ironworks, 91
Mount Auburn Cemetery, Cambridge, Massachusetts, 10, 39, 49, 71, 79, 80
Mount Calvary Cemetery, Jackson, Tennessee, 232
Mount Holly Cemetery Association, 73
Mount Holly Cemetery, Little Rock, Arkansas, 72–77, 143, 153, 164
Mount Olivet, Nashville, Tennessee, 80
Muir, John, 32
Mullen, James T., 207
Mullryne, John, 31

NAACP, 222
NASCAR, 214, 218



Nash, Francis, 79, 80
Nashville City Cemetery Association, 80
Nashville City Cemetery, Nashville, Tennessee, 9, 78–83, 141, 142, 143, 146–47
National Register of Historic Places, 39, 80, 236
Nature Symbols, 154–61
Neal Monument, 94–95
Neighbors of Woodcraft (NOW), 200, 201–2
Nelson, Willie, 242
Neoclassical Architecture, 135
Ner Neshamah, 183
New Orleans, Battle of, 18
Newfoundland Dog, 64–65
Newton, Eddie, 234
Nixon, Richard, 225
No Man's Land, 53
North Laurel Grove Cemetery, Savannah, Georgia, 139, 219–20
North Section, Magnolia Cemetery, 67
Notman, John, 57

Oak Tree, leaves, 160
Oakland Cemetery, Atlanta, Georgia, 7, 84–95, 129, 130, 132, 133, 141, 152, 155, 159, 165, 168, 169, 173, 212–13
Oakland Cemetery, Little Rock, Arkansas, 73
Oakwood Cemetery, Lanett, Alabama, 216–17
Oakwood Cemetery, Montgomery, Alabama, 96–101, 140, 149, 150, 153, 154, 155, 157, 159, 161, 162, 166, 167, 173, 175, 180; Annex, 97, 98; Complex, 97
Oakwood Cemetery, Raleigh, North Carolina, 102–9
Oakwood Cemetery, Syracuse, New York, 89
Oakwood Cemetery, Tuscumbia, Alabama, 142
Oates, William, Governor, 99
Obelisks, 83, 129–30
Odd Fellows (IOOF), Independent Order of, 11, 51, 53, 92, 187–88, 199, 207–8
Odd Fellows (GUOOF), Grand United Order of the, 207–8
Odd Fellows Rest, 51
O'Hara, Scarlett, 86, 215
O. Henry (William Sydney Porter), 225–28
"Old Glory," 82
Olive Tree, branch, 160
Omberg, J. A., 49
Order of Bugs, 187
Order of Owls (Masonic), 193
Order of the Owls (OOO), 193
Orem, Preston Ware, 46
Orleans, Charles A., 18–19
Our Lady of Perpetual Help Catholic Church Cemetery, Carrollton, Georgia, 214–15
Ouroboros or Snake, 75, 164

Overland Campaign, 65
Owl, 163
Owls, 188

Paducah Marble Works, 236
Page (Carlisle S.) Arboretum, 49
Palm Fronds, 161
Parks Obelisk, 130
Partee, Etta Grigsby, 54–55
Passionflower, 157
Pebbles, 185
Pedestal Tomb, 141
Pelican, 163–64
Père-Lachaise. See Cimetière du Père-Lachaise
Perelli, Achille, 27
Perkins, Luther, 241
Perry, Ben E., Jr., 94
Peron, Eva (Evita), 31
Peronneau, Henry and Elizabeth, 116
Peronneau, Martha, 116
Pet cemeteries, 11, 119. See also Key Underwood Coon Dog Memorial Graveyard
Petersburg, Siege of, 99
Pike Family Plot: Albert and Mary, 75
Pinckney, Charles, 114
Pine Tree (cone or apple), 161
Pizzati (Salvatore) Mausoleum, 21–22, 135
Plantation House, 68–69
Pliny, 138
Pocahontas (DOP), The Degree of, 209–10
Porter, Algernon Sidney, and Mary Swaim, 228–29
Porter: Athol Estes, 226; Margaret, 226
Porter, David Tinsley, 53
Porter, James D., 46–47
Porter, Sarah Lindsey Coleman, 226
Porter, William Sydney (O. Henry), 225–28
Posey, Dennis, 122
Presbyterian Churchyard, Greensboro, North Carolina, 166
Preservation Society of Charleston, 69
Presley, Elvis Aaron, 229–31
Presley family: Gladys Love Smith, 229–31; Jessie Garon, 229, 231; Vernon Elvis, 229, 231; Minnie Mae Hood, 231
Presley, Priscilla, 229
Price, Ray, 82
Prince Hall Eastern Star (PHES), 205
Prince Hall Grand Chapter (of the) Eastern Star (PHGCES), 205
Prince Hall Freemasons (PHF), 188, 202. See also Freemasons; Masons
Proctor, Ivan M., 104
Proctor, Madeline Jane Jones, 104
Pryor & Radford Monument Works, 236

Pugh family: Virginia Wynette, William Hollice, and Mildred Russell, 237. *See also* Wynette, Tammy
Pythian Sisters (PS), 195

Quatie, 76

Rainbow for Girls (IORG), International Order of the, 205–6
Raines, Anna Davenport, 188
Rainey, Ma, 52
Raleigh Cemetery Association, 103
Ramsey, Burke, 216
Ramsey family: JonBenét Patricia, Patricia Paugh, John Bennett, 215–16
Rathbone, Justus H., 195
Ray, Earl, 224
Receiving Tomb, 69
Recoleta Cemetery, Buenos Aires, Argentina, 31, 136
Red Cross, 189
Red Men (IORM), The Improved Order of, 209–10
Reformation, 127, 150–51
Religious Symbols, 171–85
Renaissance Revival Style, 24
Reptiles, Fowls, Insects, 162–64
Revere, Paul, 172, 203
Revolutionary War, 31, 59, 79, 80–81, 86, 114, 153, 190, 191, 209
Rhett, Robert Barnwell, 70–71
Richards (Robert H.) Mausoleum, 89–90, 132
Richardson, Henry Hobson, 132
Richardsonian Romanesque Architecture, 90, 132. *See also* Romanesque Architecture
Richey, George, 238
Rieker, Albert, 19
Riggs, Arthur J., 196
Rightor, J. H., 16
RIP, 177–78
Riverside Cemetery, Asheville, North Carolina, 225
Robertson, Felix, 81
Robertson, James, 79, 80–81
Robins (John and Elizabeth) Monument, 75
Rock Creek Church Yard, Washington, D.C., 136, 137
Rogers, Will, 40
Romanellit, R., 36
Roman Empire/symbolism, 154, 155–56, 157, 161, 164
Romanesque Architecture, 89, 132. *See also* Richardsonian Romanesque Architecture
Roosevelt, Theodore, 191
Root, George F., 149
Root, Joseph Cullen, 199
Rose, 157–58
Ross, John, 76
Ross, Robert, 43
Rotary International, 211
Royal Neighbors (RN), 200
Rural Cemeteries, definition of, 10

Russell, Thomas Chester, and Flora A., 237
Rutledge, Edward, 113

Saint Andrew, 178
Saint Christopher, 161
Saint James Episcopal Cemetery, Marietta, Georgia, 215–116
Saint John, 180–81
St. John's Lutheran Church, Charleston, South Carolina, 112
St. John the Baptist Cemetery, New Orleans, Louisiana, 140, 150
St. Louis Cemetery #1, New Orleans, Louisiana, 13, 187, 229
Saint Luke, 180–81
St. Margaret's Catholic Cemetery, Oakwood Cemetery Complex, 97, 100
Saint Mark, 180–81
St. Mary of the Annunciation Catholic Church, Charleston, South Carolina, 112
Saint Matthew, 179–80, 181
St. Michael's Episcopal Church, Charleston, South Carolina, 112
St. Paul's Cathedral, London, England, 135
St. Peter Street Cemetery, New Orleans, Louisiana, 13
St. Philip's Church (Anglican), Charleston, South Carolina, 112; Churchyard, 113–14; Churchyard East, 114; Churchyard West, 114
Saint Roch Cemetery, New Orleans, Louisiana, 187
Salvation Army, 210
Sanders, Ann Rawlins, 82–83
Sanders, Charles, 82
Sanders, Harland, 7, 39, 40–41
Sanders, Wallace, 234
Santa Croce, Church of, 24
Sarcophagi, 138–39
Sarcophagi, Tombs, and Memorials, 138–45
Satterwhite (Florence Brokaw Martin) Monument, 42–43
Satterwhite, Preston Pope, 42–43
Save the Sons of Confederate Veterans (SSCV), 190
Schockler, John, 98–99
Scipio Sarcophagus, 138, 139
Scott, Dred, 7
Scott, John, 97
Scott, Winfield, 17
Scott's Free Burying Ground, 97, 100. *See also* Oakwood Cemetery, Montgomery, Alabama
Screwmen's Benevolent Association, 187
Seamen's Cemetery, Charleston, South Carolina, 68
Sebring, Edward, 67
Secret Societies and Clubs, 186–211
Seedpods and Buds, 154
Seibert, T. Lawrence, 234
Seiler (Charles and Ernestine) Monument, 4, 35

Seligman, Moise, III, 76
Selznick, David O., 88
Sexson, William Mark, 206
Shannon (John Carrick)
 Mausoleum, 45
Sharpsburg, Battle of, 21
Shell, 180
Sherrill, Billy, 238
Sherley (Zachary Madison)
 Mausoleum, 45
Sherman, William, 89
Shiloh, Battle of, 26
Shofar Horn, 184
Shriners (Mystic) (AAONMS),
 203
Simms, William Gilmore, 67
Skelton, Red, 203
Skull, 150
Slaton, John Marshall, 91
Slave Monument, Elmwood
 Cemetery, 51
Sloan, Samuel, 106
Smith, Carl, 242
Smith, Harold, Jr., 51–52
Smith, Jasper "Jack" Newton, 94
Smith/Whaley Mausoleum, 69–70,
 126–27
Snake or Ouroboros, 164
Social Order of the Beauceant
 (SOOB), 204
Sodini, Dante, 64
Sons of Confederate Veterans
 (SCV), 101, 188, 189–90
Sons of Liberty (SL), 209
Sons of Revolutionary Sires, 191
Sons of the American Revolution
 (SAR), 191–92
Sons of Union Veterans of the Civil
 War (SUVCW), 193
Sons of Veterans of the United
 States (SV), 193
Soul Effigies and Death's Heads,
 150–52
South Nashville Women's Club, 80
South View Cemetery, Atlanta,
 Georgia, 225
Spotts (Harry I.) Mausoleum,
 44–45, 134
Springer, Jerry, 41
Specialty Cemeteries, definition
 of, 11
Speed (J. B.) Art Museum,
 Louisville, Kentucky, 43
Stanley, Thomas, 63
Star of David, 171, 183
Steele, Edward, 82
Steele, Marion, 82
Stephenson, Benjamin F., 192
Stevens, Albert C., 211
Stuart, James Ewell Brown
 (J. E. B.), 65
Stone, 180
Stonehenge, 26, 127
Stories in Stone, 147
Styron, William, 239
Sunflower, 158
Sutton, Emily, 54
Sweet Home Alabama, 120
Symbolism, 146–85

Symbolism, examples of, 93,
 94–95, 111

Table Tomb, 141
Tablet, 142
Talbot, John W., 193
Tattnall, Josiah, 31
Taylor, Sarah Knox, 58
Taylor, Zachary, 57–58
Temple Cemetery, Nashville,
 Tennessee, 139, 140
Temple of Love, Versailles, France,
 42
Temple of Vesta, Tivoli, Italy, 42
Ten Commandments, 184
Tennessee Valley Coon Hunters
 Association, 120
Tennessee Women's Historical
 Association, 81
Tent, 170
Texas Rangers, 63
Texas State Cemetery, Austin,
 Texas, 27
Theophrastus, 138
Thistle, 158
Thomas, John Hardin, 41
Thompson, Augustus, 92
Thompson, J. Edgar, 85
Thorvaldsen, Bertel, 89
Thurman, Mary Glover, 89
Tombs. See Sarcophagi, Tombs,
 and Memorials
Toof, Grace, 52
Toof, S. F., 52
Tomlin, Michael, 238
Torch (inverted), 152
Tower of the Winds, Athens,
 Greece, 25
Trail of Tears, 76
Trees, 159–61
Treestones, 144
Trosdal, Lucy Boyd, 34
Trumbauer, Horace, 42
Truman, Harry, 203
Tuileries Palace, Paris, France, 89
Tumulus, The, 127–28
Turks, Seljuk, 163
Twist-Amrein, Tyra, 41
Twist (Saundra Curry) Monument,
 41
Twist, Tonjua Lynn, 41
Tyler, John, 57, 61–63, 64, 71
Tyler, John, Sr., and Mary
 Armistead, 61

Underground Railroad, 209
Union Army/soldiers/forces, 18, 63,
 80, 82, 89, 100, 109
Uniquely Funerary Hybrid
 Architecture, 127, 135–36
Unitarian Church, Charleston,
 South Carolina, 112;
 Churchyard, 116–17
United Confederate Veterans
 (UCV), 189
United Daughters of the
 Confederacy (UDC), 188–89, 190
United States Daughters of 1812,
 76

Upshaw, Berrien Kinnard, 86, 103–4
Urn (draped), 153

Vaccaro, Felix, 25
Vaccaro, Joseph, 25
Vaccaro (Luca) Mausoleum, 25
"Vacant Chair, The," 149
Van Buren, Martin, 62
Vanderhorst Mausoleum, 70
Vatican Museum, Italy, 138, 139
Venetian Gothic Architecture, 44–45, 133–34
Victorian architecture/era, 24–25, 31, 59, 76, 85, 136, 144, 154
Villeré: Jules, 17; Marie Laure, 17
Vittorio Emmanuelle Society, 22
Vonderbank (Babette and Arthur) Mausoleum, 15, 19
Voodoo Queen Tomb, 229

Wadley and Smythe, 43
Walker (Joseph A.) Mausoleum, 18–19
Wall or Oven Vault, 140
Wallace, George Corley, and Mozell Smith, 221
Wallace, George Corley, Jr., 221–23
Wallace, Lurleen, 222–23
Wallichs, Glen, 33
Walz, John 37
War Between the States, 189. See also Civil War
War of 1812, 81
Warren, Earl, 203
Washburn, H. S., 149
Washington, George, 113, 172, 203
Watauga Settlement/Wataugans, 79, 80
Watchman's Shelter House, 41
Watkins, George Claibourne, and Mary Crease, 74
Watkins, Mary, 74–75
Watson, Gracie, 37
Watson, W. J. and Frances, 37
Webb, Sim, 233, 234–35
Weeping Willow Tree, 153, 161
Weiblen, Albert, 15, 17, 19–20, 24, 179
Weiblen, John, 15
Weiblen, Norma Merritt, 15
West, Ben, 80
West, Mae, 40
Wheat, 159
Wheel, 153
White, B. L. and R. R., 71
White City Teachers Association, 82
White, Rosalie Raymond, 71
White (W. T.) Steam Marble Works, 71
Whitestone, Henry, 42
Wildey, Thomas, 208
William, George A., 27
Williams, Adam Daniel, 223
Williams, Audrey Sheppard, 98
Williams, B. A. & G. N., 42
Williams, Billie Jean Jones Eshliman, 98

Williams, Elonzo "Lon, 97"
Williams, Hiram "Hank" King, 97–98, 237
Williams, Jett, 98
Williams, Lillie, 97, 98
Williams, Paul, 220
Wilson, John Henry, 198
Wiltberger, Peter, 31
"Witch of Yazoo City," 238–40
Witherspoon, Reese, 120
Women of the Moose (WOM) (WOTM), 198
Women of Woodcraft, 200–201
Wood and Perot, 61
Woodlawn Cemetery, New York, 89
Woodlawn Memorial Park Cemetery, Nashville, Tennessee, 237
Woodmen of America (MWA), Modern, 201
Woodmen Circle (WC), 200
Woodmen Circle (SFWC), Supreme Forest, 200
Woodmen of the World (MWW), Modern, 200, 201, 202
Woodmen of the World (WOW), 51, 144, 187, 199–90
Woodmen Rangers and Rangerettes (WRR), 200
Woolridge family: Alfred, W. F., John, Josiah, Susan Neely, Narcissa Berryman, Minerva Nichols, Maud Reeds, Minnie Neely, 235; Josiah, 236
Woolridge, Henry, 235–36
Woolson, Albert, 101, 193
World War I, 86, 105
World War II, 47, 51
Worldly Symbols, 165–70
Wray, Andrew J., 59
Wynette, Tammy, 237–38

Yahrzeit, 183
Yellow Tavern, battle of, 65
York Rite Templarism, 204. See also Knights Templar
Young, Henry Edward, 69

Zinc Tombstone, 143
Zolnay, George Julian, 59

❧

Photos courtesy of:
Bales, Jack, 239
Boraski, Robert, 241
Giusta, Tim, 230
Morris, JoAnne Prichard, 239
Ott, Bill, 243
Pompeo, Lisa, 32

DOUGLAS KEISTER

has photographed thirty critically acclaimed books, which have earned him the title "America's most noted photographer of historic architecture." He also writes and illustrates magazine articles and contributes photographs and essays to other books, calendars, posters and greeting cards. Keister is the author of the bilingual English/Spanish children's book *Fernando's Gift*.